CHARLESTON

THEN AND NOW

Pavilion
An imprint of HarperCollins*Publishers* Ltd
1 London Bridge Street
London SE1 9GF

www.harpercollins.co.uk

HarperCollins*Publishers*
Macken House
39/40 Mayor Street Upper
Dublin 1
D01 C9W8
Ireland

10 9 8 7 6 5 4 3 2 1

This edition first published in Great Britain by Pavilion
An imprint of *HarperCollinsPublishers* Ltd 2024

ACKNOWLEDGMENTS
They say the most important decision you make in life is selecting the person with whom to spend
it. I couldn't have made a better choice, Chris Handal, and I am thankful every day for your love and
support. As I get older, I appreciate more and more how much family matters: Mama, Ken, Eileen,
Taylor and our extended Handal family. I am also grateful to have some very special friends around
me: Julie, the Porch Ladies, and a long list of others I dare not list individually for fear of accidentally
leaving someone out.

I owe a debt of gratitude to the Time Machine podcasts of Dr. Nicholas Butler, historian at Charleston
County Public Library, and other primary researchers of Charleston's history, from whom I've gathered
the background to share Charleston's stories with both visitors to our city and my readers. You can
find more Charleston stories at *www.charlestonraconteurs.com*.

PICTURE CREDITS
All "Then" images courtesy of the Library of Congress with the exception of the following:
p. 43 (bottom inset) Waring Historical Library
p. 56 (inset) The Charleston Museum Archives
p. 106 Alpha Stock / Alamy Stock Photo
With thanks to the Historic Charleston Foundation for the images on pages 54, 88 (inset image), 112,
118, 122 (inset)

All "Now" photography ©Pavilion Image Library/Karl Mondon, with the exception of the photographs
on the following pages:
p. 18 (inset) Jonathan Becker/Contour by Getty Images
p. 25 (top) Kruck20 / Alamy Stock Photo
p. 51 (main image) Steven Hyatt
p. 121 Profreader/Wikimedia Commons
p. 133 (bottom left) Spiderman (Frank) https//www.flickr.com/photos/spiderman/25668658
the following photos taken by Leigh Jones Handal pages 81, 99, 135, 141

Publishing Director: Stephanie Milner
Commissioning Editor: Frank Hopkinson
Editor: Sarah Epton
Editorial Assistant: Shamar Gunning
Design Director: Laura Russell
Designer: Cara Rogers
Design Assistant: Lily Wilson
Production Controller: Louis Harvey
Indexer: Colin Hynson

CHARLESTON
THEN AND NOW

LEIGH JONES HANDAL

PAVILION

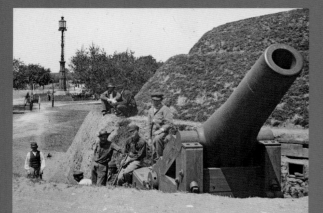

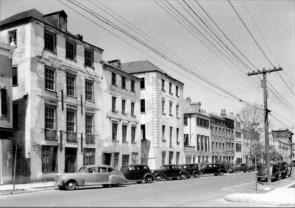

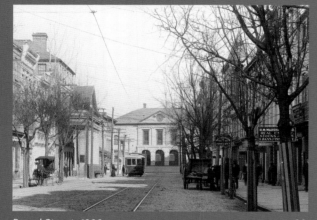

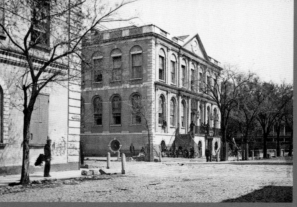

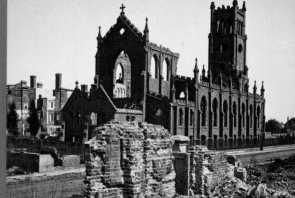

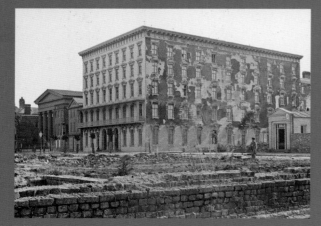

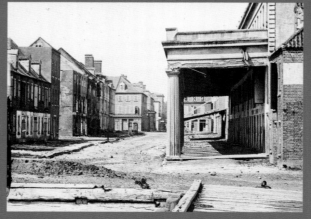

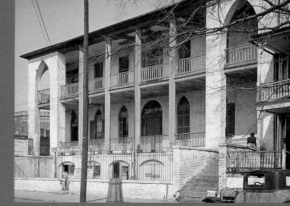

U.S. Customs House, 1958 p. 82

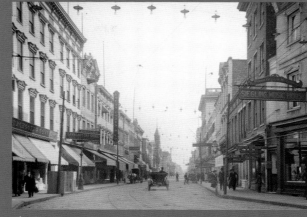

King Street, c. 1910 p. 90

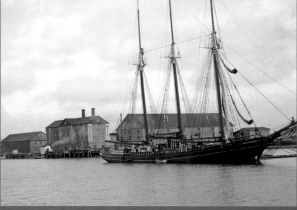

West Point Rice Mill, 1907 p. 100

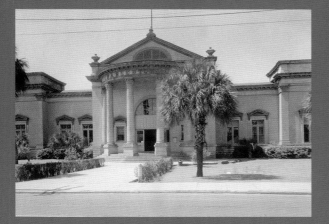

Thomson Auditorium, c. 1895 p. 102

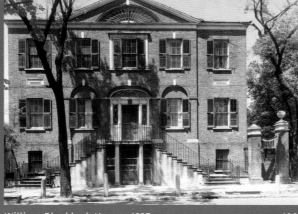

William Blacklock House, 1937 p. 108

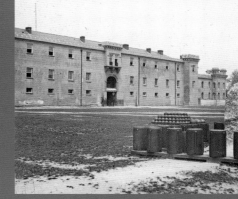

The (Old) Citadel, 1865 p. 114

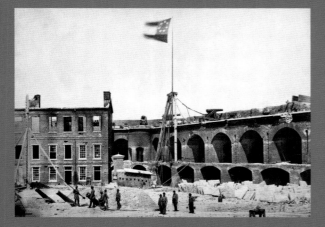

Fort Sumter, 1861 p. 122

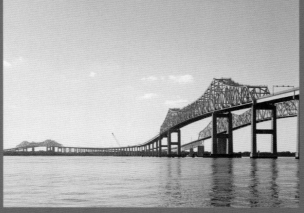

Cooper River Bridges, c. 1978 p. 132

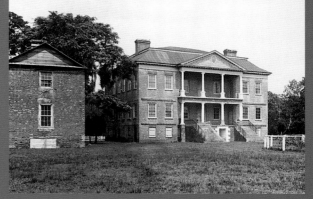

Drayton Hall, c. 1890 p. 142

CHARLESTON
INTRODUCTION

I was seven years old when I fell in love with Charleston on a Brownie Scout field trip. I vividly remember things about that first visit, like walking awe-struck beneath a giant whale skeleton to gawk at the mummy and shrunken heads in the old Charleston Museum (this location and many others can be found within the pages of this book), and the mustiness of the building with its very old dust. I remember visiting the Powder Magazine, where I bought a toy cannon as a souvenir for my little brother. What I remember most vividly, however, was the sensation I experienced when I first stepped out of the car onto the parking lot at the Heart of Charleston Motor Hotel, the moment I knew I was connected to this place and its history.

A little more than a decade later, when the time came for me to leave my small-town home, I made a beeline for the College of Charleston. Following college graduation I left to pursue graduate studies and start a career. Yet I always kept an eye out for the opportunity to return to the city where I knew I belonged, which I eventually did. By that time, however, the old Heart of Charleston Motor Hotel at 200 Meeting Street, where I'd first fallen in love with this city, had been demolished and replaced by a bank. Yet there was a certain karma about its demolition, for one of Charleston's brightest architectural stars, the Charleston Hotel, had been torn down to make way for the motor court. When it opened in 1838, the old Charleston Hotel was one of the most iconic hotels in the country, and certainly in Charleston. Perhaps its most remarkable feature, among many, was a block-long colonnade of 14 giant order Corinthian columns fronting a four-story Parthenon-style

façade that dominated the streetscape. According to late 19th-century photographer S.T. Sounder, the hotel ranked among the finest in America, "not only in the manner of its conduct, but as regards its situation and fine appearance. Its situation between two streets, gives it a fine circulation of air, making it exceedingly pleasant and desirable during the heated term of summer."

What the grand 19th-century Charleston Hotel did not have however, was parking, and by the 1920s times had changed and parking was essential. The property became derelict, a shadow of its former self, taking in cheap boarders for as little as $3 a night. The hotel could no longer compete with lesser facilities which were able to provide parking. And so, in 1960 Charleston's *grande dame* was demolished to make room for the new Heart of Charleston Motor Hotel. More than 150,000 of the old hotel's bricks were reused to build the nondescript two-story motel, with its swimming pool and coveted off-street parking. Still, Charlestonians were so distraught by the hotel's loss that they pushed to expand the city's protected historic district above Broad Street.

Today I like to think it was the spirit of the grand old Charleston Hotel—rather than the unremarkable Heart of Charleston Motor Hotel—that spoke to me so strongly on my first visit, igniting a passion for Charleston that has lasted more than a half century. Since then, I've had the privilege of knowing many of the places included in *Charleston Then and Now* well. As a College of Charleston alumna, I have been a part of the centuries-old traditions of the Cistern Yard. During the time I worked at Historic

Charleston Foundation, my office in the historic Capt. James Missroon House at 40 East Bay Street had the best view in town of the city's beautiful, historic High Battery.

I later worked at the American College of the Building Arts, where I had an office in the Old District Jail, and once—on a bet—I spent the night there just to prove I'd do it. The American College of the Building Arts then moved to the Old Trolley Barn, circa 1897, an exceptional example of how an old building can acquire a meaningful second life through rehabilitation. My husband Chris and I often attend events at the Gaillard Center, Queen Street Playhouse, Dock Street Theatre, and French Huguenot Church.

The places we love, like people, often change and dramatically so, or can even be lost to us forever. Sometimes that's a good thing, other times it is devastating. I hope you will enjoy the following stories of places that have been remarkably preserved or repurposed, as well as places, like the old Charleston Museum, where only the remaining columns recall a different time in Charleston's history.

RIGHT: A view looking east on Broad Street, the civic heart of the Holy City.

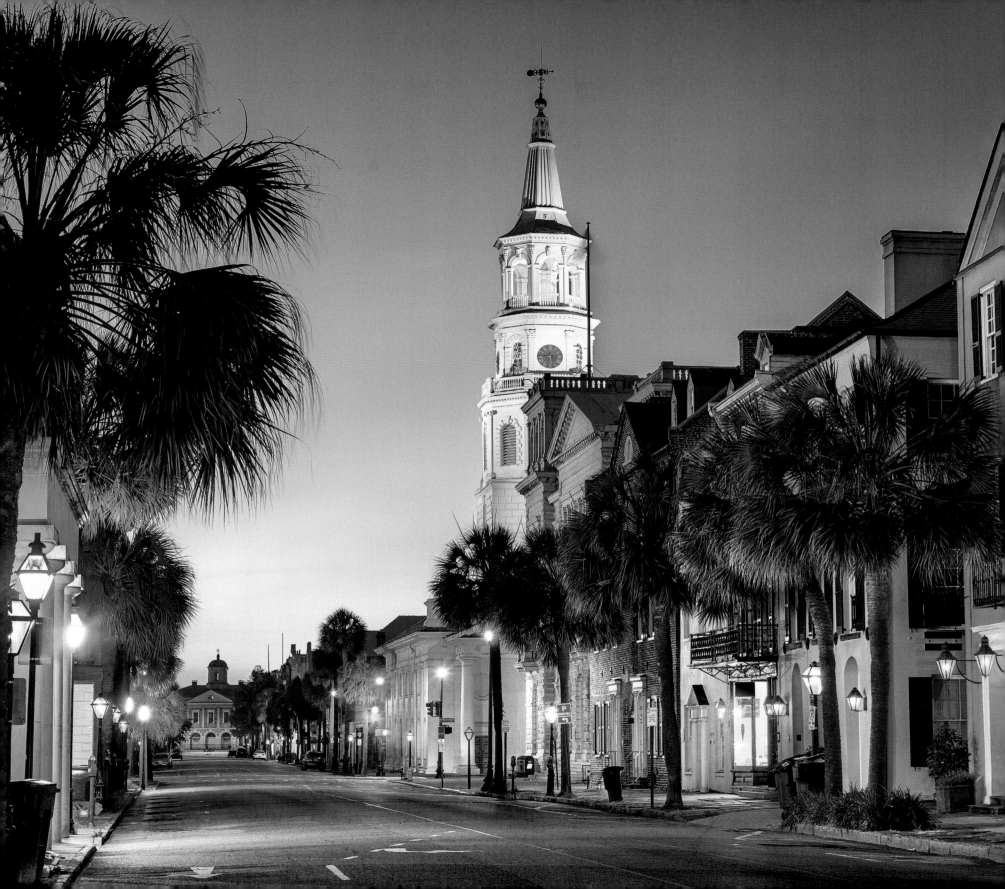

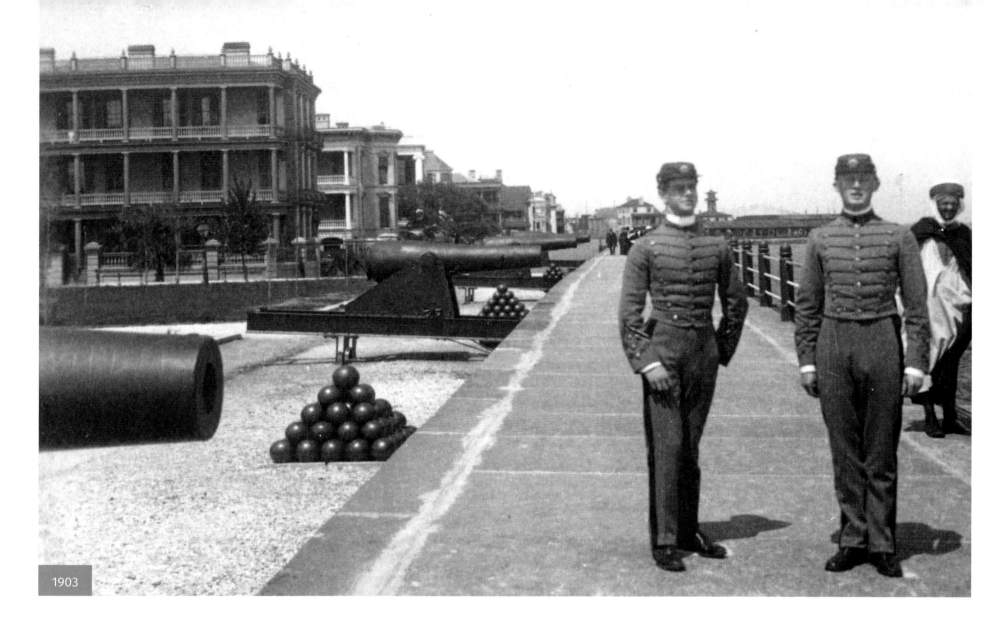

1903

HIGH BATTERY
Charleston's iconic pedestrian promenade for 200 years

ABOVE: The earliest Charles Town settlers wisely built their peninsular colony on high ground. Beyond its southern boundary at Vanderhorst Creek (today's Water Street), lay marshes and a sandy beach called White Point, or Oyster Point.

Colonists established Charles Town as the only English walled city in North America. Yet as its population grew, so did the colony's footprint. In 1731, the provincial government ordered a bridge to be built over Vanderhorst Creek to extend Church Street to White Point, where they built a brick fortification. They added a protective seawall, a double row of wooden pilings, which was destroyed in the 1752 hurricane.

Royal Gov. James Glen then ordered hundreds of free and enslaved laborers to build a new earthen wall from Granville Bastion (today 40 East Bay Street) to White Point, with ramparts to shield the colony's cannon. This battery was strengthened in the late 1760s, and by the start of the American Revolution, it stretched nearly half a mile south of Granville Bastion, defending Charles Town against British naval attacks.

The fortifications were later dismantled, but the city retained the seawall, widening it into a 60-foot promenade. Its crushed ramparts were used to fill in the marshes behind it to create new residential lots, highly valued for their views and sea breezes.

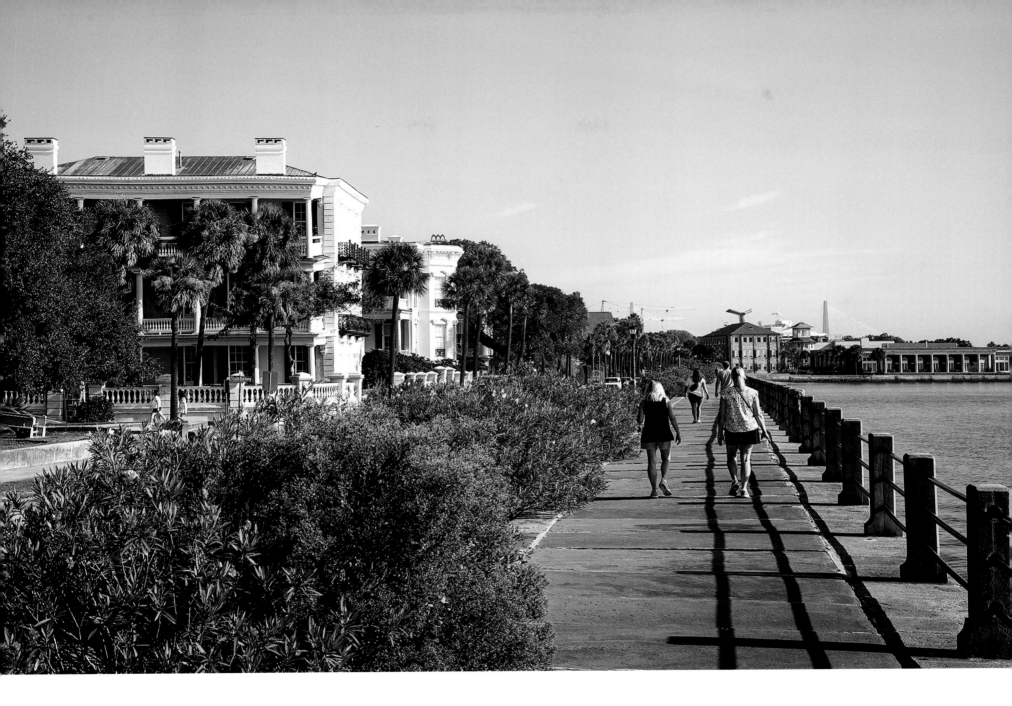

An ambitious and expensive project, the new battery no longer bordered the peninsula's beach, but was actually built out into Charleston Harbor's waters. Hurricanes in 1797, 1800 and 1804 set the project back for years. Finally, by 1818 High Battery was completed. Soon wealthy antebellum planters and merchants began building dazzling new townhouses, where they resided during Charleston's social season. For the next four decades, High Battery was a place of beauty, grandeur, and gaiety—until new earthworks were thrown up in 1861 to create Battery Ramsay.

ABOVE: High Battery is among Charleston's biggest tourist draws. Locals join the city's visitors in enjoying both the beauty of the harbor's waters, as well as the grand architecture of the palatial East Battery residences. Hurricanes and tropical storms have taken their toll over the decades, however, eroding its concrete and exposing rebar. Restorations initiated in 2019 along the Low Battery seawall are slowly making their way toward High Battery, recreating Charleston's historic seawall to be more beautiful and resilient than ever.

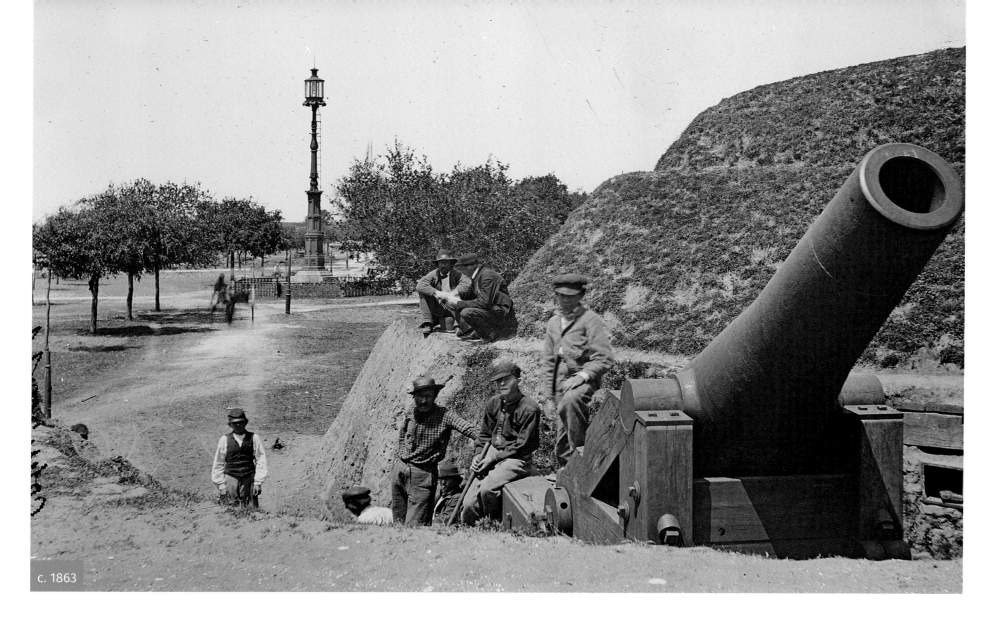

c. 1863

BATTERY RAMSAY
From pleasure garden to military fortress

ABOVE: Sometimes the beauty of a place can hide its harsh history. Such is the case at the southern tip of Charleston's peninsula city, in a park known as White Point Garden.

When the English settlers sailed past this spot in April 1670, it was nothing more than marshes surrounding a sandy beach piled high with sun-bleached oyster shells discarded by Native Americans—thus the name White Point. By 1837, the city had filled in about seven of the marshy acres surrounding the shell mound to create a waterfront park.

In 1861, however, the park's shady, tree-lined pathways were destroyed as the Confederate Army threw up massive earthworks mounted with three 10-inch muzzle Columbiad cannon along its eastern façade. The battery's name honored Confederate Major David Ramsay, who was mortally wounded on nearby Morris Island in 1863. As seen above, civilians and veterans gathered around one of the cannons that defended Charleston during a four-year bombardment by federal troops and confederates stationed here had a front-row seat to witness the first shots of the American Civil

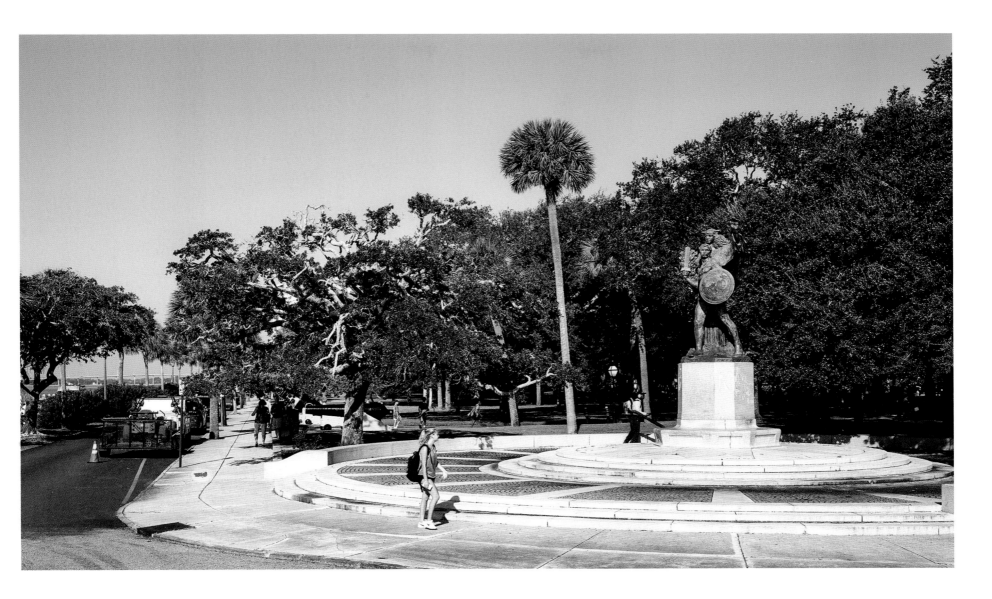

War being fired at Fort Sumter, a war that would go on to claim between 620,000 and 750,000 lives. The night before Charleston fell to Federal troops on February 18, 1865, Confederate Gen. P.G.T. Beauregard gave orders to destroy anything the Union Army could use if left behind. Too large to be loaded on the last train out, Battery Ramsay's cannon were blown up by the soldiers who had manned them.

ABOVE: After the war, the park returned to its former use as an open urban space in which to share a picnic, throw a frisbee, or read quietly under an oak's gentle shade. Couples, families, dog-walkers, and joggers have reclaimed the park with no visible signs of Battery Ramsay remaining. Muzzles of the cannon that ornament White Point Garden are filled with concrete, situated there for show as kids clamber around on top of them, posing for their parents' cameras. Memorial plaques interpret the monuments that now occupy the site of Battery Ramsay, sharing the history of Charleston and the 19th-century war that split the nation apart.

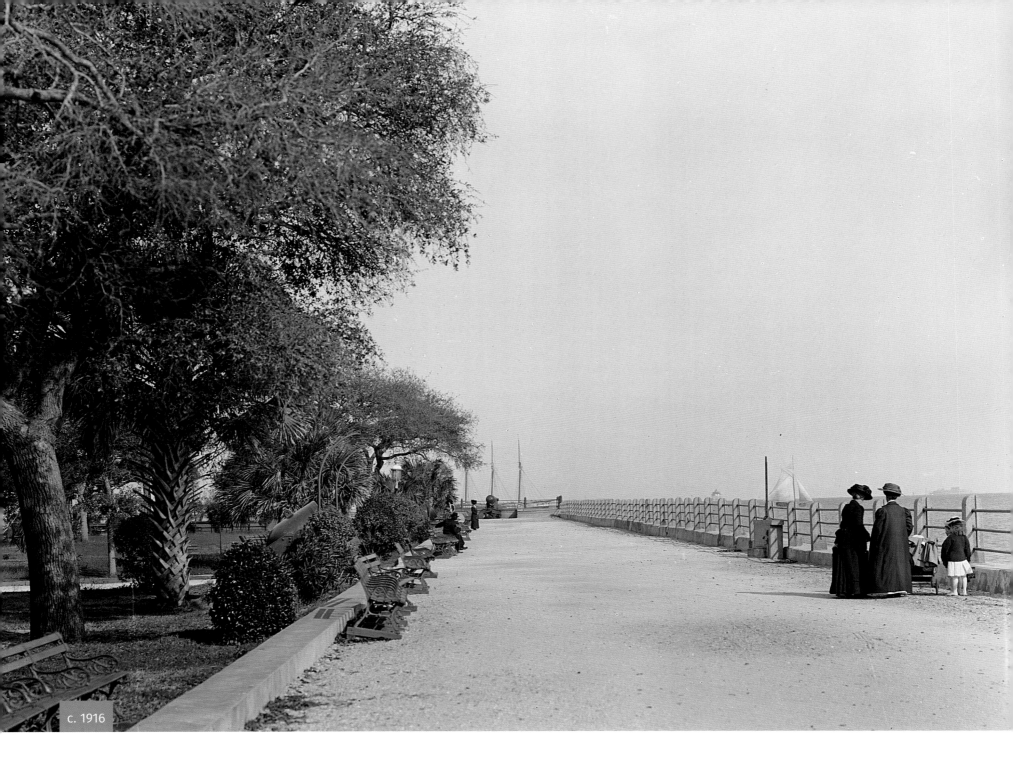

c. 1916

LOW BATTERY

Renewed optimism for the 20th century

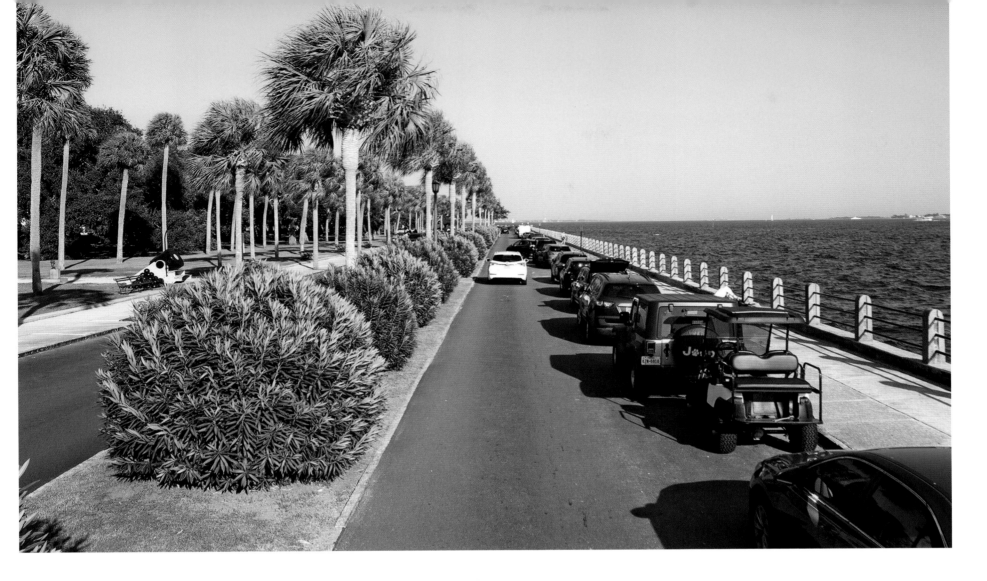

LEFT: Unlike High Battery's 18th-century defensive beginnings, Low Battery was created to convert marshy land into prime real estate. City officials discussed the idea in the 1850s, yet war, an earthquake, hurricanes and economic downturns kept the project on hold for decades. The dawn of the 20th century brought a renewed sense of optimism among Charlestonians, and although plans to expand the park were abandoned, officials broke ground for a new boulevard and seawall in July 1909. Shortages of materials and labor, however, sometimes resulted in the use of inferior products and structural shortcuts, and there were questions about if and how automobiles should be accommodated. By Christmas 1911 the first 3,885 feet of Low Battery, from King Street to Tradd Street's western end, was completed, but a 1,000-foot gap connecting the two batteries remained unfinished, and oyster shells used to top the new boulevard were absorbed into the muddy landfill. In 1916 philanthropist Andrew Buist Murray, fed up with the muck and delays, donated $40,000 to finish the connection to High Battery and pave the boulevard with asphalt to accommodate automobiles. In 1919 Murray Boulevard and its Low Battery seawall were completed.

ABOVE: Dozens of hurricanes have driven salty waves crashing over Low Battery, each taking its toll on the seawall (not to mention the houses it was built to protect). Given its often shoddy workmanship with sub-par materials, it's hardly surprising that the seawall has settled, cracked, crumbled and sloped, exposing gaping holes and rusting rebar.

In the summer of 2017, the city announced plans to rebuild Low Battery, addressing structural problems and drainage, while incorporating amenities such as benches and landscaping. The four-phase renovation is estimated to cost $70 million. As of April 2023, Phases I and II have been completed, with a beautiful new promenade stretching from the end of Tradd Street to Limehouse Street. Phase III began in April 2023 to repair the promenade from Limehouse Street to the west edge of White Point Garden. The final phase will again reconnect Low Battery to High Battery. While High Battery remains a "must-see" for Charleston's seven million tourists each year, Low Battery is more often used by locals to walk their dogs, get a little fresh air, or drop a fishing line.

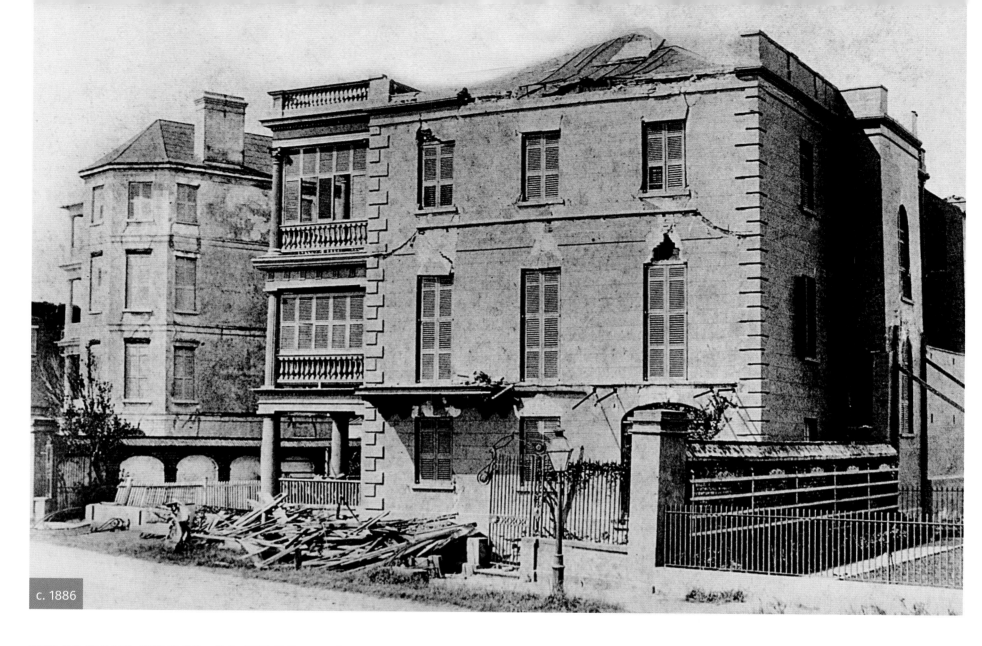

c. 1886

EDMONDSTON-ALSTON HOUSE, C. 1825, 21 EAST BATTERY

Oldest antebellum mansion on East Battery

ABOVE: Two years after completing his mansion at 19 East Battery in 1815, William Holmes sold 70 feet of street frontage along the northern edge of his property to Scottish merchant Charles Edmondston. This lot, however, was lower than the bump of land where Holmes had built his mansion on the former site of Fort Mechanic amid the marsh. As a result Edmondston waited for the completion of High Battery and its accompanying infill project before building his late-Federal-style townhouse in 1825, during the height of his commercial success. His house became the second substantial residence built along the new East Battery, a few blocks south of the noise, smells and bustle of the busy seaport's wharves.

After losing everything in the financial Panic of 1837, Edmondston sold his residence to rice planter Charles Alston. Alston added a new entrance facing East Battery along with a vestibule, but otherwise preserved the structural footprint of the house. He did, however, make substantial style changes, adding Greek Revival decorative features, a second-floor balcony, and a parapet bearing his family's coat of arms. Business

14

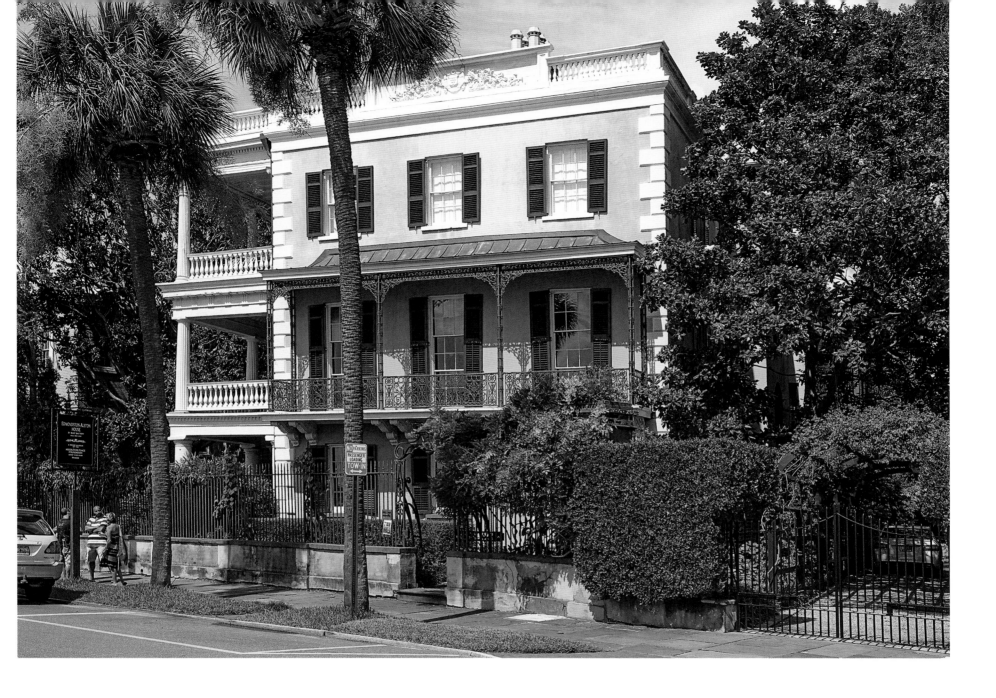

associates were received on the first floor, while the second floor drawing rooms were reserved for family and special friends.

It made a grand entertaining space, especially when the piazza doors were opened to maximize one's appreciation for the sea breezes and harbor view. From here Gen. P.G.T. Beauregard watched the bombing of Fort Sumter on April 12, 1861. Eight months later, Gen. Robert E. Lee sought refuge here after the Great Fire of 1861 threatened his lodgings at the Mills House Hotel on Meeting Street.

ABOVE: The house has remained in the Alston family since 1838, though it was absorbed within the nonprofit trust of the Middleton Place Foundation in the 1970s. Current family members live on the third floor, while the first two floors are open to the public as a house museum. It is one of the few house museums to contain its original family furnishings, including books, china, silver, and art—all of which tell a rich story of the families who lived here throughout the Civil War, earthquake of 1886, and numerous other challenges of the 19th and 20th centuries, including the stories of the enslaved people who lived and worked here.

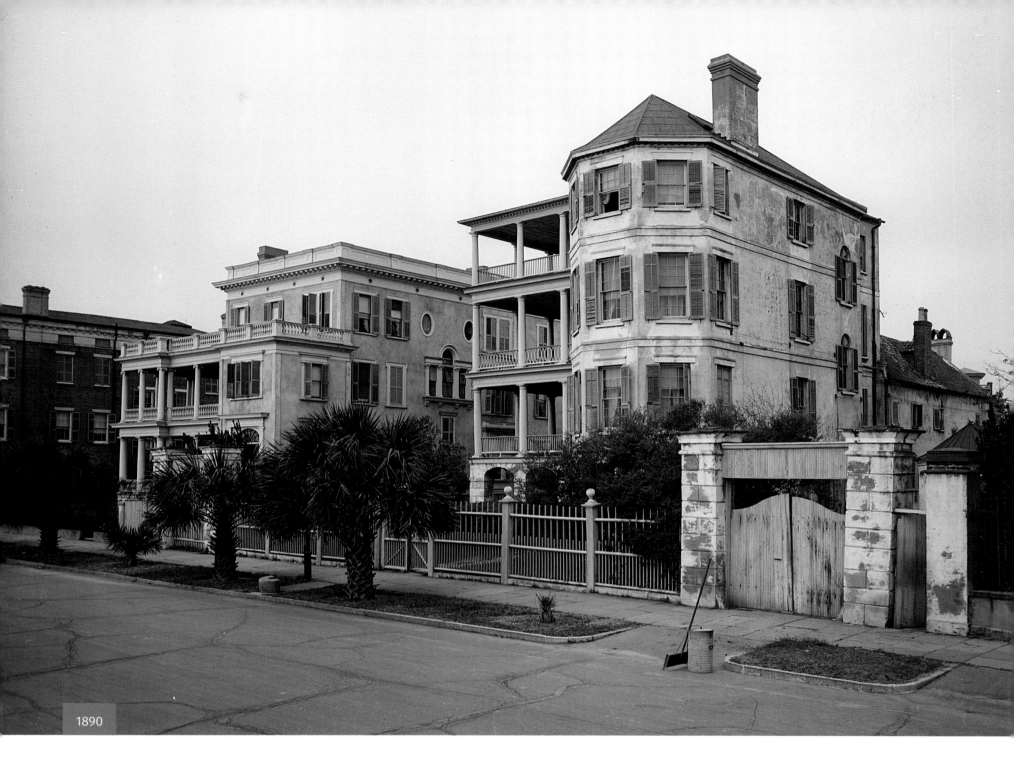

1890

JULIUS M. VISANSKA HOUSE, 19 EAST BATTERY

Site of the first house on High Battery is now the most recently built

16

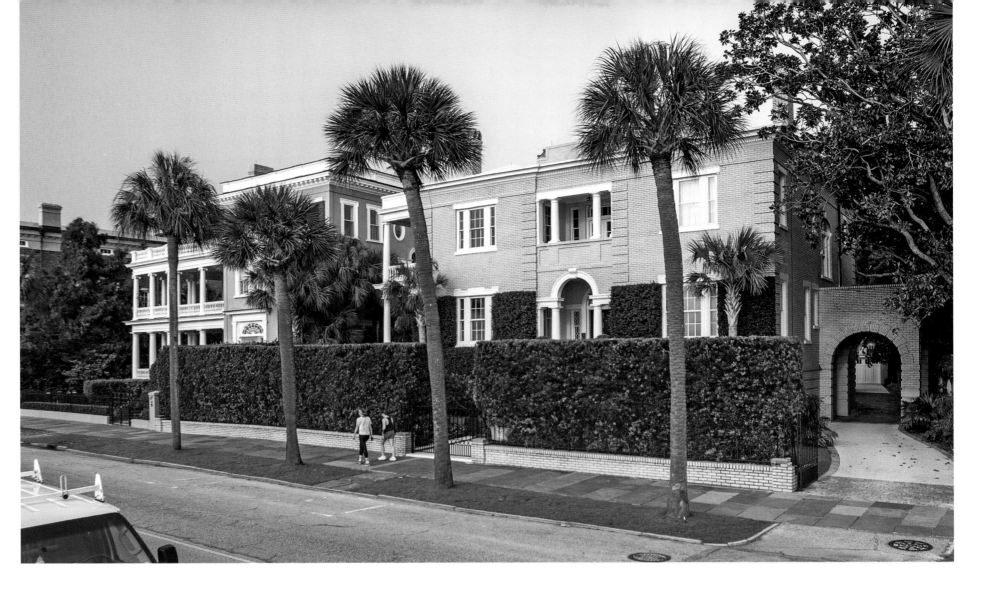

LEFT: The lots at 17 through 21 East Battery have a rich military history. An earthen fort—Lyttleton's Bastion—was first built here during the French and Indian War (1754–1763) on a bump of high ground between the colony's southeastern edge and White Point. The fort was refurbished during the American Revolution and later dismantled, though as unrest between the British and French threatened international conflict in 1794, Congress authorized construction of a new wooden fort. When construction costs exceeded the allocated federal funding, local carpenters donated their labor to complete it. The hurricane of 1804 wrecked the fort, which was then rebuilt of brick.

After the War of 1812 the fort was dismantled for good, and the lot sold to Elizabeth Edwards Holmes. Here in 1815 she and her husband, John, built an impressive four-story Adamesque mansion, the first along the new street. Among its furnishings was a handsome bookcase that had been handed down through the Edwards family. The residence remained in the family until 1909 when it was purchased by Robert P. Tucker, who later demolished the mansion, though his reasons for doing so are unclear.

ABOVE: In 1919, Tucker sold the lot of his demolished house to haberdasher Julius M. Visanska, who built a distinctive 7,000 sq. ft., two-story yellow brick house designed by Charleston architect Albert Simons, and employing a mix of Renaissance and Greek Revival styles and a Charleston double-house footprint. When completed in 1920, the newest house on High Battery was one of the most expensive properties in Charleston.

The building has changed hands numerous times over the past century. The U.S. Navy briefly commandeered it during World War II for its magnificent views of the harbor, watching for any potential attacks.

Much of the Holmes Mansion's fine interior details were salvaged and reused at 46 Murray Boulevard along Low Battery. The Edwards-Holmes bookcase is now exhibited at the Heyward-Washington Museum house and is considered to be among the most important examples of colonial-era craftsmanship in America.

MILES BREWTON HOUSE, 27 KING STREET

Among the finest Georgian-Palladian residences in America

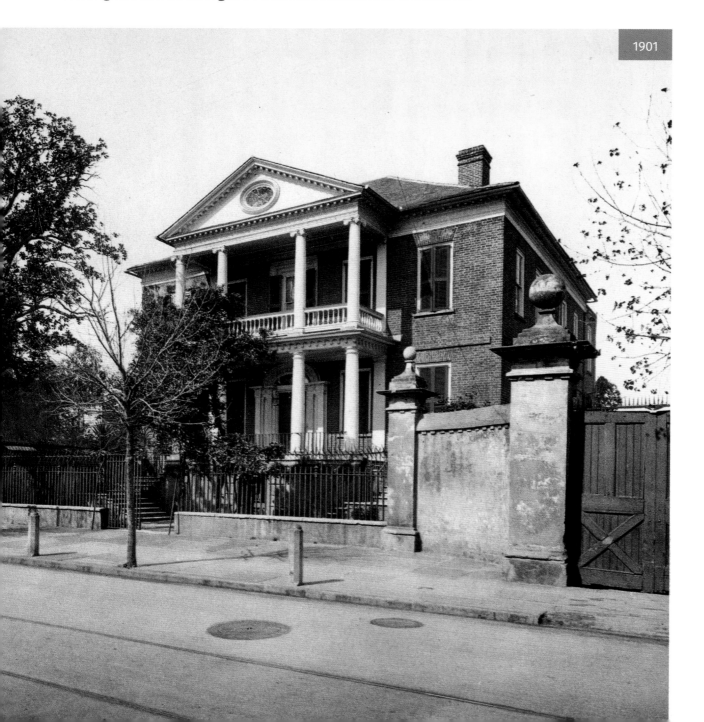

1901

LEFT: Miles Brewton was one of the wealthiest merchants and slave traders in the British colonies, and his marriage to Mary Izard added several plantations to those he already owned. With that wealth, Brewton set out to build one of the finest townhouses in America. Using the best artisans and materials, Brewton built his brick double house over a raised basement with a two-story portico featuring Ionic over Doric columns of stone imported from England. The entrance and flanking stairs are marble, and the front door's elliptical fanlight is the oldest and finest in the city. Master builder Ezra Waite is credited with the intricate exterior and interior wood carvings. A mahogany staircase leads upstairs to a grand ballroom, and the two-acre complex included a carriage house, slave quarters and garden pavilion. The Brewtons lived in their new residence for only six years, at which time Brewton was elected to the Second Continental Congress. As he and his family traveled to Philadelphia, their ship went down. There were no survivors. The house passed to his sister Rebecca, another ardent Patriot. It was with some irony then that when Charleston fell to the British in 1780, Sir Henry Clinton established his headquarters in the house. Clinton's profile and a warship can still be seen etched into the parlor's marble mantel.

BELOW: Master builder Ezra Waite collaborated with Miles Brewton in designing his house and is credited with doing most of the residence's intricate carving.

c. 1933

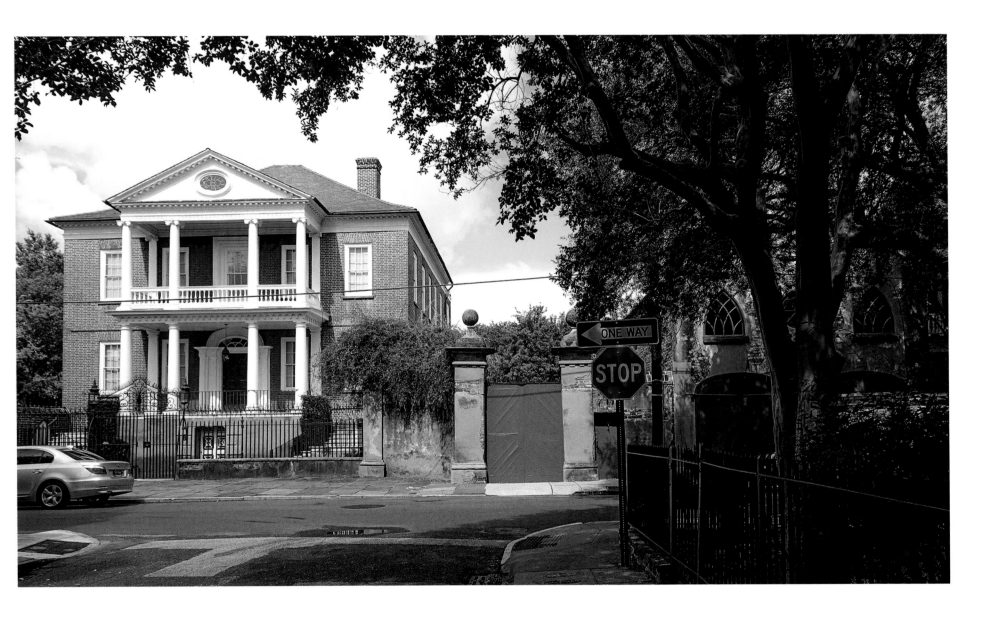

ABOVE: Brewton's house has withstood more than 250 years of natural and man-made disasters. It remains in his family to this day and has never been sold. Named a National Historic Landmark in 1960, the property was restored by Peter and Patricia Manigault from 1988 to 1992. After extensive research, the Manigaults were able to replicate historic wallpapers and paint colors from salvaged fragments, including some found in a centuries-old rat's nest. Ceiling medallions, Delft fireplace tiles, gilding, ironwork, Waite's carvings and other elements were restored. The house was retrofitted with electrical, plumbing, heating, and cooling systems, and an elevator, all with thoughtful attention to preserving its historic interiors. The garden maintains much of its 18th-century footprint. At the rear stand four stone columns that were part of Brewton's boat landing when the waterfront once bordered the property. The front gate and fence feature one of the few remaining *chevaux de fries*, or defensive spikes. In the grand ballroom, Brewton's crystal chandelier is the only colonial chandelier remaining in South Carolina, creating the ambience of a previous era.

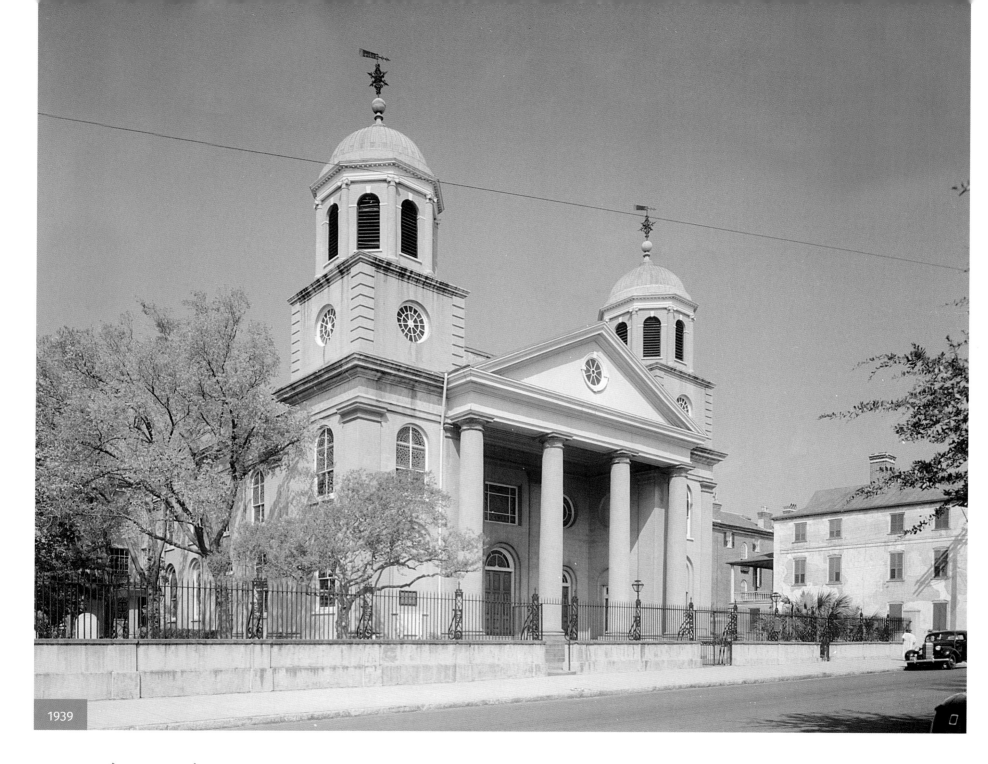

1939

FIRST (SCOTS) PRESBYTERIAN CHURCH

Kilts, Bagpipes, and Kirkin' o' th' Tartans

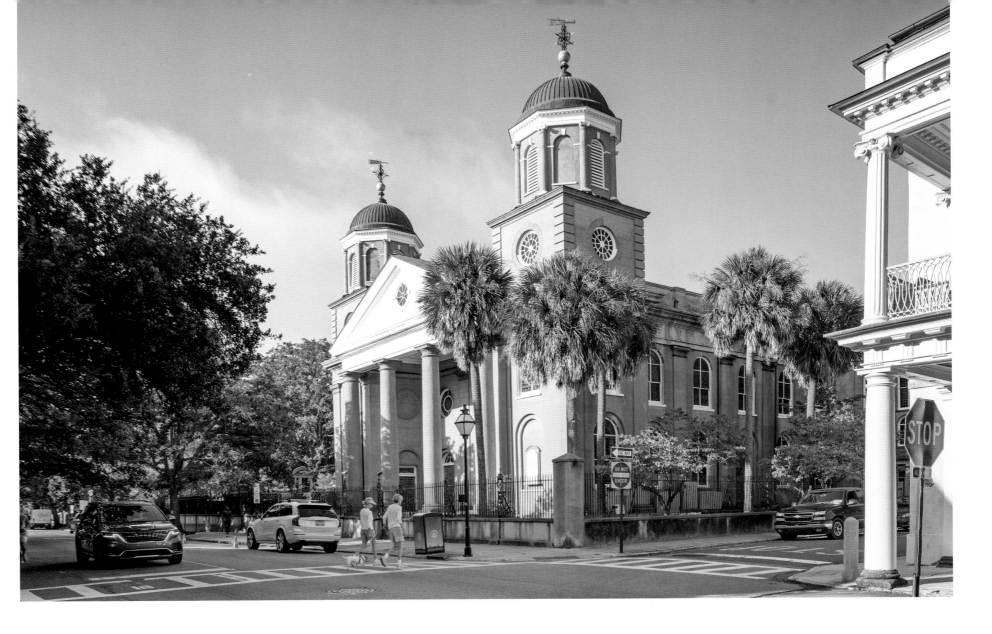

LEFT: The first documented Scottish immigrant to Charles Town, John Crafford, arrived aboard the *James of Erwin* in 1682. Religious tolerance made the Lowcountry an attractive choice for Crafford's Presbyterian countrymen, who worshiped together at the Independent Meeting House, which became Circular Church. More Scots arrived after the 1707 Treaty of Union united England and Scotland, and by 1731, 12 Scottish families had left the Independent Church to establish Charleston's fifth oldest congregation. Originally called the Scots' Kirk, their new church was completed by 1734 a few blocks south of the old one. This wooden church was enlarged several times, and in 1814, it was replaced by a larger stucco-over-masonry building with gilded bell towers on either side of a columned portico, a design attributed to bothers John and James Gordon, members of the congregation. The Seal of the Church of Scotland adorns the entry's stained-glass window, and wrought iron grilles feature Scottish thistles.

ABOVE: The congregation donated their bells to the Confederacy for ammunition in 1861. They were never replaced, until 1999 when a church in England offered to sell a set of bells cast in 1814, the year First Scots' was completed. Unfortunately the south bell tower, which had been damaged in the earthquake, could not support the bells' weight. The largest bell, however, weighing 1,470 pounds, was hung in the north tower. The church underwent renovations after the 1886 earthquake and a fire in 1945, and again in 1987.

More than 800 documented souls rest in First Scots' churchyard, about 50 of them dating to the 18th century. A 1772 memorial salvaged from the first wooden church, honoring member Lady Anne Murray, has been preserved and can be seen today. Scottish Heritage Sunday is celebrated each September with kilts, bagpipes, and the Kirkin' o' th' Tartans, at which the minister blesses each of the clans' colors.

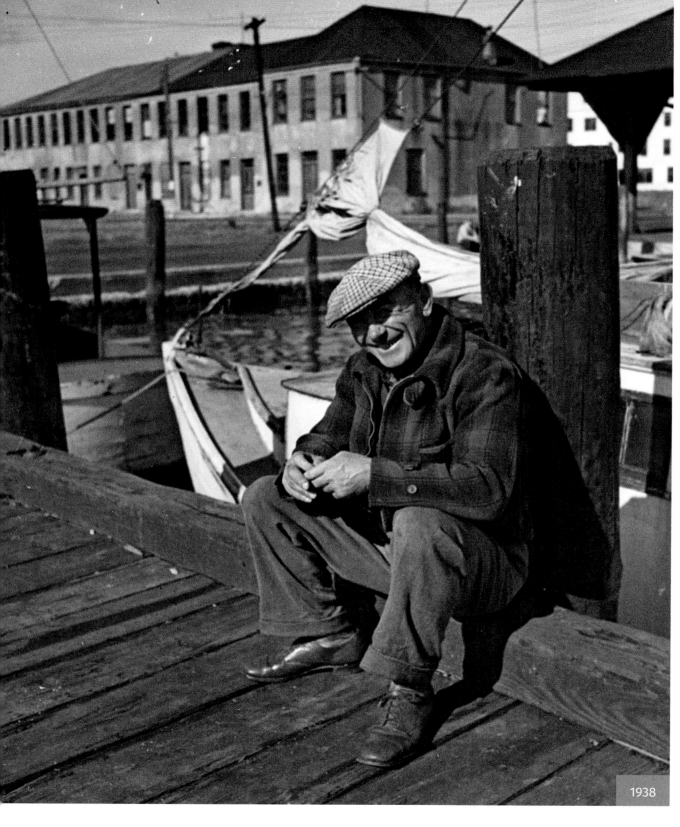

1938

ADGER'S WHARVES, CONCORD STREET
Stylish neighborhood was once part of a bustling waterfront

LEFT: During the late 18th and 19th centuries, the shady lane one finds here today served as the bustling hub of Charleston's shipping industry, a vital part of the city's economy. Then, East Bay Street defined the eastern edge of the colony's peninsula. Beyond lay tidal marshes filled with pluff mud that was exposed and then inundated with the tide's ebb and flow. Over these marshlands merchants built long wharves out into the Cooper River, where ships carrying everything from new settlers to rice, cotton, and dry goods tied up to load and unload their cargoes.

Merchant William Greenwood was a consigner of tea, which was so controversially taxed under Parliament's Tea Act of 1773 that it became a catalyst for the American Revolution. Greenwood built his wharf opposite Tradd and Elliott streets, site of the colony's first market. By the end of the 18th century, William Crafts had acquired both Greenwood's Wharf as well as the one south of it and consolidated them into Crafts' North and South Wharves. Around 1842 James Adger & Co. purchased the property and renamed it Adger's Wharves. Under his ownership, the wharves became the southern terminus of the first steamships to run between Charleston and New York, making Adger the wealthiest man in South Carolina and one of the wealthiest in America in the decades before the Civil War.

Over time the wharves grew larger, wider. Infill and buildings were added. By the outbreak of the Civil War, Adger had constructed several brick warehouses with brokers' offices along the northern side of his wharf. Some were damaged in the war and others added afterward. The 1884 Sanborn insurance map shows warehouses along the north side of Adger's Wharf, including those seen in the background of the 1938 image. By this time, the wharves were used for smaller boats and fishermen.

ABOVE: In the 20th century, port activities moved further north along the Cooper River into North Charleston and the Wando terminal, away from the historic downtown district. The wharves south of Broad Street, including Adger's, became streets. North and South Adger's Wharf are two of several along the infilled area east of East Bay Street that still have "wharf" in their names. While their exterior architectural features have been preserved, the wharves' warehouses gradually were rehabilitated into residential and office use. Today Adger's Wharf serves as the southern terminus of Charleston's beautiful Waterfront Park, with a new pedestrian pier reaching out into the harbor's waters, recalling the days when this was the busiest shipping port in the North American colonies. Heavy chains, used for decorative purposes, recall the days when sea-going vessels would dock here to load and unload their cargoes.

RAINBOW ROW, 79–107 EAST BAY STREET

With stories as colorful as their exteriors

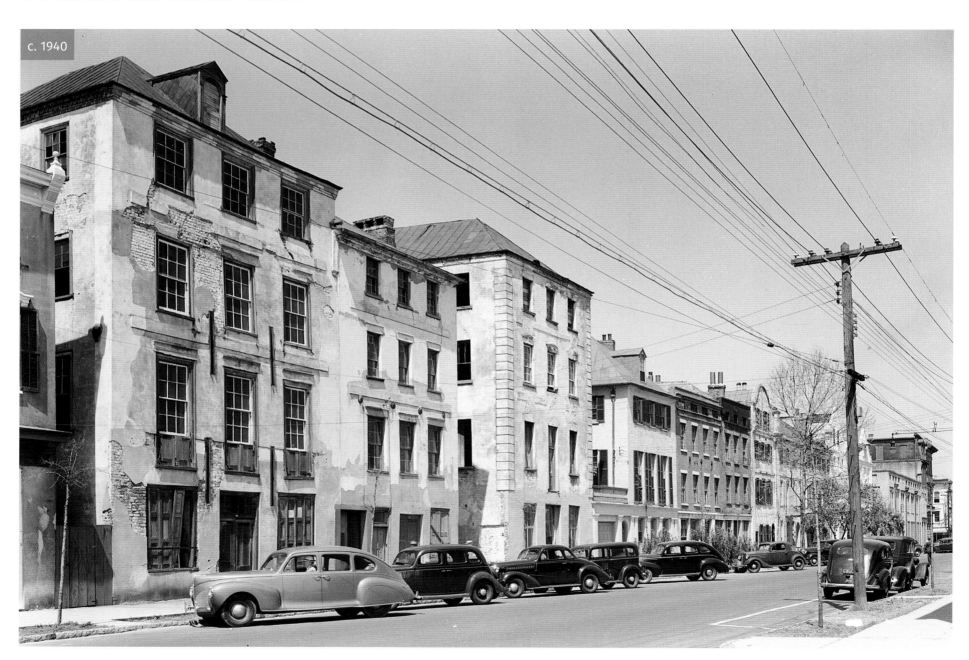

c. 1940

The row had deteriorated into slum conditions by the last half of the 19th century before becoming the birthplace of America's preservation movement in the 1920s, when six of the properties were purchased and restored by Susan Pringle Frost, a realtor and founder of the Society for the Preservation of Old Dwellings. Frost reinvested proceeds from one house into renovating the next. She sold 99–101 East Bay to her friend Dorothy Porcher Legge in 1930. Thinking the streetscape looked rather dingy, Legge painted her house pink, for no other reason than she liked the color. It was a hit. Soon her neighbors began painting their restored houses in Caribbean hues, which seems appropriate given colonial Charles Town's close connections with the West Indies. And that is the true story of Rainbow Row's colors.

LEFT: Few visitors leave Charleston without having seen Rainbow Row, America's longest cluster of intact colonial Georgian row houses. Some of the stories told about the properties are as colorful as their exteriors. One explanation for their pastel hues is that drunken sailors used the colors to recall where they were boarding. Another claims the colors allowed illiterate people to find shops whose signs they couldn't read. Neither story holds water, as the stucco-over-brick buildings were all a natural greenish-gray until the 1930s.

These residences, built along what was known as Bay Street, were the colony's commercial hub. The oldest, the Othniel Beale House at 99–101 East Bay Street, was built soon after the Fire of 1740. Unlike its neighbors, it survived the Fire of 1788. The William Stone House at 83 East Bay, c. 1784, was completed by the Tory merchant's agents after he fled to England following the American Revolution. The largest property, the James Gordon House at 87 East Bay, was built in 1792 by one of the brothers who built the First (Scots) Presbyterian Church. Its neighbor at 91 East Bay Street, c. 1788, was built by the firm Leger and Greenwood, who imported the controversial tea that was seized during the Charleston Tea Party in 1773. South Carolina surveyor James Cook built his house and shop on the next lot, replacing a property that burned in the Fire of 1788.

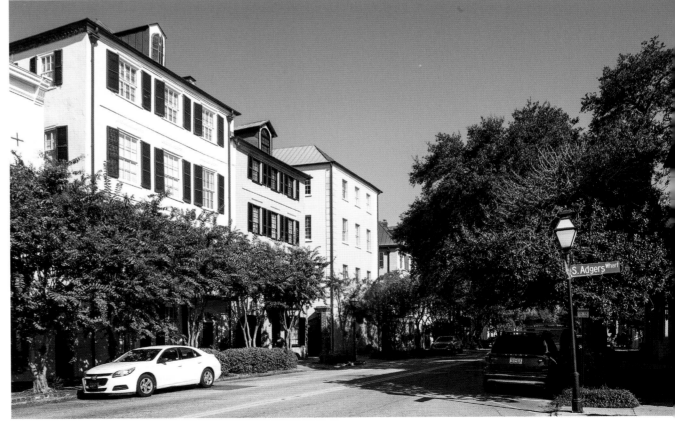

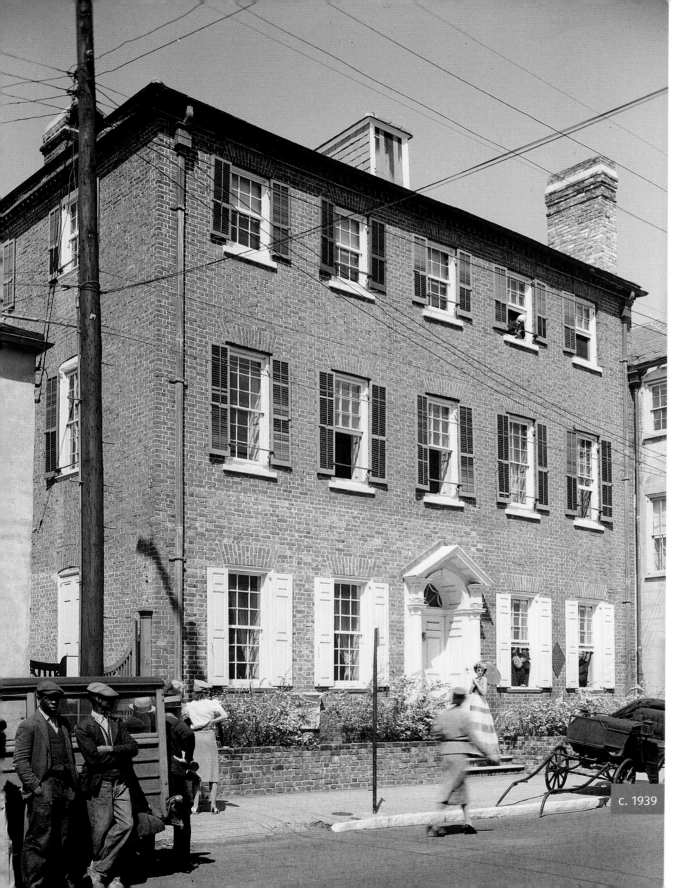

c. 1939

HEYWARD-WASHINGTON HOUSE, 87 CHURCH STREET

George Washington slept here

LEFT: Gunsmith John Milner owned a wooden house and shop on this lot as early as 1730, which archaeological evidence indicates burned in the Fire of 1740. Nine years later his son established a brick residence here. In 1772, rice planter Daniel Heyward razed Milner's house and built the current three-story Georgian double house, one of Charleston's largest colonial residences. Heyward gave the house to his son, Thomas Heyward Jr., who in 1777 was an artillery officer in the American Revolution, one of South Carolina's four signers of the Declaration of Independence, and a member of Congress until he became a circuit judge in 1778. He was captured when the city fell to the British in 1780 and released in a prisoner exchange a year later.

The city rented Heyward's house to use as President George Washington's residence during his week-long visit to Charleston in 1791. It has been known as the Heyward-Washington House ever since.

BELOW: A view of the house during its use as a bakery (1883-1929), when its first floor had been rehabilitated as a dry goods storefront. The house had greatly deteriorated after the Civil War.

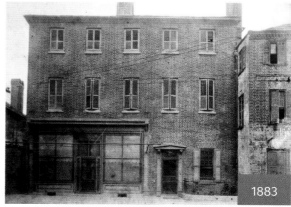

1883

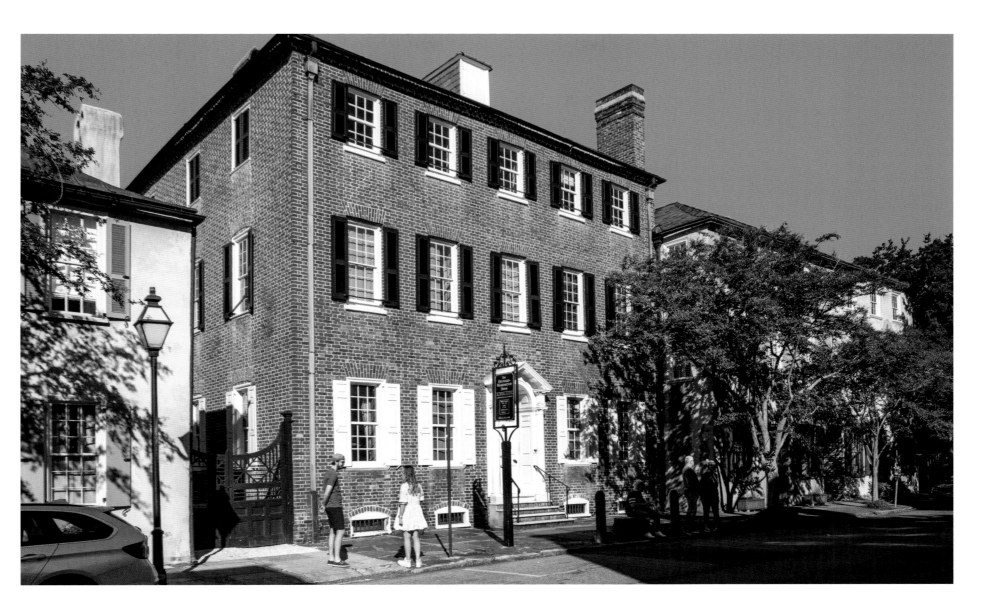

Heyward sold the property three years later to Judge John Grimké, father of abolitionists and suffragettes Sarah and Angelina Grimké. It is believed that their experiences while living here shaped their views on the injustices of slavery. Grimké sold the house to Margaret Munro, who operated it as a boarding house before leaving it to her granddaughter, Elizabeth Jane Hervey Trott, in 1857. Elizabeth's husband died in 1863 and she fled with their children to the Upstate for the remainder of the Civil War. Union soldiers were billeted at the house after the city fell in 1865.

ABOVE: The house was saved from destruction by The Charleston Museum, with assistance from the Society for the Preservation of Old Dwellings, in 1929. Today the museum showcases an excellent collection of Charleston-made furniture, including the Edwards-Holmes bookcase, considered one of the finest examples of American-made colonial furniture. Archeological studies allowed the property's 18th-century parterre garden to be restored as well. John Milner's 1740 outbuildings remain onsite. The property was declared a National Historic Landmark in 1970.

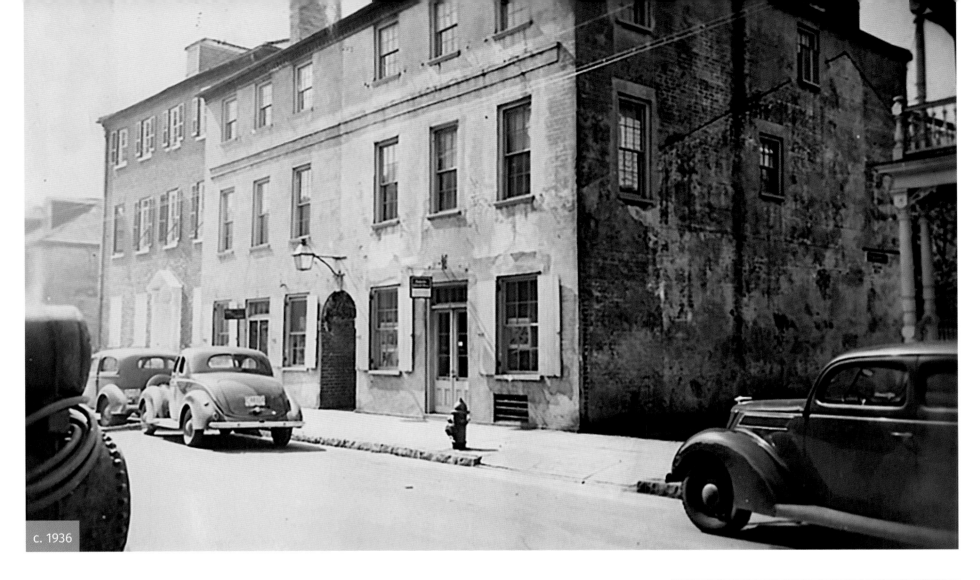

c. 1936

CABBAGE ROW, 89–91 CHURCH STREET
Dramatic setting of America's first opera

ABOVE: Before his death in 1749, William Hendricks directed his executors to complete construction of these three-story, stuccoed brick tenements connected through a central arcade. Later damaged in the 1886 earthquake, the tenements deteriorated into slums, and as many as 10 families—mostly first- and second-generation descendants of emancipated slaves—lived in the tightly packed rooms. Residents sold cabbages and other produce, loudly hawking their wares from open windows, which gave rise to the nickname "Cabbage Row." Municipal records paint an impoverished picture of the living conditions. One white neighbor, however, a young writer named DuBose Heyward, saw life in Cabbage Row with more humanity and compassion. Though descended from one of Charleston's most prominent families, Heyward had grown up poor after the death of his father, working for a while on the waterfront alongside black stevedores. Living a half block south of the tenements, Heyward

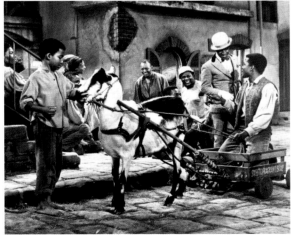

RIGHT INSET: In this scene from *Porgy and Bess*, Goat Sammie (named for his goat cart) confronts Bess's drug dealer, Sportin' Life.

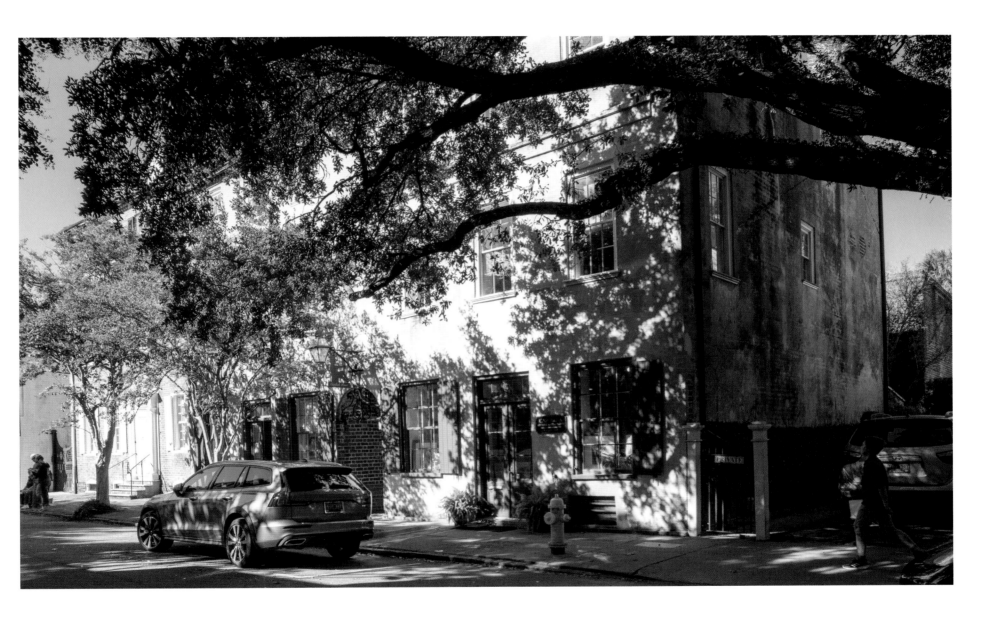

passed Cabbage Row daily, observing its tenants' lives. In 1925 he wrote a short novel, *Porgy*, telling the poignant story of a crippled beggar trying to save the life of the woman he loved from her violent boyfriend and her drug dealer. Heyward's wife, Dorothy, was a playwright, and together they staged the story for theater, fictionally moving the tenement to Charleston's waterfront and renaming it Catfish Row. Composer George Gershwin read the book and in 1935 collaborated with the Heywards and his brother Ira to transform the story into America's first native opera, *Porgy and Bess*.

ABOVE: Landscape architect and preservationist Loutrell W. Briggs purchased Cabbage Row in 1928 and set about restoring the buildings as rental housing for artists during Charleston's Renaissance period. Mr. and Mrs. Reynolds Brown purchased the rear dependencies and undertook their restoration into posh single-family residences. Today, Cabbage Row includes a mix of single-family residences and upscale rentals, one selling recently for nearly $6 million, while a 920 sq. ft. rental unit was advertised at $3,200 per month.

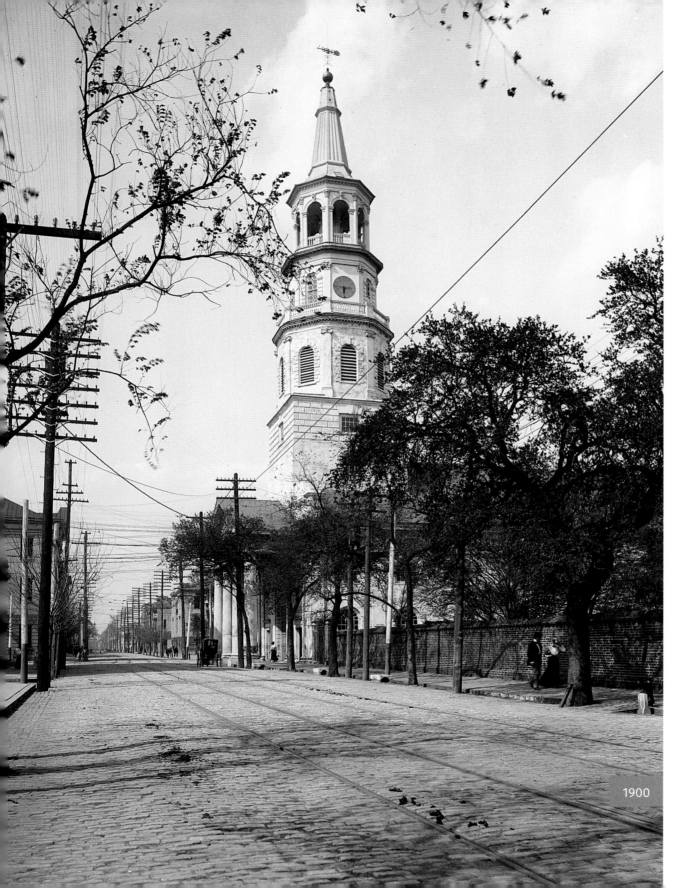

1900

ST. MICHAEL'S CHURCH, 71 BROAD STREET

One of the finest Colonial Georgian churches in America

LEFT: Charleston's first church was St. Philip's Anglican, built *c.* 1680 on the southeast corner of Broad and Meeting streets. The congregation outgrew the small wooden church and in 1727 built a larger one on Church Street. As Anglicanism flourished, the Provincial Assembly created a second parish in 1751, and St. Michael's was completed 10 years later on St. Philip's original site. Architecturally, the church reflected the wealth of Charleston's 18th-century merchants and planters. The two-story stuccoed brick church features a 186-foot steeple with clock, vane and bell tower, a giant classical portico supported by Tuscan columns, and a slate roof.

George Washington worshiped in pew number 43 during his 1791 visit, as did Robert E. Lee 70 years later. Yet St. Michael's gleaming white steeple was soon a target for the Federal bombardment of the city during the Civil War, as it had been for the British during the American Revolution. The church survived both, though its portico was destroyed in the 1886 earthquake.

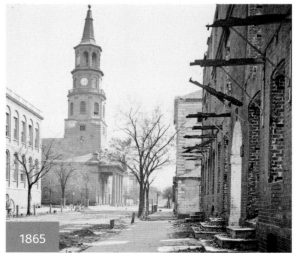

1865

RIGHT: St. Michael's steeple is one of Charleston's most iconic images and its bells a cherished part of the historic district, though St. Philip's congregants have never let St. Michael's forget their Civil War *faux pas* (see below). The church has retained its colonial footprint, with the addition of a sacristy in 1883. Yet its steeple now stands almost 8 inches out of plum, its weight having caused the church to tilt westward in the 1886 earthquake. Still, its original box pews and stone floor remain, as does its communion rail, forged in 1772. Its 1803 brass chandelier has been electrified. Scars from a Union shell remain on the pulpit. Most days, when services are not in progress, the church is open to the public. Few experiences are finer than stopping by on a day when the organist is practicing.

LEFT INSET: St. Michael's eight bells, cast in 1764 by Lester and Peck of London, were stolen by the British in 1782 but later returned. As the Civil War began, vestries of both St. Philip's and St. Michael's prayed for guidance in deciding whether they should donate their bells to the Confederacy. St. Philip's did so. St. Michael's, however, hid their bells in Columbia in anticipation of Union General William T. Sherman burning Charleston. What a surprise, then, when Sherman destroyed Columbia rather than going to Charleston. The barn under which the bells were hidden burned with a heat so intense they were destroyed. Their remains were sent back to London to be recast. Upon their return, however, they were incorrectly installed by local artisans. For the next 125 years, the bells were never rung, but only chimed—until they were damaged again in Hurricane Hugo (1989). This time, after they were repaired in London, English foundrymen came to install them. In 1993, for the first time since before the Civil War, St. Michael's bells rang again.

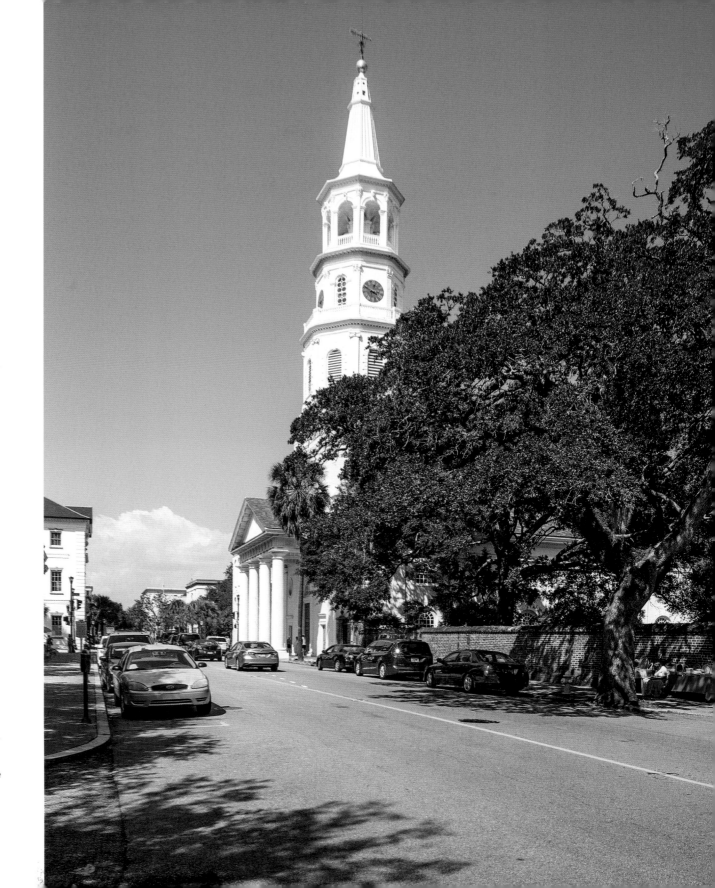

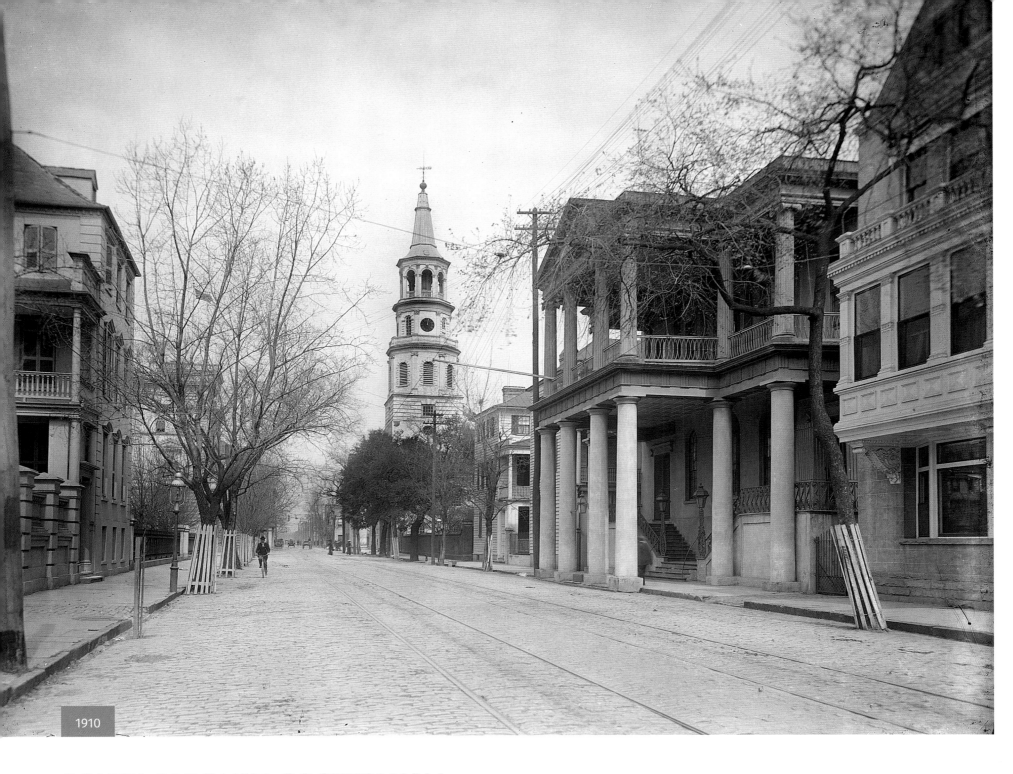

1910

SOUTH CAROLINA SOCIETY HALL
Nearly three centuries of mixing business with pleasure

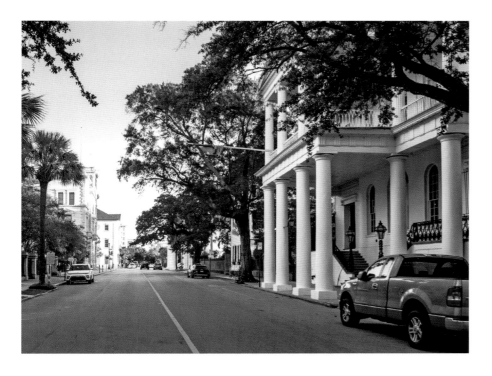

LEFT: Within the colony's diverse population, fellow countrymen established benevolent societies who helped immigrants or those struggling financially. In the 1730s, when a Huguenot tavern owner was experiencing financial hardship, his friends met at his tavern often, adding onto their bar tab two bits (16 pence), acquiring the nickname the Two-Bit Club. Though the tavern owner got back on his feet, the group continued meeting, next raising money to build a boys' school. They began including non-French members and changed their name to the South Carolina Society, building a girls' school and membership hall at 72 Meeting Street. A two-story stucco building on a high basement, the first floor served as a school, while the upstairs featured a large meeting hall. In 1825, architect Frederick Wesner added a two-story portico featuring Doric and Ionic columns. The school closed in 1840 when public education made it unnecessary.

ABOVE AND RIGHT: The South Carolina Society remains a social organization today, with a coveted membership open only to descendants of early members. They meet regularly in their hall, a popular rental venue for weddings, cotillions and other social events. Today, the society supports scholarships at the College of Charleston.

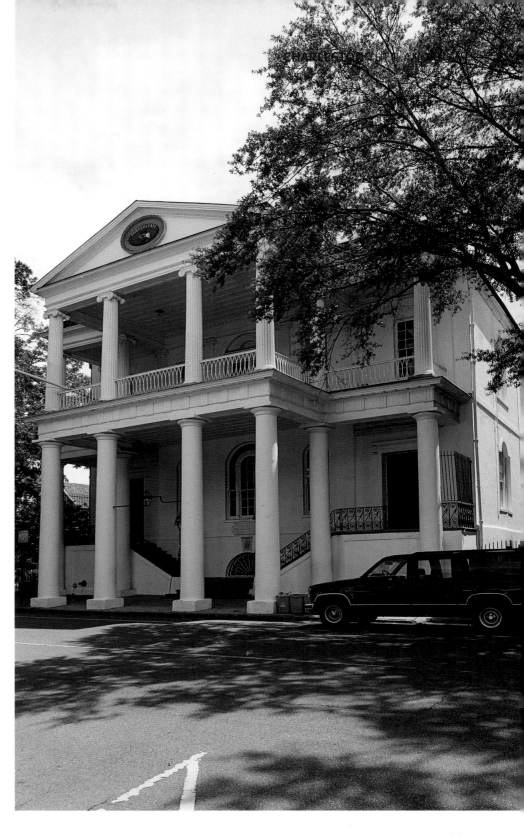

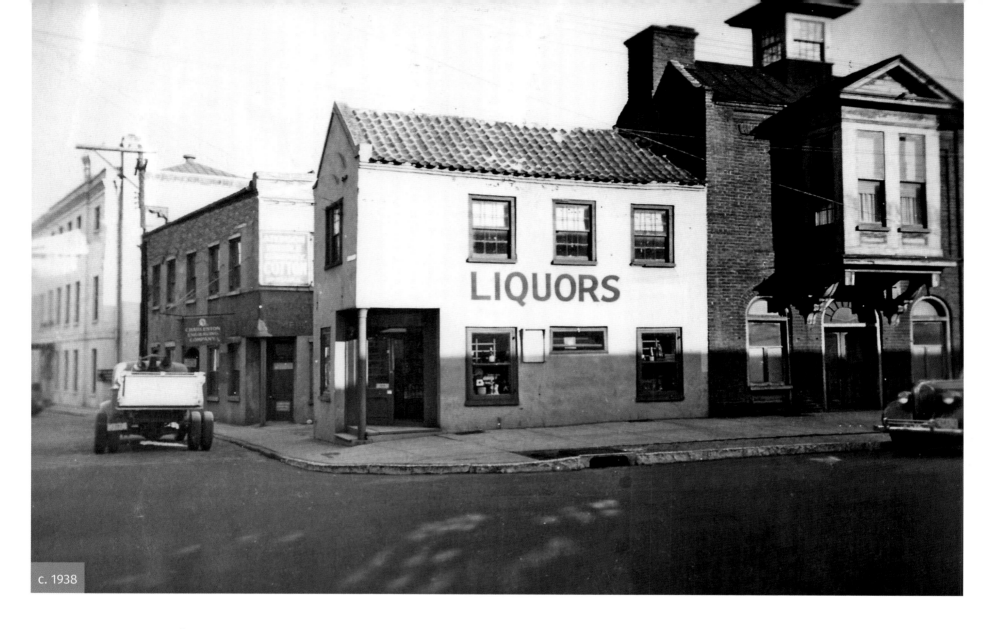

c. 1938

CHAMPNEYS' ROW, 114–120 EAST BAY STREET
Interpreting the story of a Charleston Loyalist

ABOVE: According to the National Historical Marker Database, letters found in Scotland and the Netherlands proclaim this small row of commercial buildings to be the "nation's oldest Spirits Establishment," dating to 1686. That popular assertion, however, is inaccurate.

In the early 18th century, Ebenezer Simmons owned this parcel, with a wharf to the east of the colonial-era Watch House (now site of the Old Exchange) and 11 buildings to its south. Because they were located east of the colony's defensive curtain wall, their height was restricted by law to one story and they were required to be set back from the wall by 50 feet. Upon Simmons' retirement, his apprentice, John Champneys, first rented, then purchased this commercial row of shops. Unfortunately, all of them were damaged or destroyed in a fire on Christmas Day in 1770.

As the American Revolution approached, Champneys declared himself a Loyalist, and in 1776 his row of buildings east of the wall was demolished for a gun battery. He fled to France, but returned when the city fell to the British in 1780. Though he quickly rebuilt, the Loyalist lost everything again in the Americans' Confiscation Act of 1782. His row went up for auction and it was purchased by his first cousin, who

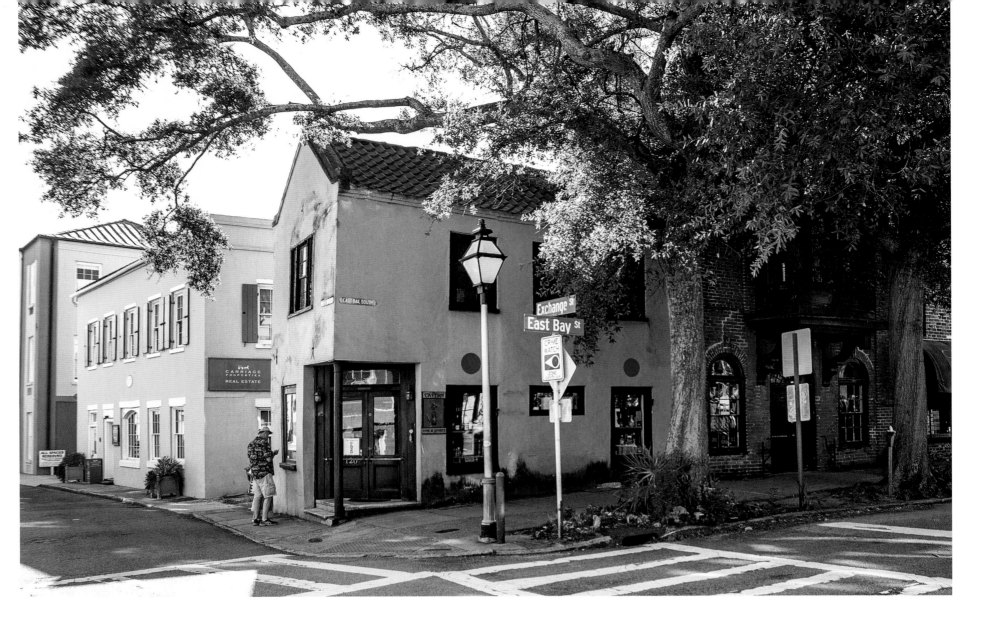

was a Patriot. Though Champneys' initial efforts to repatriate himself as a citizen failed, after much effort he eventually reclaimed his citizenship and commercial row in 1789, which his cousin returned to him for a nominal fee.

Champneys sold the brick stores in 1794 to the trustees of Catherine Coates, a legally independent "feme sole" and the wife of Capt. Thomas Coates. The buildings thereafter became known as Coates' Row and remain so today. Research by Dr. Nicholas Butler, of the Charleston County Public Library, indicates that the earliest of the present structures was built c. 1781.

ABOVE: Today known as Charleston Spirits, the northernmost store sells a large selection of liquors and beers, featuring local brands. Though its history as a drinking establishment dates back to Catherine Coates' ownership, one would be hard pressed to prove it is the oldest tavern in America.

RIGHT: The history of these four small commercial buildings tells a larger, more poignant story about the tribulations of British Loyalists such as John Champneys during and in the aftermath of the American Revolution.

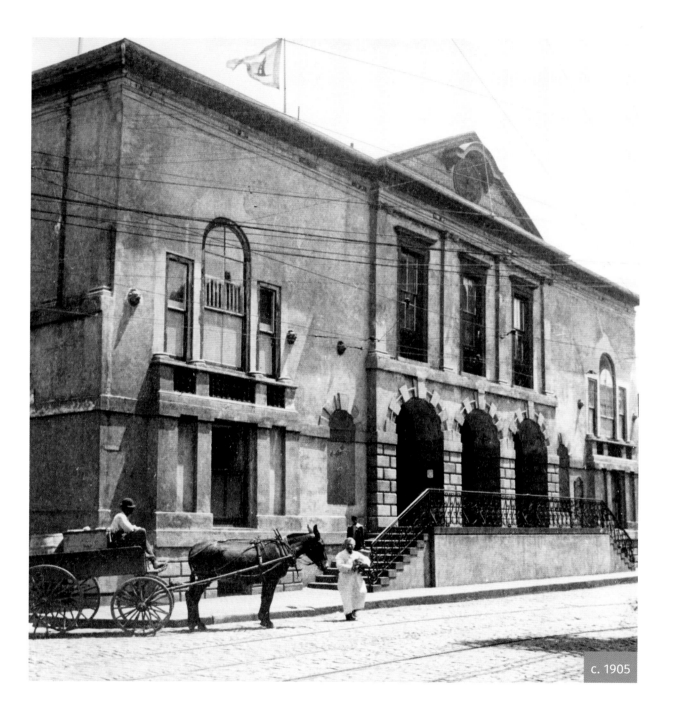

c. 1905

THE OLD EXCHANGE, BROAD AND MEETING STREETS

One of America's three most historically important colonial buildings

LEFT: For more than 250 years, the eastern terminus of Broad Street has been a center of life in Charleston, having served as a market, military fortification, police station, commercial exchange and customs house, prison, City Hall, post office, and headquarters for the American, British and Confederate armies.

Built atop Half Moon Battery, Charleston's Exchange was constructed of imported Portland stone by brothers Peter and John Adam Horlbeck between 1767 and 1771. Its Palladian design featured an open arcade on the first floor and assembly area on the second.

Royal governors arrived here before 1773, when Patriots met here to protest the British Tea Act. While Boston's Patriots dumped tea in their harbor, Charlestonians wisely stored their confiscated tea in the Exchange, using proceeds from its sale to finance the Revolution. Its ground-level dungeon served as a prison holding British officers before the city fell in 1780, after which it held more than 60 Americans, including Christopher Gadsden and Isaac Hayne.

In 1791 the Exchange, then serving as City Hall, hosted President George Washington, who delivered a stirring address from its balcony. The building was conveyed to the federal government in 1818 for use as a post office. Public auctions, including those for real estate and enslaved people, were held on the north side of the property through the 1850s.

RIGHT: The Rebecca Motte Chapter of the Daughters of the American Revolution purchased the Exchange in 1917, and established it as a museum interpreting the Revolutionary period. Archaeologists have uncovered part of the early colony's Half Moon Bastion, which can be seen in the dungeon. Designated a National Historic Landmark in 1973, it is considered one of the three most important colonial buildings still in existence.

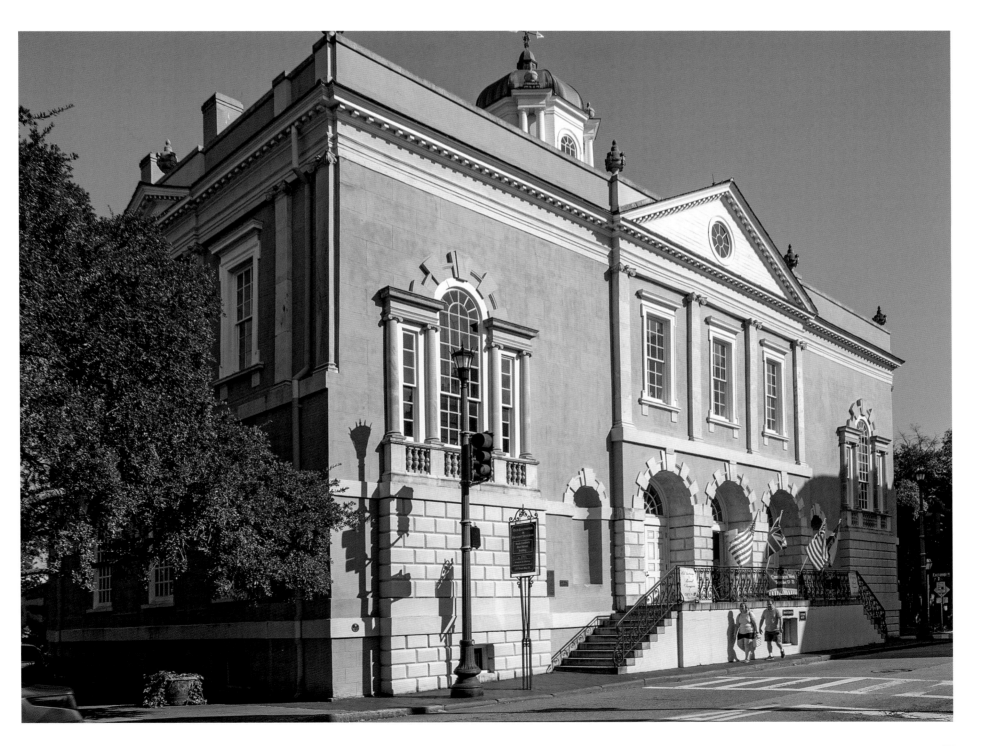

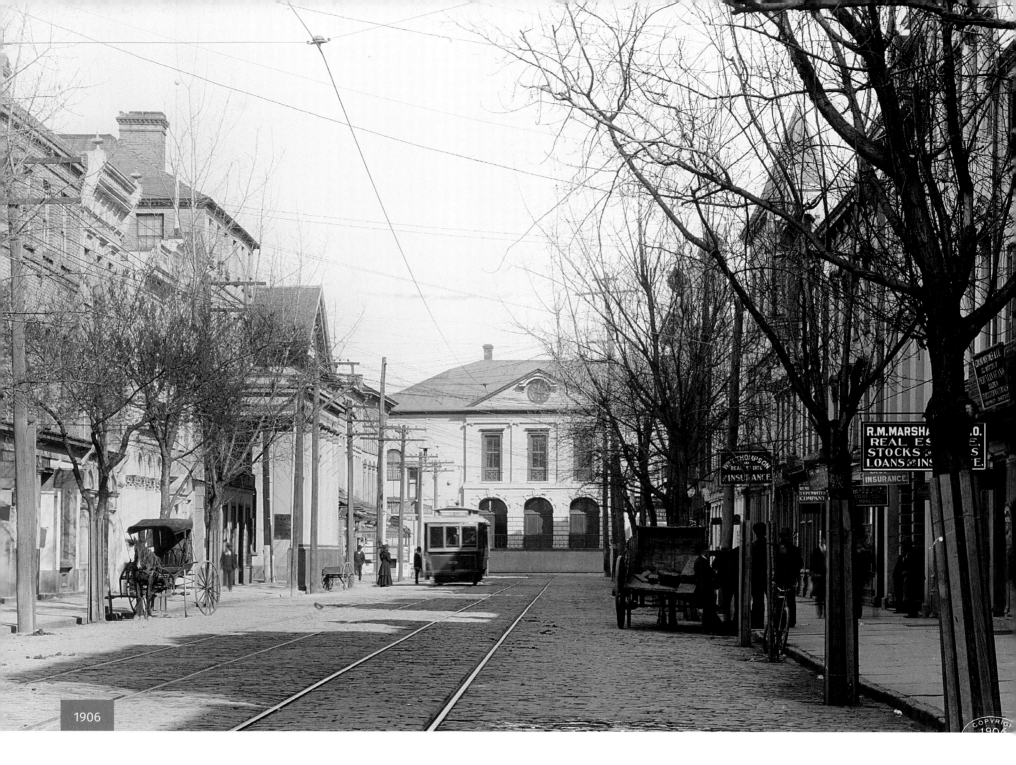

1906

BROAD STREET, LOOKING EAST

Where civic buildings have defined a community

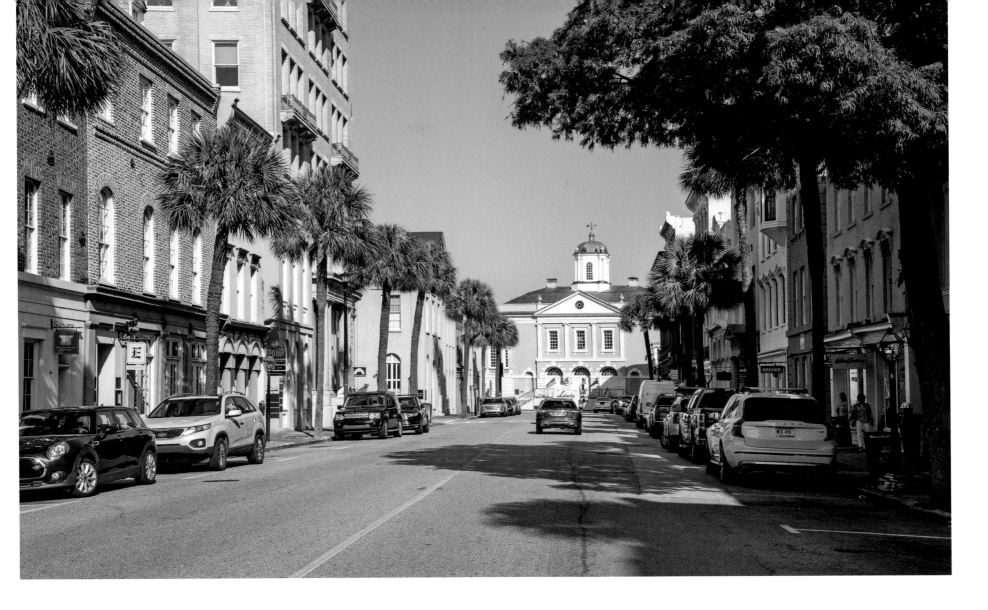

LEFT: When designing Charles Town's "Grande Modell," English philosopher John Locke borrowed an urban planning concept from Rome: a public space where a group of civic buildings built closely together creates a community hub. For almost 350 years, Charleston's civic, banking and commercial activities have been centered along Broad Street's urban core.

Records from 1698 to 1714 refer to the corridor as both Broad Street and Cooper Street—the latter honoring one of Charles Town's Lords Proprietors and John Locke's patron, Lord Anthony Ashley Cooper—but eventually Broad Street prevailed, stretching from Half Moon Battery at its eastern terminus to originally end at the beef market (now City Hall), where it met Meeting Street on the west. Throughout most of the 18th century, this portion of Broad Street was occupied by craftsmen and merchants. By 1771, the Exchange and Provost Dungeon had been built over Half Moon Battery and the city's original defensive wall.

ABOVE: From King Street east, Broad Street remains the site of Charleston's principal civic buildings, including City Hall, Charleston County Courthouse (the former state house), U.S. Post Office and Federal Courthouse, and St. Michael's Church. Preservationists who sought to restore the courthouse at its historic location after it was heavily damaged in Hurricane Hugo (1989) founded their arguments upon the fact that dozens of offices along and near Broad Street were predicated upon the judiciary function remaining there. If the court moved to a more central location, so too would its dependent offices, and the city would lose this critical professional buffer between the commercial retail district to its north and historic residential district to its south.

Many of the buildings along Broad Street are excellent examples of adaptive reuse, including real estate offices, restaurants and art galleries. Despite hurricanes, the strongest earthquake east of the Mississippi, two wars, and economic downturns, Broad Street has preserved much of its 18th- and 19th-century architecture and character.

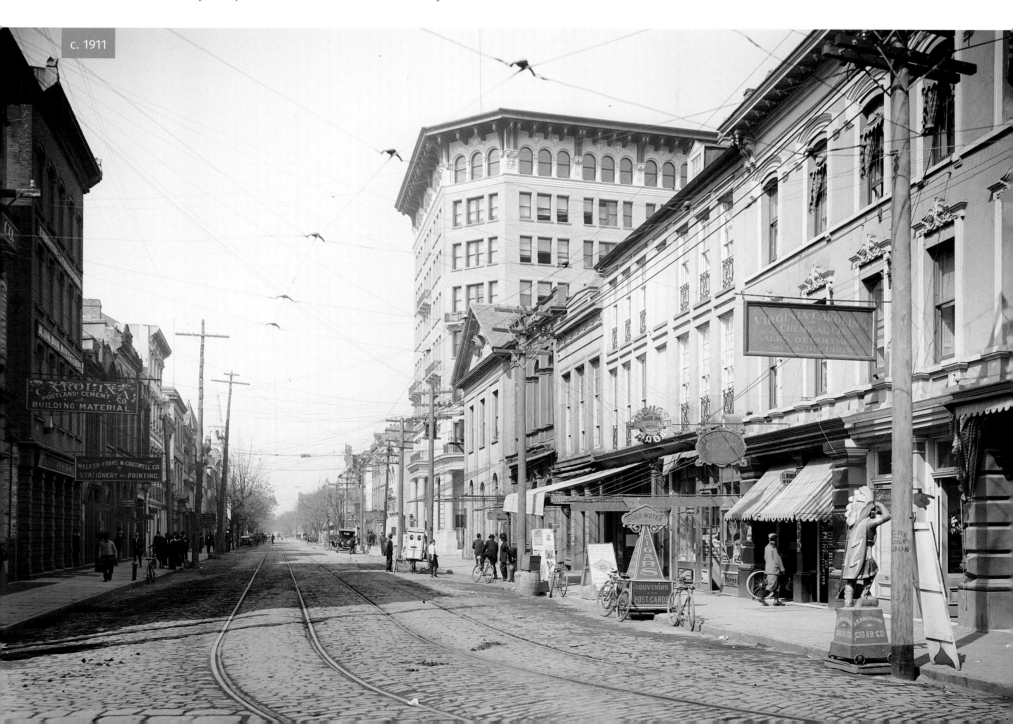

LEFT: When Charleston's first (and many wish last) skyscraper was completed in 1911, some saw the eight-story People's Building as a sign of progress. Others saw it as an apalling break with the character and scale of the historic district, towering over church steeples and ruining the skyline.

Mayor Goodwyn Rhett, president of the People's Bank of Charleston, was the driving force behind the 65,000 sq. ft. Renaissance Revival building. Made of concrete and steel, its first two floors were faced with Winnsboro granite, the rest with yellow brick. On opening in April 1911, most Charlestonians were not impressed. To win critics over, Rhett invited President William Howard Taft to visit. From the building's top, Taft proclaimed: "I don't believe that it did ruin the skyline, but if it did, the view from up here makes it worth it." Charlestonians disagreed and swore never again, one of the first steps toward the city's preservation movement of the 1920s.

BELOW: The bank closed in 1936. In 1950, a new owner installed two marble leopards carved from Italian marble at the main entrance, hoping that might soften Charlestonians' disdain for the building. It didn't. For the remainder of the century, it housed an odd mix of accounting, dental and law offices, along with a few condos.

As a new millennium dawned in 2000, MSK Construction renovated the weather-worn landmark. Easements ensured the bottom four floors would remain office and retail space. The fifth, sixth and seventh floors were converted into several condos per floor, and the single eighth floor condo was connected to an inset addition, set back from the roofline for a roof-top garden. When vandals destroyed one leopard in 2011, the other was moved indoors and the pair replaced with replicas. ABC's *World News Tonight* broadcast the 2017 solar eclipse live from the penthouse, which sold in 2020 for $12 million, a residential record for the historic district.

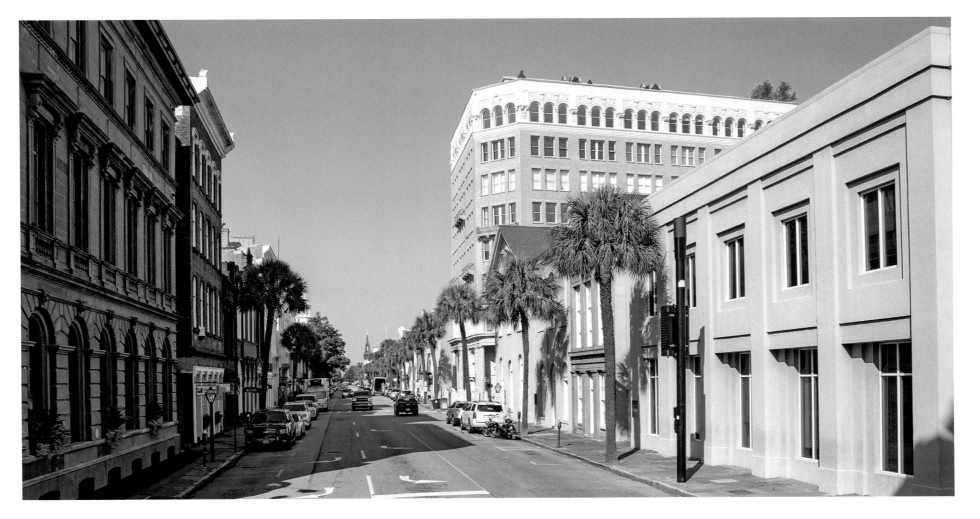

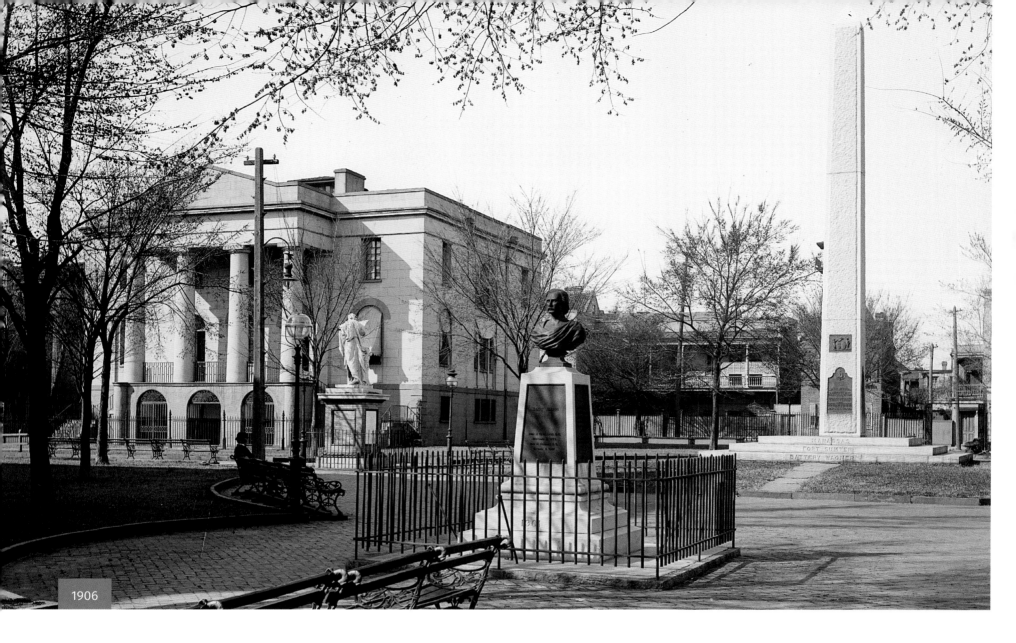

1906

WASHINGTON PARK, CORNER OF BROAD AND MEETING STREETS

An oasis of rest and reflection at the city's urban core

ABOVE: Also known as Washington Square, this 1.4-acre park near the intersection of Broad and Meeting streets wraps around the north and east sides of Charleston City Hall. The site had previously been home to the colony's meat market and Corbett's Thatched Tavern. It opened as City Hall Park in 1818 when municipal headquarters moved from the Old Exchange Building into the Adamesque bank that had been built there seventeen years earlier. This small oasis of moss-draped oaks, colorful flower beds, and brick paths was renamed in 1881 in honor of President Washington on the

100th anniversary of his victory at Yorktown and the 90th anniversary of his visit to Charleston.

The Washington Light Infantry erected the park's central obelisk in 1891, honoring members who had died in combat, and the bust of poet Henry Timrod a decade later. The statue of British Prime Minister William Pitt the Elder, who championed the American colonies' rights in the 18th century, was decapitated by a falling tree branch in 1938 and replaced in 1999 with a bronze statue of President George Washington.

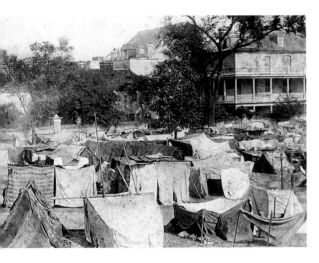

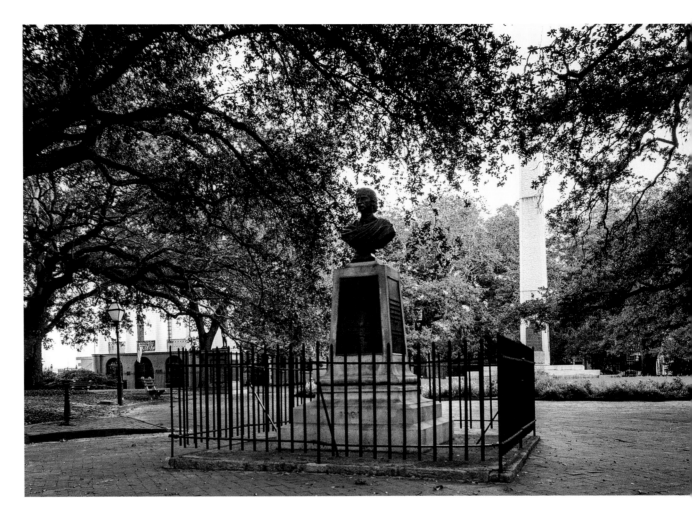

ABOVE AND TOP: When the largest earthquake along the East Coast struck on the night of Aug. 31, 1886, its initial shock lasted 45 seconds and damaged nearly all of Charleston's 8,000 buildings. The first strong aftershock occured 10 minutes after the first; seven aftershocks rocked the city within the next 24 hours. Residents too frightened to return to their damaged homes erected tent cities in local parks and other open spaces where they felt safer from falling debris.

ABOVE: The elements found in Washington Park today are iconic Charleston: gas lanterns, wrought iron gates, oaks draped in Spanish moss, surrounded by centuries-old civic buildings and residences. A cobblestone street serves as its northern boundary. Travel writers have described it as a serene pocket of quiet in a busy urban setting that epitomizes Charleston's unique appeal. Its patrons include professionals who work in the surrounding offices as they take their breaks, and it is a favorite spot for visitors to meet their tour guides. Everything about the park's ambience invites one to slow down and rest in the shade of an oak, perhaps taking a moment to reflect as well. Today the park serves as the mustering spot for members of Charleston's many historic civic and social organizations to gather annually to begin their annual march to White Point Garden in celebration of Carolina Day.

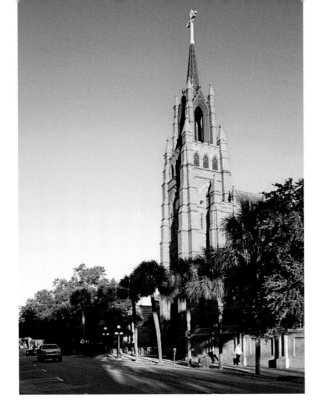

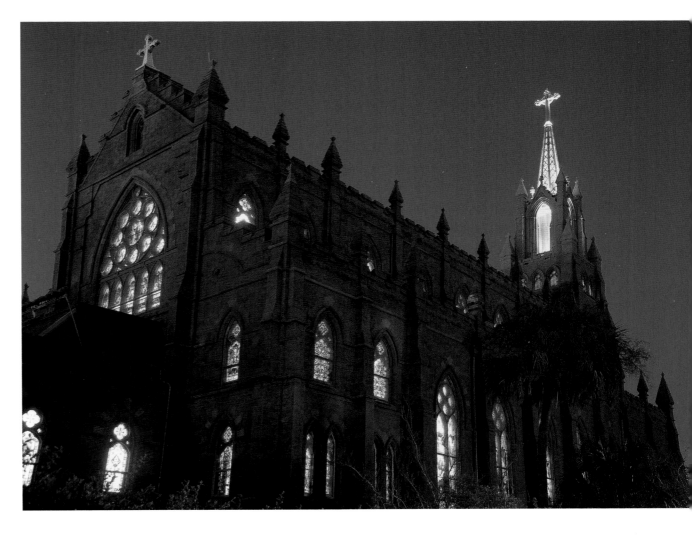

LEFT: While Charles Town was known for welcoming nearly all faiths, Catholics were the exception during the colony's first century. That had nothing to do with theology, but because colonists suspected that Catholics might be in league with the Spanish in Florida, who asserted an earlier claim to this region and occasionally came up to skirmish for it. After the American Revolution, the Spanish were no longer a threat, and Catholics established their first church in the Carolinas and Georgia, St. Mary's, in 1800, in what had been a Methodist sanctuary on Hasell Street, across from Kahal Kadosh Beth Elohim synagogue.

Twenty years later, Charleston's first Catholic Bishop, John England, purchased a lot on the corner of Broad and Friend (now Legare) streets, once the site of a popular garden known as New Vauxhall. He began raising funds for a new cathedral, though died before the campaign was completed. His successor, Bishop Ignatius A. Reynolds, saw it through and construction of the ornate Gothic cathedral began in 1852. Bishop Reynolds consecrated the church in the names of St. John and St. Finbar in April 1854.

Just seven years later, the cathedral was destroyed, along with one-third of Charleston's residences and business district, in the Great Fire of 1861. As if to add insult to injury, the ruined but still upright steeple tower crumbled in the Great Earthquake of 1886. For nearly three decades, the church's ruins lay abandoned.

In 1890, its original architect, Patrick C. Keely, undertook the rebuilding of a new cathedral, which he completed in 1907. Designed much like its predecessor, it too was made from Connecticut brownstone in the Gothic style. Yet funds ran out before the church was finished, and Keely never completed the steeple tower. His drawings for it were eventually lost.

ABOVE: After more than a century, Charleston architect Glenn Keyes completed the missing spire, which was not only in keeping with the cathedral's historic architecture, but also met modern building codes to withstand 135-mile-per-hour hurricane winds. In 2010, the renamed Cathedral of St. John the Baptist, complete with its inspirational 85-foot-high spire, was finally finished.

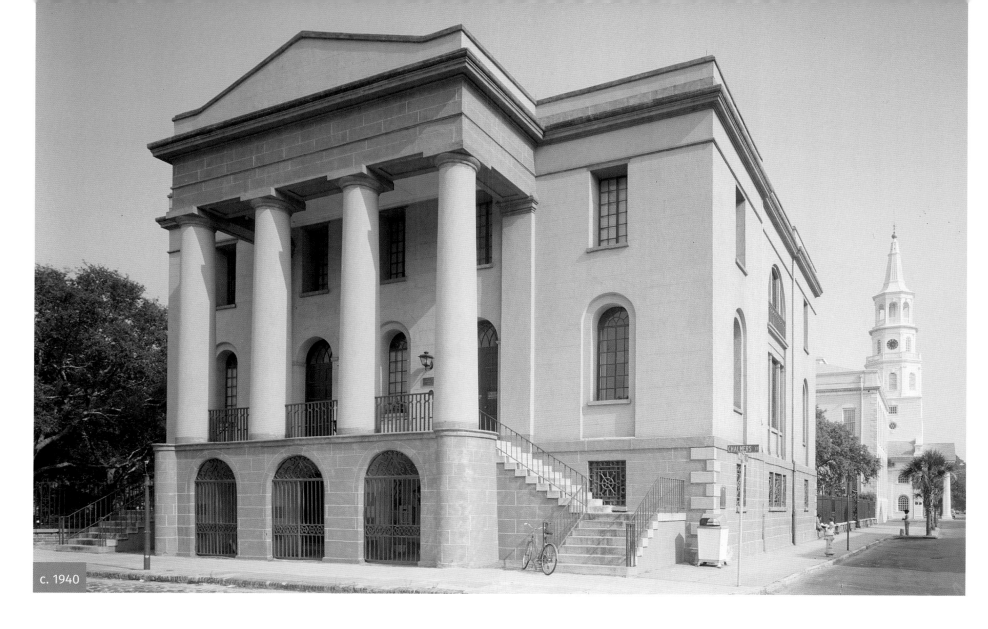

c. 1940

THE FIREPROOF BUILDING, 100 MEETING STREET
America's first fire-resistant building

ABOVE: Flames fueled by turpentine raged along Charles Town's waterfront in November 1740, obliterating more than 300 residences, commercial buildings and wharves. In January 1778, what began as a pre-dawn kitchen fire destroyed 250 houses between Queen Street and Granville Bastion. These were just two of numerous 18th-century blazes that destroyed not only lives but many of the colony's early records as well.

Architect Robert Mills sought to create a structure that would protect the state's most important documents from fire when he designed the Charleston District Records Office in 1822. Born in Charleston and considered by many to be America's first native-born architect, Mills also designed the Washington Monument, U.S. Treasury Building, U.S. Patent Office, and many other notable civic buildings and churches along the East Coast. He designed the nation's first fire-resistant building on the northwest corner of Washington Park using nonflammable materials: stuccoed brick walls on a brownstone first floor, stone floors and staircases, and a copper roof. Window sashes, frames and shutters were all made of iron. The two-story Palladian building with classic Doric porticos was also set apart from neighboring structures, creating a natural firebreak when it opened in 1827.

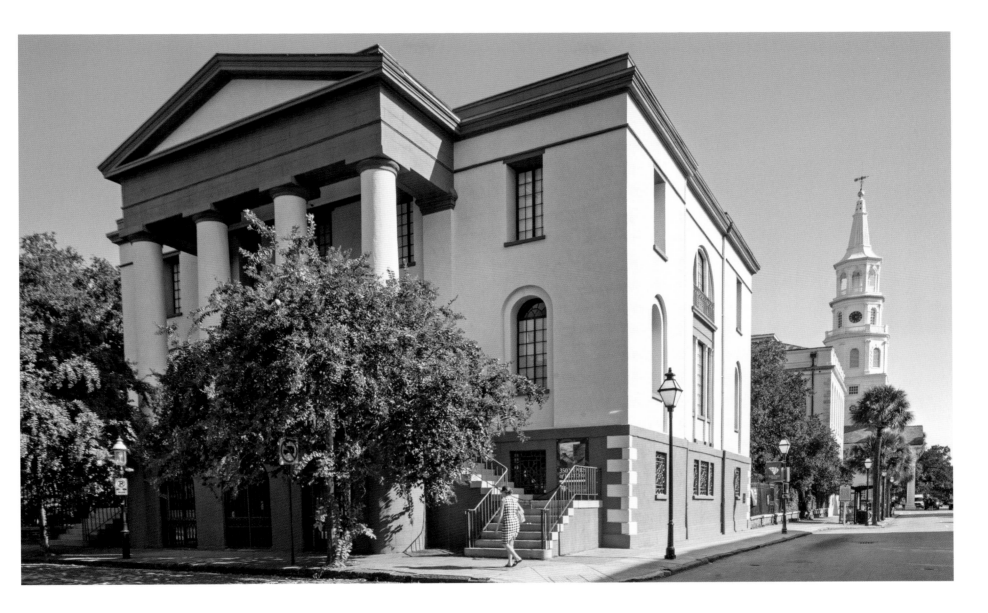

ABOVE: Other than changes in its uses, Mills' Fireproof Building has remained virtually intact since its completion. With such sound construction, it survived and protected its documents during Charleston's most destructive fire ever in 1861, and the 1886 earthquake damaged only its exterior stairs. It is believed to be the oldest fire-resistant building in the country.

The Fireproof Building housed the county's documents, along with offices for the county's supervisor, auditor, treasurer and others, until 1942. It was leased to the S.C. Historical Society in 1955 and became its official headquarters in 1968. After serving for more than six decades as the repository of the Historical Society, in 2018 the society moved its 2,000,000-piece archive to the College of Charleston's Addlestone Library, providing an environment with better-controlled temperatures and humidity. It then undertook a $6.8 million rehabilitation of the Fireproof Building, making repairs and adding an elevator and new HVAC system. It reopened later that year as the S.C. Historical Society Museum.

BATSON'S GAS STATION, 108 MEETING STREET

A catalyst for America's first preservation movement

BELOW: America's preservation movement began in 1920 when a group of angry, fearless and determined Charleston ladies raised a row over Standard Oil of New Jersey Co.'s plans to demolish the Joseph Manigault House at 350 Meeting Street to build a gas station. The Neoclassical house had been designed in 1803 by Joseph's brother Gabriel. It was quite the battle, but eventually the women's efforts saved

the grand house and its gardens. Unfortunately, nine years later, when Standard Oil purchased Gabriel's house at the southeast corner of Meeting and George streets, the oil company won. They demolished the house, as well as three others built between 1782 and 1805 several blocks south of it at Meeting and Chalmers Streets. Yet the victory wasn't pretty. To assuage outraged preservationists, the oil company salvaged

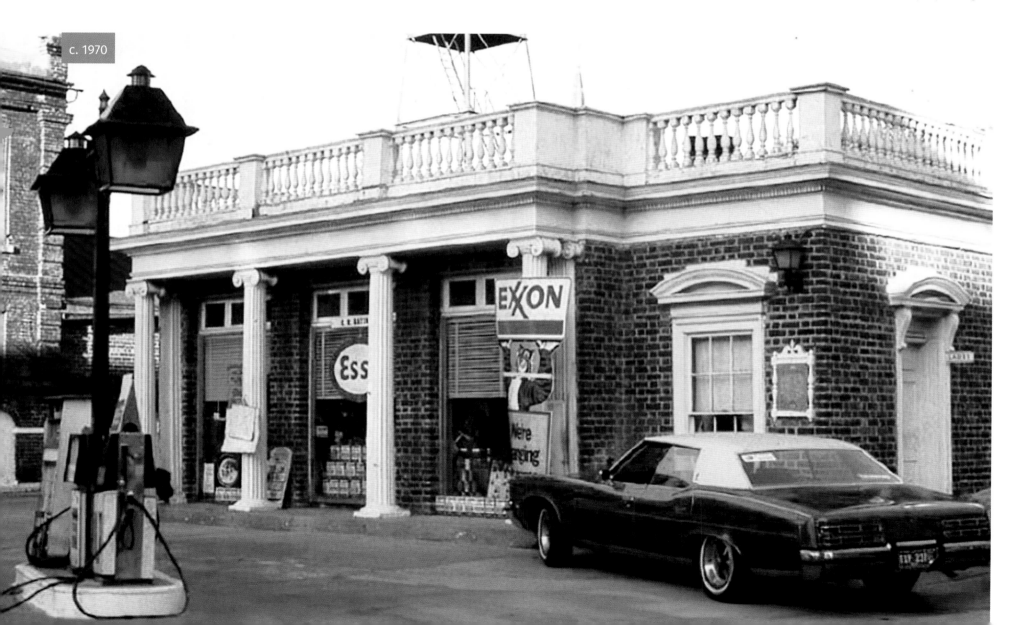

c. 1970

architectural details of Manigault's house, including bricks, balustrades, pilasters and window surrounds, which architect Albert Simmons incorporated into the Colonial Revival design of the two new gas stations. If a few found comfort in this decorative homage, many did not, and they pushed the City Council into creating America's first historic zoning ordinances—a designated historic district and a Board of Architectural Review—in 1931. By then, however, the Standard Oil station at 108 Meeting Street had been completed. C.R. "Charlie" Batson owned the gas station when it closed in 1981.

BELOW: Four years later the property was transferred to the Historic Charleston Foundation, and today it houses its shop, a nonprofit retailer selling 18th- and 19th-century reproduction furniture, china, jewelry and other items inspired by Charleston's history. Proceeds from sales support the foundation's mission; inside are exhibits that chronicle Charleston's preservation story. A plaque on the building's exterior reads: "In order to preserve the architectural features of Charleston, this brickwork & woodwork of the demolished Gabriel Manigault House 1800 A.D. were used in this station."

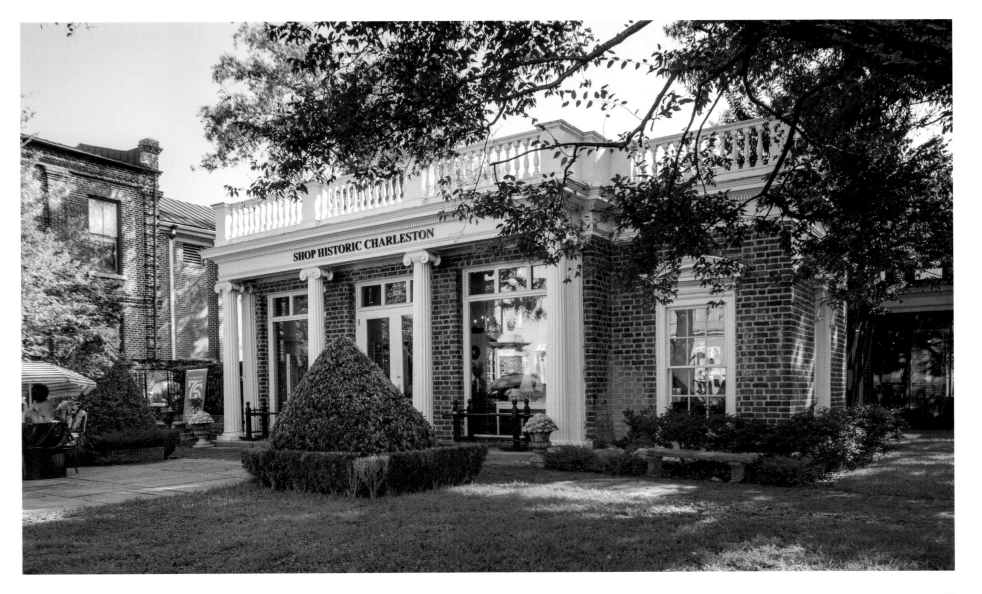

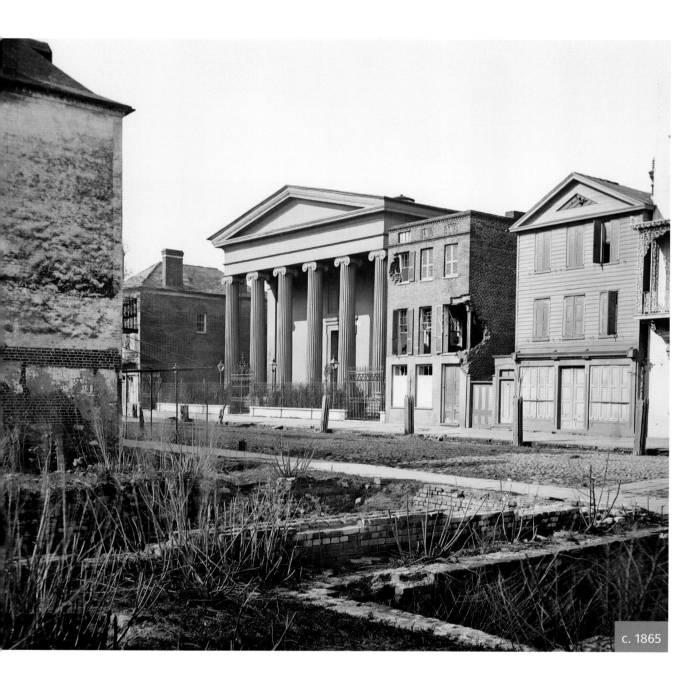

c. 1865

LEFT: The Hibernian Society was founded in 1801 to assist new Irish immigrants. Its presidency alternated annually between a Catholic and Protestant member, a rare collaboration for that time.

The Hibernians completed construction of a new meeting hall in 1840. Architect Thomas Ustick Walter, who also designed the dome and wings of the U.S. Capitol, found inspiration in Athens' Temple of Ilissus for its Greek Revival design featuring six Ionic columns supporting a two-story portico with entablature and pediment. Above the entrance is the image of an Irish harp, a gilded motif repeated in its gates, believed to have been wrought by blacksmith Christopher Werner. The entrance of the brick and stucco building opens into a large stair hall with domed ceiling and rotunda, and three tiers of circular balconies featuring Doric, Ionic and Corinthian columns. Both floors are dominated by large halls with supporting rooms.

The hall has been used by many over the years. The St. Cecilia Society held concerts and balls here. Annual celebrations included St. Patrick's Day and New Year's Day. In addition to The Citadel commencement in 1855, other events included a show by P.T. Barnum sensation

HIBERNIAN HALL, 105 MEETING STREET
Venue for one of the most critical political gatherings in American history

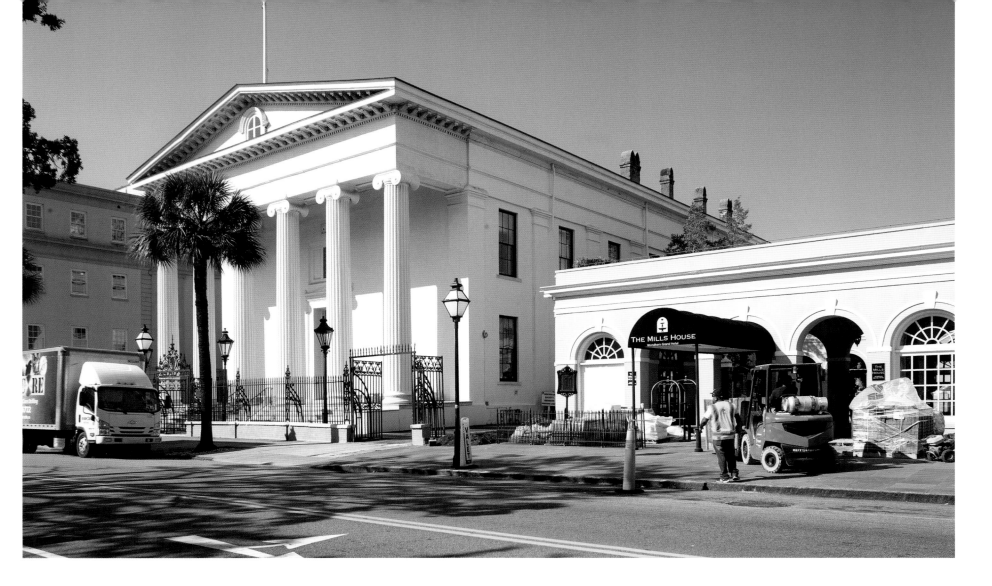

Tom Thumb (real name Charles Sherwood Stratton), in 1847; a panorama of moving images from Italy (1859); and a vocal performance by President Woodrow Wilson's daughter, Margaret (1917).

Yet the most historically significant event at Hibernian Hall was the failed 1860 Democratic Convention, which the National Register for Historic Places calls "one of the most critical political assemblies in the Nation's history," as it set the nation on the path toward Civil War. Here supporters of Stephen A. Douglas as the 1860 Presidential nominee staged passionate debates in the hall's first floor. Hundreds of cots were set up on the second floor as sleeping quarters. Some say the vitriol

and divisiveness within Hibernian Hall led to the election of a relatively unknown Republican named Abraham Lincoln.

Thanks to a shift in the wind during the Great Fire of 1861, Hibernian Hall was not destroyed. The other two Charleston venues that played prominently in the 1860 convention, however—S.C. Institute Hall and St. Andrew's Society Hall—were both obliterated in the blaze, leaving Hibernian Hall as the only extant venue associated with the convention. Unfortunately, its portico crumbled into Meeting Street in the earthquake of 1886. It was rebuilt with more elaborate detailing and the addition of an Italianate window in the pediment.

ABOVE: Membership in the all-male Hibernian Society remains as much a badge of hereditary honor as ever in Charleston. The hall continues to serve as a venue for wedding receptions, debutante balls and fundraising galas. It remains the heart of the city's annual St. Patrick's Day celebration.

LEFT INSET: Though it escaped relatively unscathed by the Federal bombardment during the Civil War and Fire of 1861, the Hibernian Society Hall's portico was destroyed in the Earthquake of 1886, as was the portico of St. Michael's Church and that of the City Guard House, both just a block south of the benevolent society's hall. The quake was estimated to have registered about a 7.3 on today's Richter Scale.

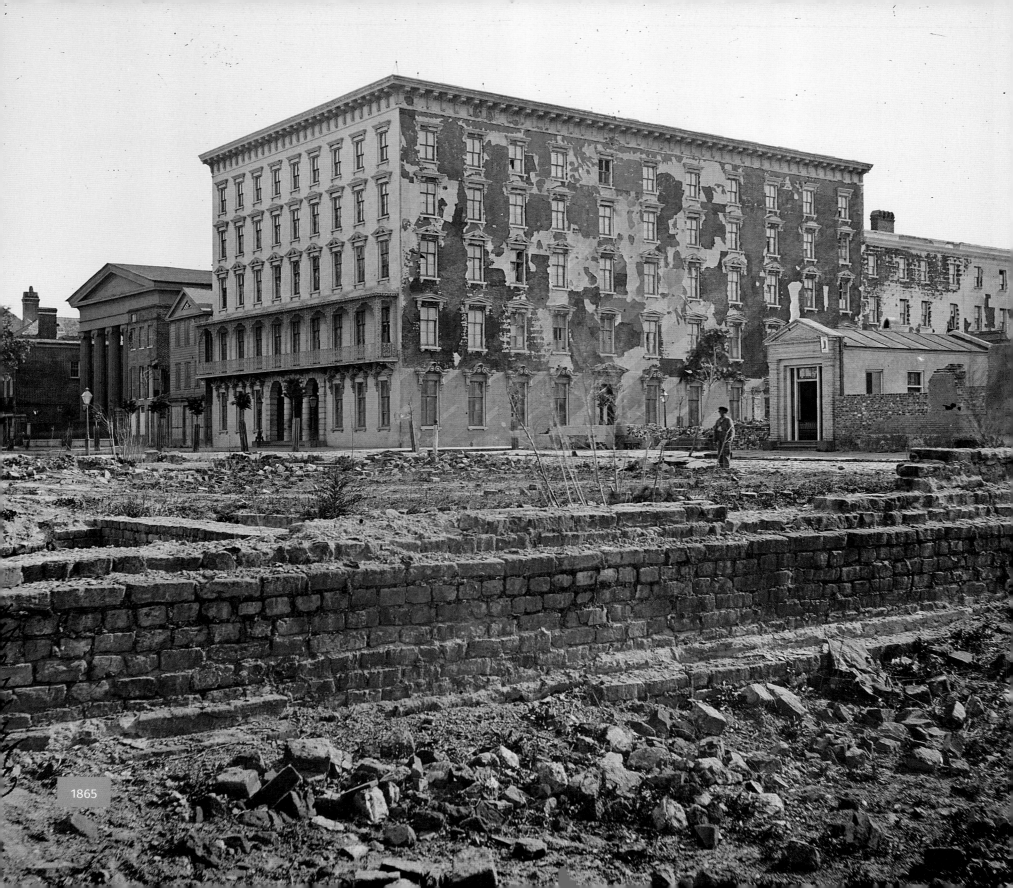
1865

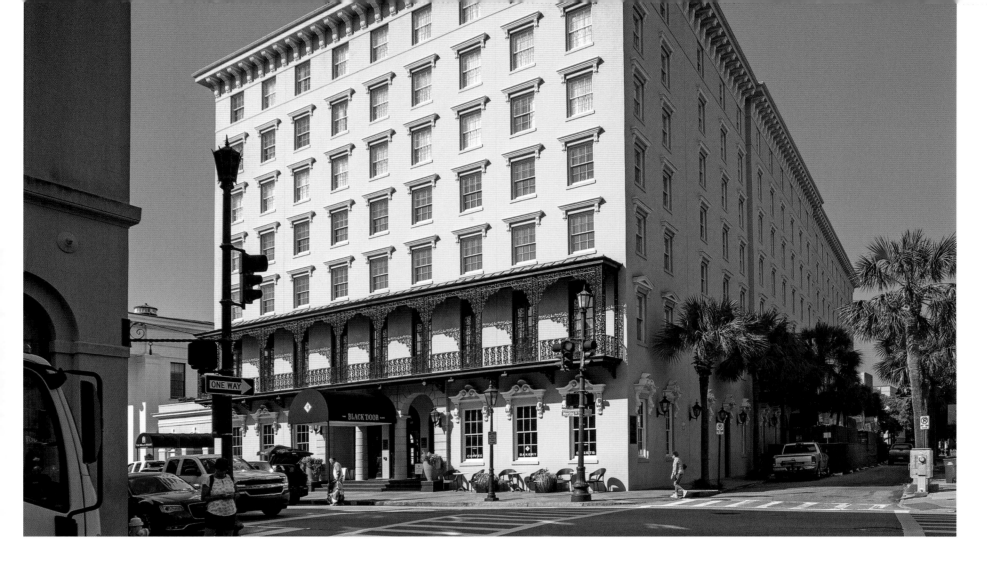

MILLS HOUSE, 115 MEETING STREET

A survivor of Charleston's natural and man-made disasters

LEFT: Otis Mills built his 180-room, five-story hotel at the corner of Meeting and Queen streets in 1853. A reporter covering its grand opening wrote nearly a full page describing its ornate terra-cotta window cornices, iron balconies, marble mantels and arcaded entry. It even had steam heat and running water.

The largest fire in Charleston's history raced down Meeting Street on December 11, 1861, destroying everything in its path. Confederate Gen. Robert E. Lee, a guest at the hotel that evening, watched the approaching inferno from the roof. Though Lee fled, many of the enslaved staff stayed behind, frantically waving wet linens out the windows to stave off the sparks. Whether it was their heroic efforts or a shift in the strong winds, somehow the Mills survived when nearly everything around it burned.

Mills sold the hotel two years later, after which time it passed through a string of owners, including Cecilia Lawton in 1902, who renamed it the St. John's Hotel.

ABOVE: By the 1920s, competition began cutting into the St. John's popularity and the hotel was finally sold at auction in 1968 to three preservation-minded businessmen who hoped to restore it. Unfortunately, they found that even a building that had survived the 1861 fire, 567 days of bombardment by the Union Army, the largest earthquake ever to strike the U.S. East Coast and dozens of hurricanes was no match for one of Charleston's most destructive nuisances: termites. The hotel was determined to be structurally unsound, beyond repair, and was condemned. The new owners carefully dismantled it, salvaging as much of its historic fabric as possible, including its ironwork and terra-cotta. Pieces that weren't salvageable were reproduced. They then rebuilt the Mills as similar as possible to the original, except for adding two additional floors, taking its height to seven stories. The Mills House began welcoming new guests in October 1970 and remains one of Charleston's premier accommodations.

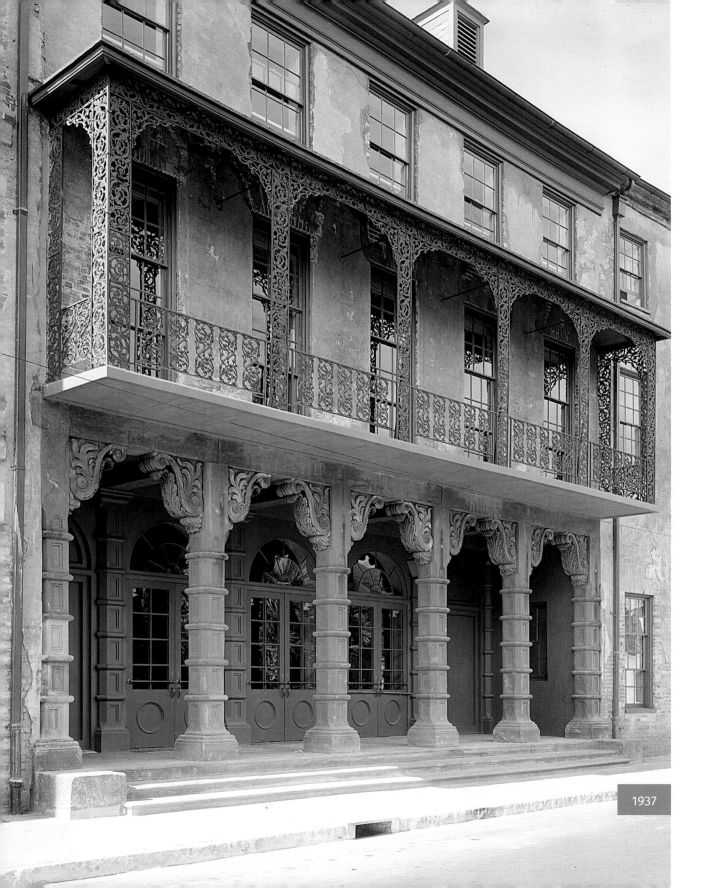

1937

DOCK STREET THEATRE, 135 CHURCH STREET

One of the oldest, if not the first, buildings in America built for theatrical performances

LEFT: In the 17th century, the street we know today as Queen Street wasn't a street at all. East of Church Street it was a mudflat, with a boat dock jutting into the Cooper River. The street that ran to that dock was thus called Dock Street. It was renamed Queen Street around 1702 in honor of Queen Caroline upon her marriage to King George II.

The first—and only—mention of the original Dock Street Theatre ran in the *South-Carolina Gazette*, advertising its opening performance of the comedy *The Recruiting Officer* on February 12, 1736, at "the new theatre in Dock Street." Though little documentation exists, this much smaller theater's entrance probably faced Dock Street. It may have burned in the Fire of 1740, as newspaper ads show a second theater at this site by 1754, which disappeared from the records after 1766.

In 1809, Mr. and Mrs. Alexander Calder, proprietors of the Planters Inn on Meeting Street, announced they had purchased a "large and commodious" townhouse on the southwest corner of Church and Queen streets with the intention of establishing a new hotel there. The hotel was then bought and renovated in 1855 by J.W. Gamble, who probably moved its entrance to Church Street, adding sandstone columns, a wrought iron balcony, and carved wooden brackets. By this time, Planters had become one of the South's finest hotels, renowned for its grand balls, service and fine dining.

Things went downhill after the Civil War. By 1884, the hotel had become cheap apartments, and by the 1930s it was uninhabitable and slated for demolition. Mayor Burnet R. Maybank saw its potential, however, and secured funding from the Federal Emergency Relief Administration to rehabilitate the property as a theater. The grand Church Street entrance became the theater's lobby, and the new venue opened on November 26, 1937, with a revival of *The Recruiting Officer*.

RIGHT: Despite its entrance on Church Street, the new theater was renamed Dock Street by civic leaders after the colonial-era theater which had stood along the northern edge of the property that became Planters Hotel. Owned by the City of Charleston, it remains one of Charleston's most popular venues, with Charleston Stage serving as its resident company. Popular late-night host Stephen Colbert had his beginnings here as a child actor. It is used frequently by the Spoleto Festival USA and others for a variety of activities. An extensive renovation in 2010 provided updates and polish to its interior facilities.

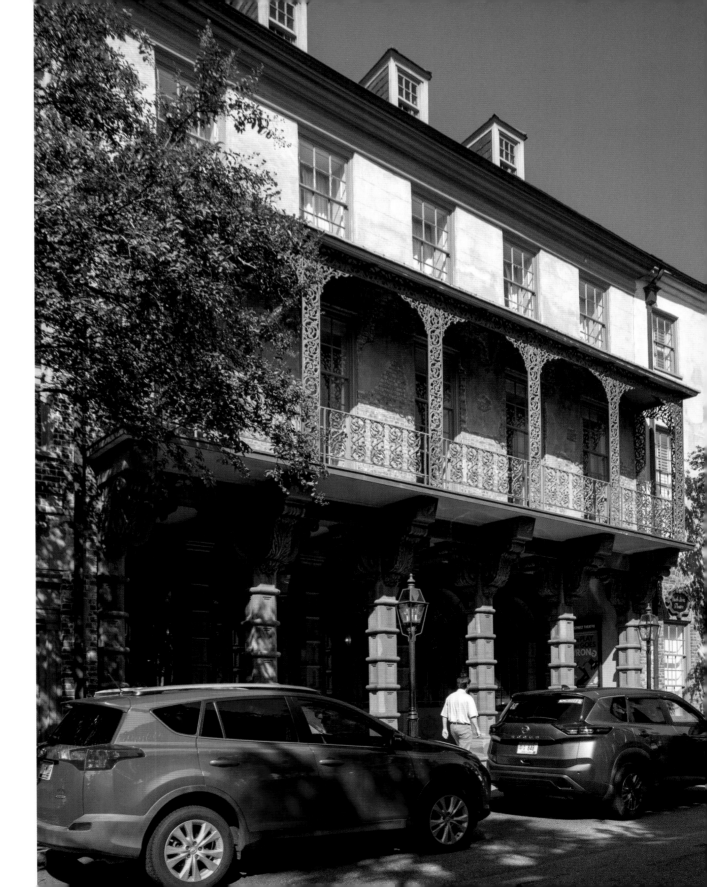

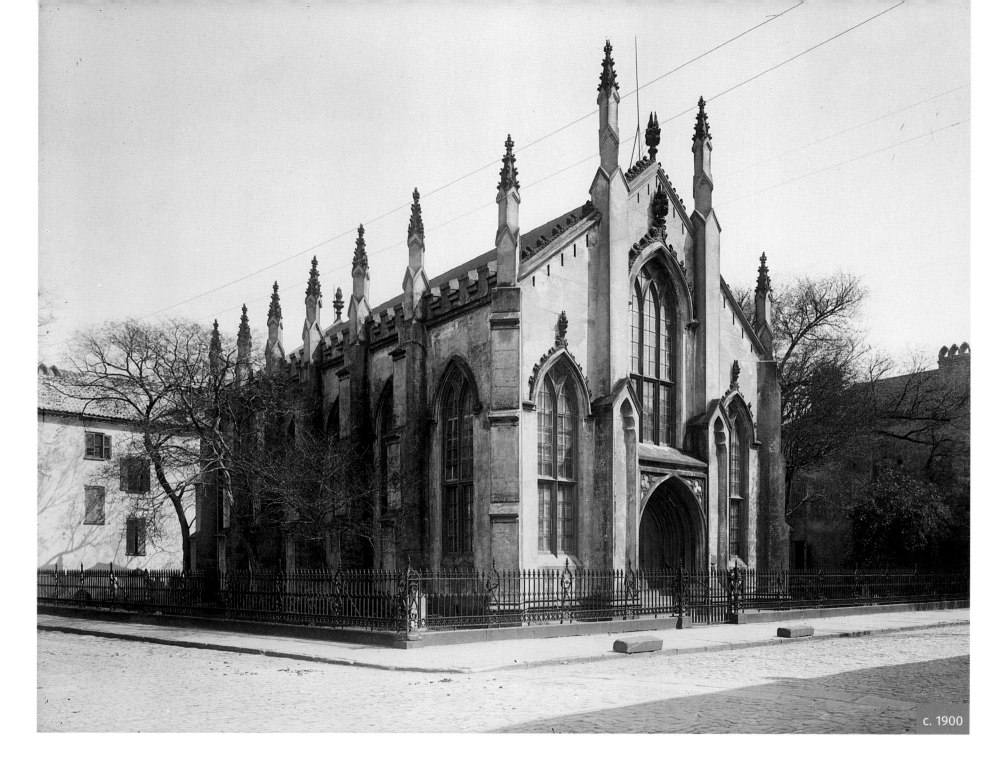

c. 1900

THE FRENCH HUGUENOT CHURCH, 138 CHURCH STREET

The only French Calvinist congregation in the United States

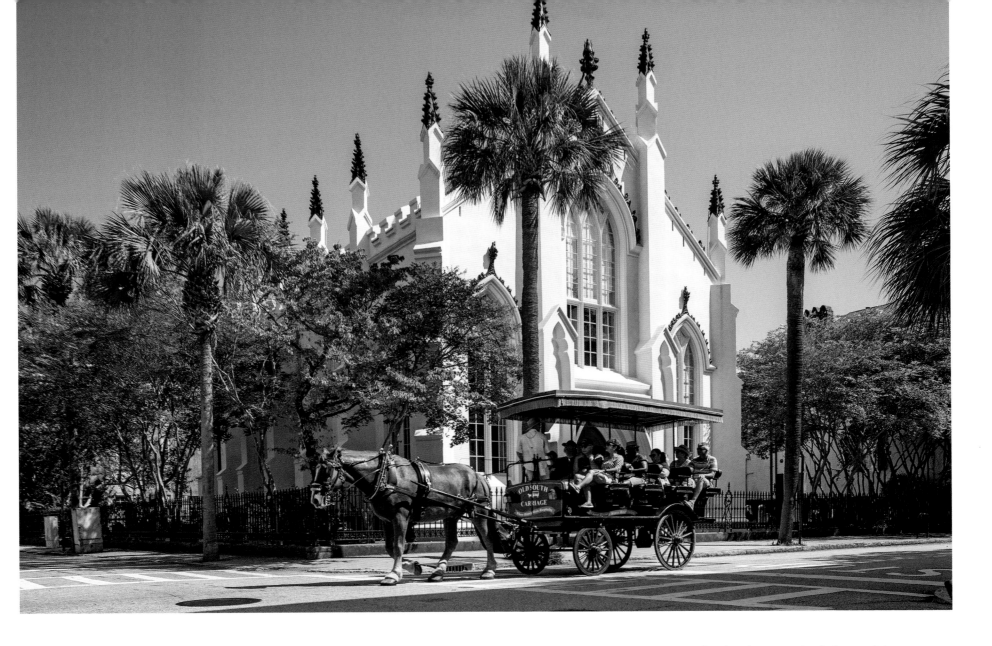

LEFT: French Huguenots first arrived in Charles Town in 1680 when His Majesty's Ship *Richmond* arrived with 45 of the Protestant Calvinists aboard. The English encouraged Huguenot refugees to settle in Charles Town, as many were prosperous merchants, artisans and tradesmen. By 1687, they had built a small church at the end of Dock street (now Queen Street). This first church was intentionally blown up to create a fire break in 1796, which was especially unfortunate as the fire was arrested up the street at St. Philip's Church. A new brick church was completed in 1800.

Membership in the Huguenot Church declined, but spirits were renewed in 1844–45 when the present Gothic Revival church was built by architect Edward Brickell White. This church was damaged during the Civil War and in the 1886 earthquake but was restored with funds from Huguenot descendant Charles Lanier.

ABOVE: For most of the 20th century, the church was used only for special events. However, with a renewed enthusiasm for their heritage, Huguenot descendants reopened the church in 1983 with services that follow the 18th-century French liturgy. Weekly services are in English, though an annual service is in French. An extensive renovation was undertaken in 2008–2013, after jolts from the Dock Street Theatre's renovation caused structural damage to the church. While today a number of Huguenot congregations worship within churches of various denominations, Charleston's is the nation's only remaining independent Huguenot church building in America.

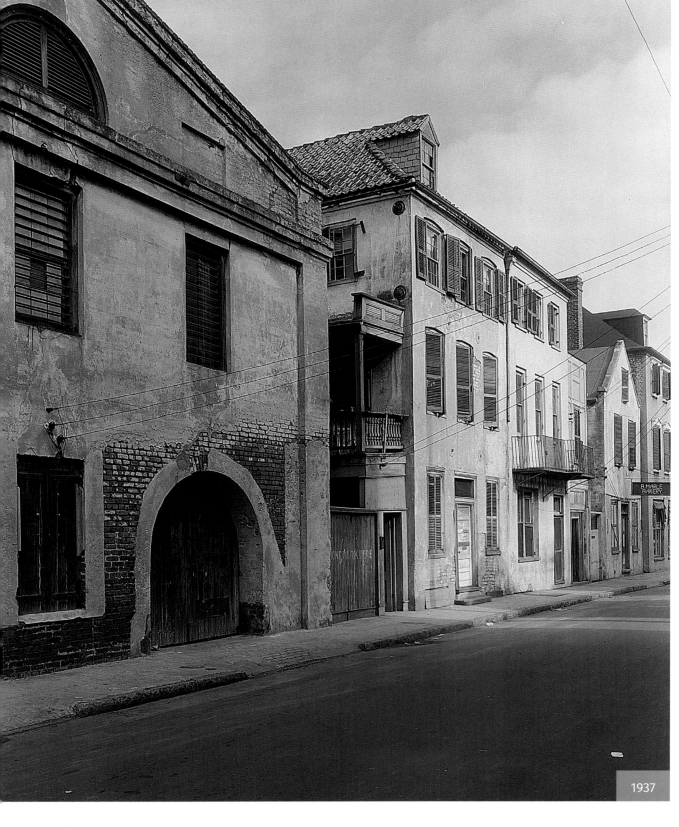

1937

QUEEN STREET PLAYHOUSE, 20 QUEEN STREET

Home of Charleston's oldest theater company

LEFT: Arthur Kiddle built his two-story cotton warehouse on a vacant lot bordered by Queen Street to its south and Kinloch's Court (now Philadelphia Alley) to its west around 1830. The warehouse, which ran 140 feet along the alley, serves as a good example of vernacular architecture in the Romanesque Revival style, featuring two arched façade entrances.

Kiddle built his warehouse when the state's cotton industry was flourishing. More than 500 million pounds of Sea Island Cotton, worth some $3.6 billion in today's dollars, were exported through Charleston's port in the first half of the 19th century. Cotton continued to play a major role in the region's economy after the Civil War and into the early 20th century—until the arrival of the boll weevil in the 1920s. The ravenous pest devastated the cotton industry, and Kiddle's warehouse closed after nearly a century.

In 1934, during Charleston's cultural renaissance, philanthropist Eliza Huger Dunkin Kammerer donated Kiddle's warehouse to The Footlight Players. Founded in 1931, The Footlight Players staged the revival of *The Recruiting Officer* as the 1937 opening performance of the new Dock Street Theatre.

Because the warehouse had little more than four walls and a roof, the theater company used it for storage and scenery production while continuing to perform at venues throughout the city. As performance spaces around town began to disappear, however, dozens of volunteers came together in 1941 to rehabilitate Kiddle's warehouse into a playhouse. On its eastern wall artists Alfred Hutty and Emmett Robinson painted an impressive mural depicting 24 significant personalities from Charleston's theatrical history—from an unidentified actress who took the stage name Monimia after playing the lead character in a 1735 performance of *The Orphan*, to Dr. John

64

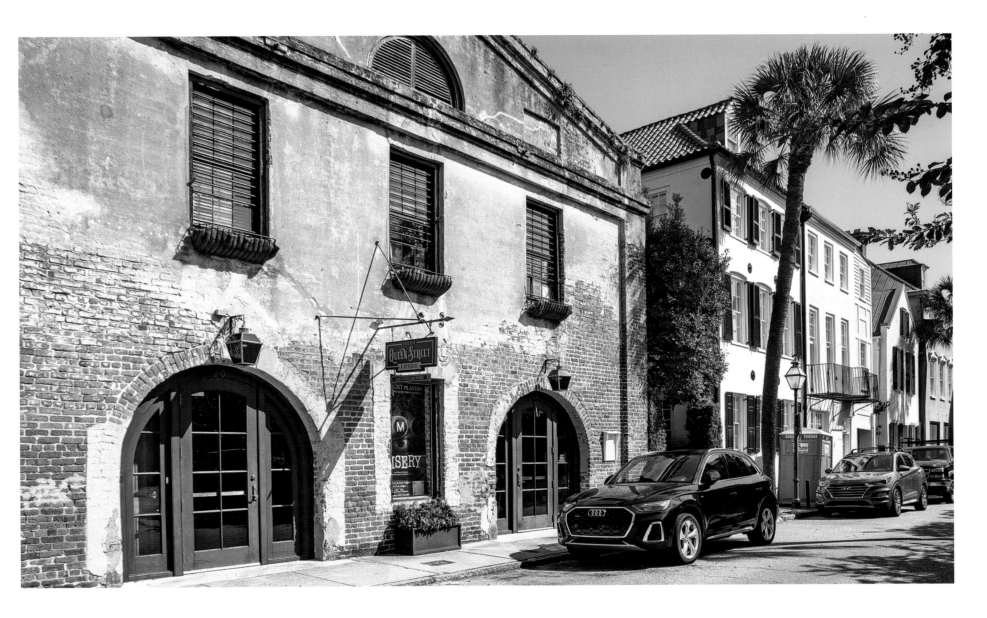

Beaufain Irving (1825–1877), a critic for the *Charleston Courier* who wrote under the pseudonym "A Friend of the Drama." Above the stage is a wooden cartouche dating from 1860 which originally hung in the Academy of Music on Meeting Street before it was demolished to make way for the Riviera Theater.

The Footlight Players continued performing at various venues until 1986, when the Queen Street Theatre was renovated again and modern technology upgraded. Since then, the company has performed exclusively at the old warehouse.

ABOVE: Kiddle's warehouse retains much of its original character, including its arched entrances, gabled parapet with a lunette window, and lime-washed stucco. The theater seats 250 and has a set shop, costume shop, rehearsal spaces and offices.

The Footlight Players remain South Carolina's oldest community theater company. Under the leadership of Brian Porter and Kyle Barnette, it weathered the pandemic, as many companies around the country disbanded. Today, the Footlight Players continue to provide a rich tradition of excellent community theater at the Queen Street Playhouse.

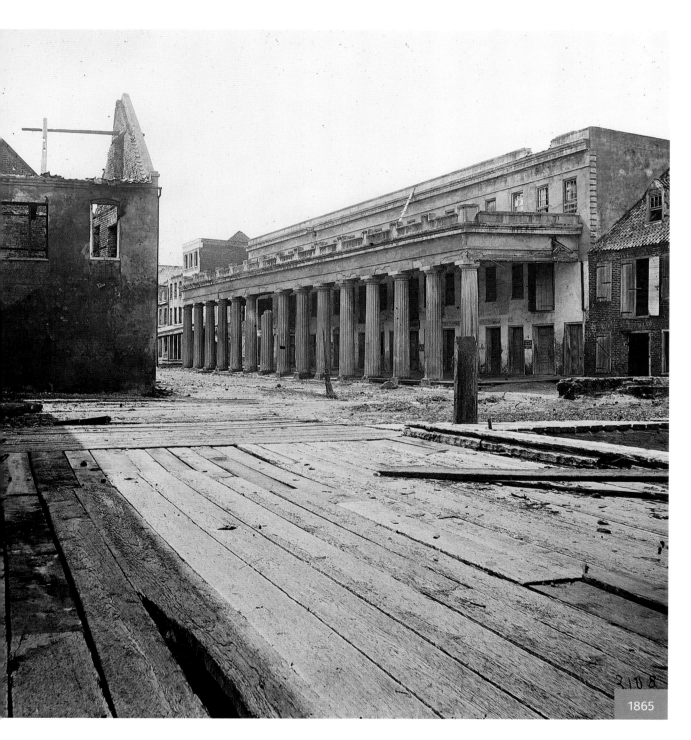

1865

VENDUE RANGE
Screams of happy children now heard at site of Union shelling

LEFT: Throughout the colonial era, Charles Town's eastern shoreline came up to East Bay Street. From there colonists built long shipping docks stretching out into the Cooper River. The docks grew wider over time, as buildings and infill were added. Wealthy Santee rice and indigo planters docked here at Prioleau's Wharf to attend services at the French Huguenot Church—they would arrive in Charles Town with the outgoing tide, then return as the waters flowed back in.

After the American Revolution, the city built a public landing here, where, in 1791, President George Washington first set foot in Charleston amid madly cheering, banner-waving crowds. A decade later the city demolished several market areas around what had grown into a 72-foot-wide, 450-foot-long wharf and redeveloped the site as a "range" of new commercial buildings, designed not for retail sales but for vendue sales, where goods were sold auction-style to the

BELOW: Vendue Range was virtually abandoned, its eclectic awnings and noisy crowds fading into history.

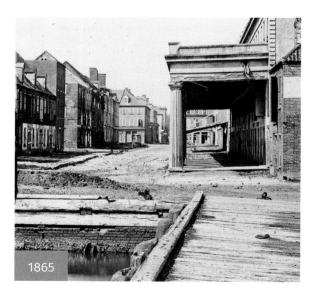

1865

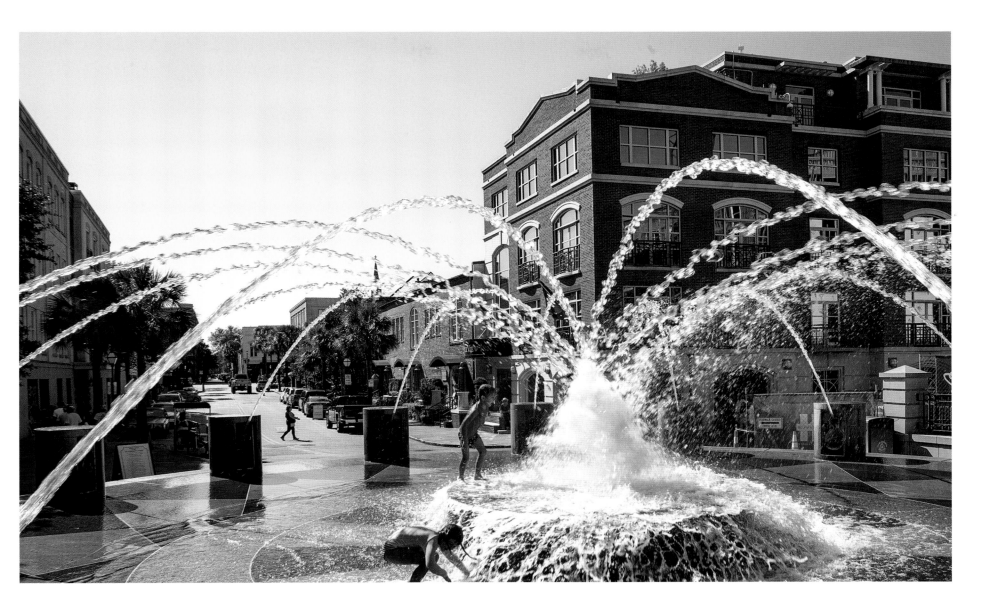

highest bidder. Vendue masters set up their wares under temporary, haphazardly arranged awnings to provide shade for their buyers. By January 1810, local newspapers were advertising sales taking place along the "new Vendue Range."

The wharf and surrounding area were damaged during the Civil War; it is generally thought that the first Federal shell to hit the peninsula city did so at Prioleau's Wharf. The wharf continued to be used as a landing site through the mid-20th century, when the last passenger steamships stopped running.

ABOVE: The former mudflat—now a city street—was revitalized in the 1980s by Mayor Joseph P. Riley Jr., who redeveloped it and later its adjacent area into Waterfront Park. The range's old warehouses have become upscale hotels, condominiums, boutique retail shops, art galleries and quaint eateries. One of the park's most popular features, its public fountain, sits squarely in the center of the old Prioleau's Wharf, providing hours of summer fun and heat relief to thousands of children and tourists.

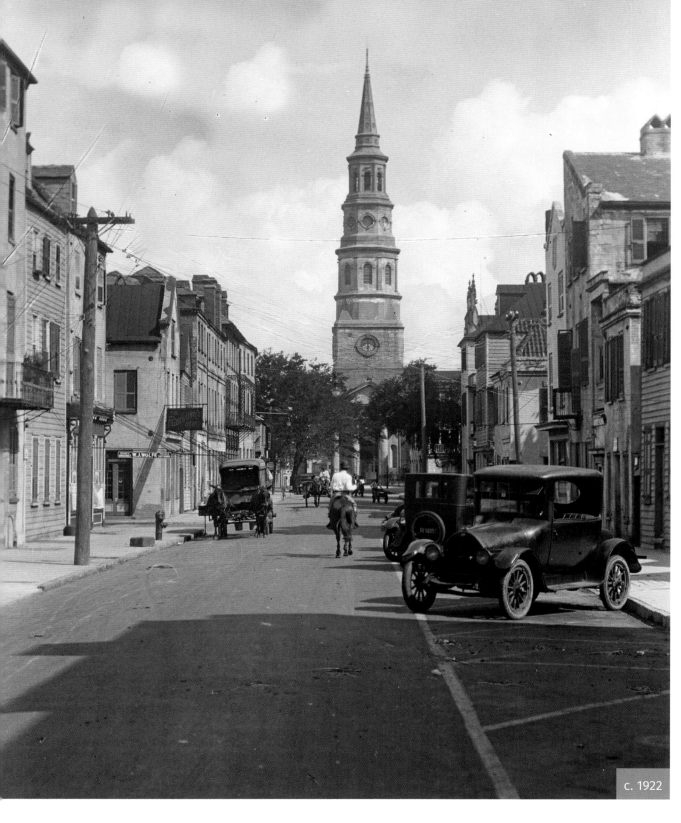

ST. PHILIP'S CHURCH, 146 CHURCH STREET
First Anglican congregation south of Virginia

LEFT: St. Philip's Church was founded in 1680 as the first Anglican congregation south of Virginia. Built of local cypress in the northwest corner of the Walled City, their first church was damaged in a 1710 hurricane. Because of that, and their growing congregation, they built a larger church on Church Street. Its first service was on Easter 1723. This second St. Philip's, partially funded through duties on rum and enslaved people, was widely acclaimed. English statesman Edmund Burke wrote in 1777: "St. Philip's is spacious, and executed in a very handsome taste, exceeding everything of that kind which we have in America."

This church was saved during a 1796 fire by an enslaved man named Will. As sparking embers threatened its roof, according to historian Charles Fraser, Will "at the risk of his life, climbed to the very summit of the belfry, and tore off the burning shingles." Afterward, the vestry paid Will's owner $707.14 for his freedom. He spent the rest of his life as the church sexton.

Unfortunately, Will was not around in 1835, when St. Philip's burned to the ground in another fire.

BELOW: A new, wider street wrapped around the porticos to access the Market, as seen below.

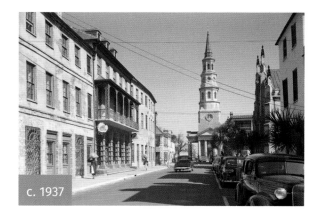

c. 1922

c. 1937

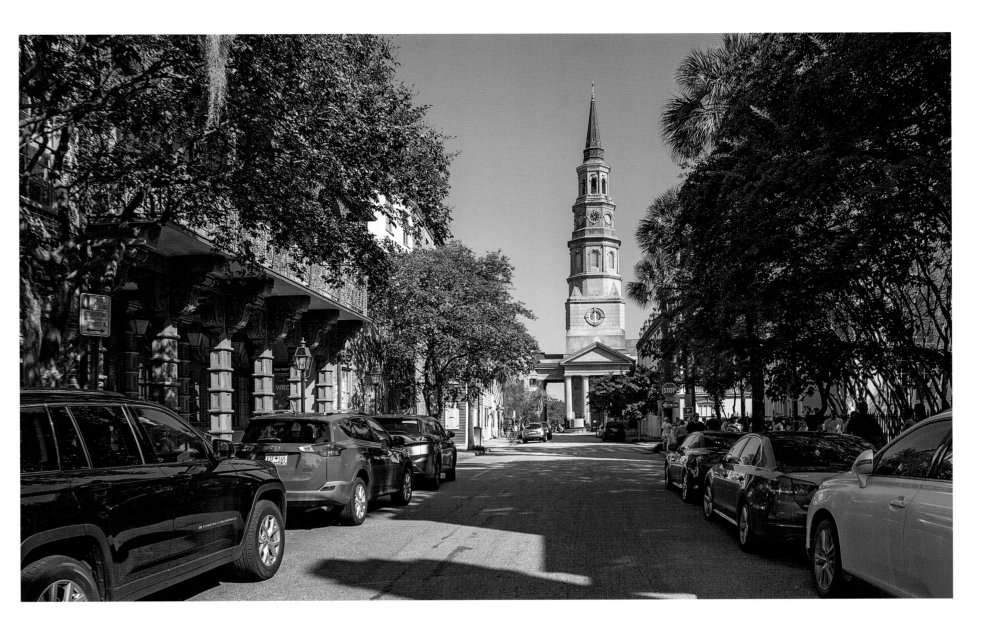

A new church was erected by 1838 with the capacity to seat 800, though not without controversy. By then, the Market had moved north of the church, which had been the terminus of Church Street. While some wanted to maintain the church as the street's visual apex, others thought it commercially expedient to extend Church Street to the Market. A compromise sited the new church 22 feet east of its original foundation, bringing its porticos in line with Church Street's north/south axis.

ABOVE: St. Philip's has changed little since 1838. In 2012 it hosted the convention whereby the Anglican Diocese of South Carolina broke from the Episcopal Church over theological differences. Lawsuits regarding which diocese owned the church ensued. In 2022 the S.C. Supreme Court confirmed St. Philip's congregants' right to continue worshiping in their historic sanctuary. The view of St. Philip's porticos and steeple rising above Church Street is one of the most photographed images of the city.

S.C. INSTITUTE HALL, 134 MEETING STREET

The birthplace of secession and Civil War

LEFT: The S.C. Institute for the Promotion of Art, Mechanical Ingenuity, and Industry was founded in 1849 to promote the state's economic resources to investors. By 1854, a new exhibit hall for the Institute was completed on Meeting Street, next to Circular Church. Architects Edward Jones and Francis Lee designed the hall in the Italianate style and many believe it was their finest example of introducing Romanticism into Charleston's architectural continuum. With a seating capacity of 3,000, it was the city's largest venue. Unfortunately, the building survived only six years, and its commercial exhibits are not what we remember Institute Hall for today.

Because of its seating capacity, the hall hosted the April 1860 National Democratic Convention, a debacle that would go down in history as delegates from the North and South split into regional factions over states' rights and slavery. Unable to garner enough votes to declare a Presidential candidate, the convention disbanded in chaos as delegates stormed out. It later reconvened in Baltimore, where Stephen Douglas was eventually declared the Democratic candidate, though he never received the votes needed by a true quorum.

As South Carolina's delegates had promised, the state convened a Secession Convention soon after news of Abraham Lincoln's presidential election reached Charleston on November 7. Originally convened on December 16 in the state's capital of Columbia, the meeting moved to Charleston days later following rumors of a smallpox outbreak. Delegates met at St. Andrews Hall on Broad Street to draw up the Ordinance of Secession on December 20; yet with excitement and fanaticism running high, secessionists wanted to put on a show for the document's signing. It was decided to move the signing of the declaration to the larger S.C. Institute Hall.

Despite the warnings of Charleston's respected barrister James L. Petigru that "South Carolina is too

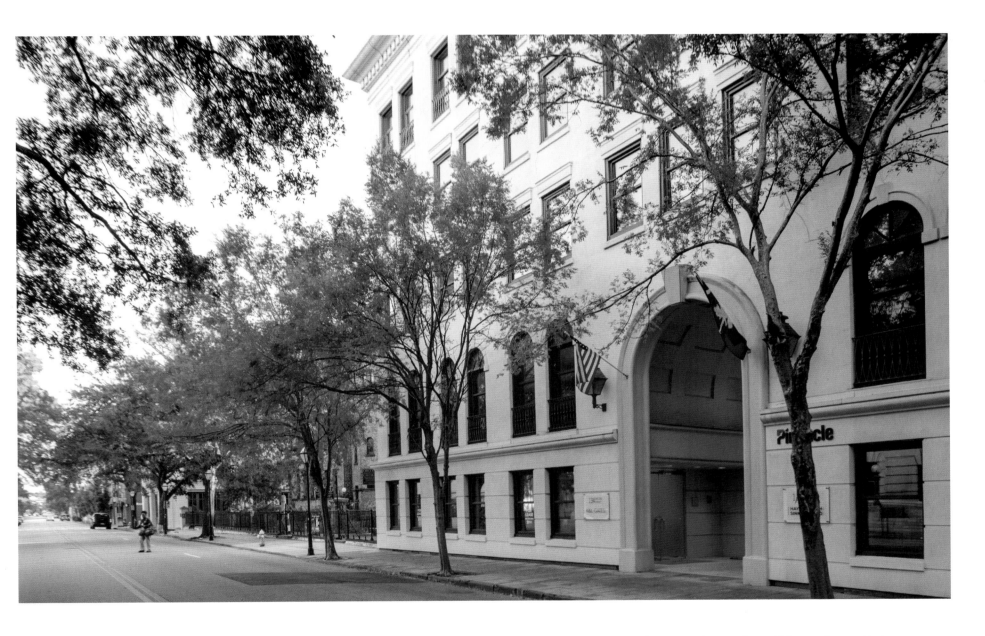

small to be a Republic and too large to be an insane asylum," the ordinance was signed and celebrated throughout the night. South Carolina had taken the first step in leading America toward civil war. News of secession "spread like wildfire," according to the next day's *Charleston Mercury* newspaper. These were prophetic words indeed as a year later, on December 11, 1861, the hall burned to the ground in a conflagration that destroyed nearly one-third of the city's residential, civic and commercial buildings.

ABOVE: Secession Hall, as the S.C. Institute Hall would forever be recalled, was never rebuilt after the fire. Today the site is occupied by a five-story building constructed in 1985 (and remodeled in 2015) that offers more than 70,000 square feet of commercial office space, including legal, financial and real estate offices. Its two-story arched doorway, however, pays homage to its history-making predecessor.

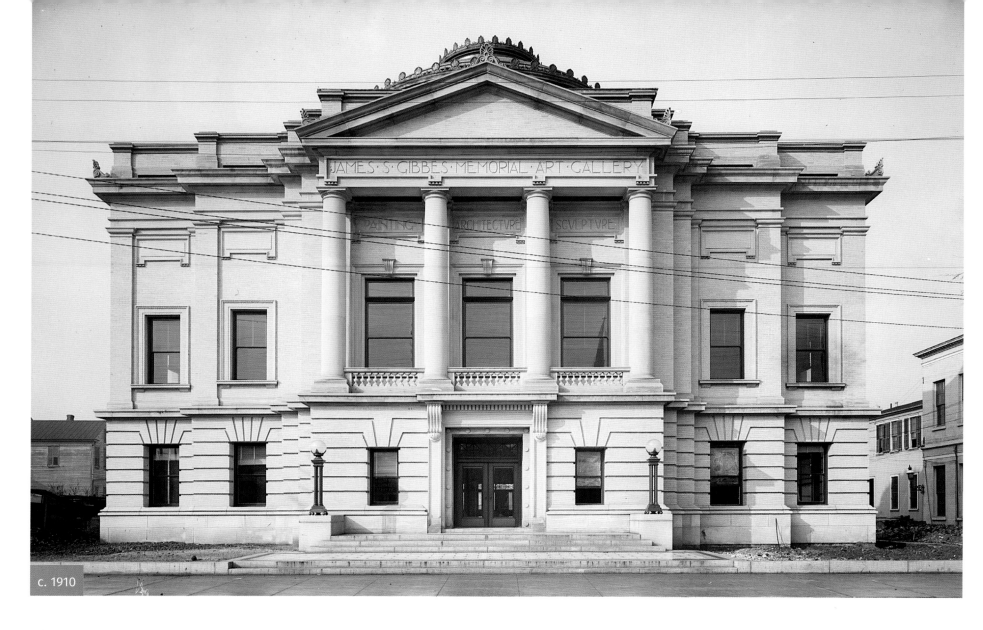

c. 1910

GIBBES MUSEUM OF ART, 135 MEETING STREET
Cultivating the arts and arts education

ABOVE: The S.C. Agricultural Society's exhibit hall occupied this site in 1881. By 1888, however, the hall was being used as an opera house, which burned on New Year's Day 1894. Five years later, James Shoolbred Gibbes, a successful merchant, railroad stockholder, founder of the National Bank of Charleston and art enthusiast, died. Having no children, he bequeathed $100,000 to the Carolina Arts Association for the "erection of a suitable building for the exhibition of paintings." The arts association was chartered in 1858 to cultivate the arts and promote arts education in Charleston.

Though the will was contested by Gibbes' nieces and nephews, the court ruled in December 1901 that the bequest was valid. Ruins of the agricultural hall were cleared, and work began on a new art museum in September 1903. Architect Frank Pierce Milburn designed the two-story Beaux Arts building with a grand stained-glass, Tiffany-style rotunda dome, Doric columns, and pediment-capped windows and doors. The building's base was made of South Carolina granite with exterior walls of pressed brick and Indiana limestone, topped by a red tile roof. Named for its patron, the Gibbes Museum of Art opened on April 11, 1905, at which time its collections included more than 300 paintings, 200 miniatures, Japanese prints and bronze statues.

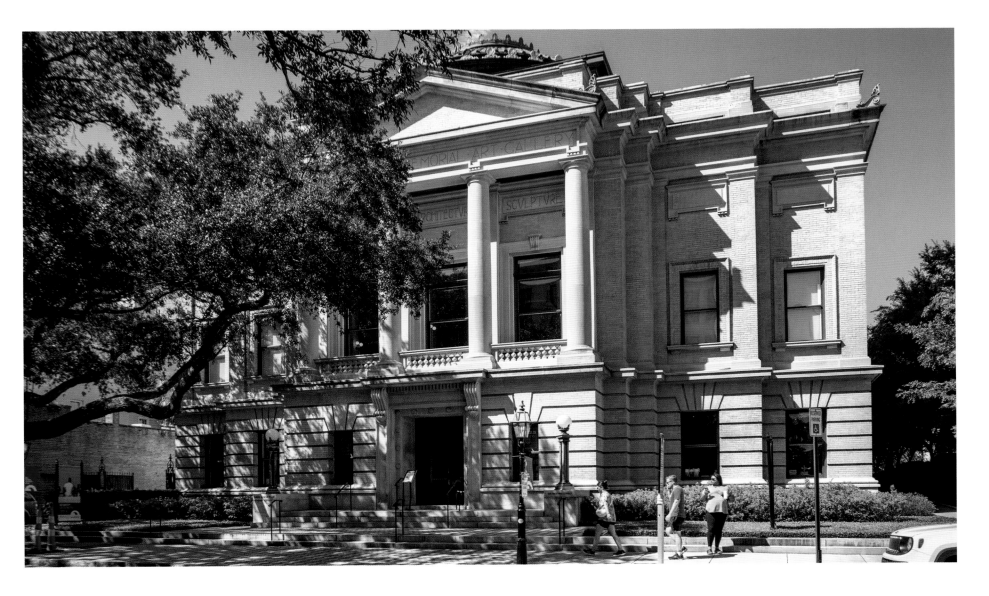

ABOVE: The Carolina Arts Association remodeled the museum in 1976, then another five-year, $13.5-million-capital campaign was undertaken in March 2011 to expand its programs. Despite its many renovations, the façade of the Gibbes Museum has remained nearly unchanged. Its permanent collection spans 400 years of American Southern art, from the colonial era to the present, conveying Charleston's aesthetic tastes throughout the city's history. The Gibbes also houses one of America's most important collections of 18th, 19th and early 20th-century miniatures, an art form that began in Charleston. Among its other collections are works from the Charleston Renaissance period that emerged between the two World Wars, Charleston-made furniture and other decorative items from The Rivers Collection, and cultural collections such as sweetgrass baskets that interpret the legacy of slavery in America.

The Gibbes continues to fulfill the Carolina Arts Association's 1858 mission to cultivate the arts and promote education by offering lectures, art classes and school programs. Collections found on its ground floor are free and open to the public. The outdoor reception area behind the building is part of the city's Gateway Walk from Archdale to Church streets, founded by the Garden Club of Charleston.

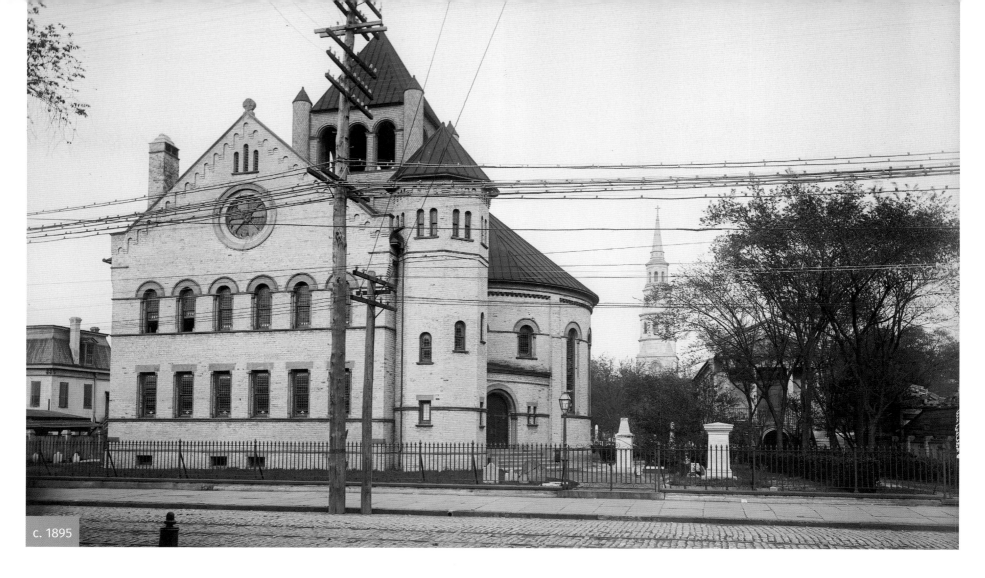

c. 1895

CIRCULAR CHURCH, 150 MEETING STREET

A house of worship "somewhat distinct and singular from them all"

ABOVE: A year after Anglicans established St. Philip's as the colony's first church, others came together to establish a house of worship for Dissenters who had not yet sorted themselves out into various denominations. Documents from 1775 record the congregation "suffered itself to be called either Presbyterian, Congregational, or Independent: sometimes by one of the names, sometimes by two of them, and at other times by all three. We do not find that this church is either Presbyterian, Congregational, or Independent, but somewhat distinct and singular

from them all." To distinguish themselves from Anglicans, dissenting colonists did not "go to church," but instead "attended meetings." They built their first wooden building called the White Meeting House (from which Meeting Street gets its name) here in 1681. This was replaced with a larger brick structure in 1732. When the city fell to the British in 1780, the meeting house was used as a military hospital and badly

RIGHT: A group of newly emancipated African-American children gather around the ruined base of one of Circular Church's columns.

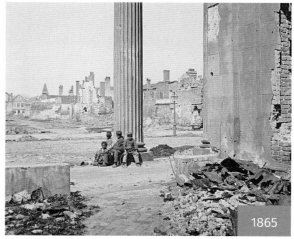

1865

74

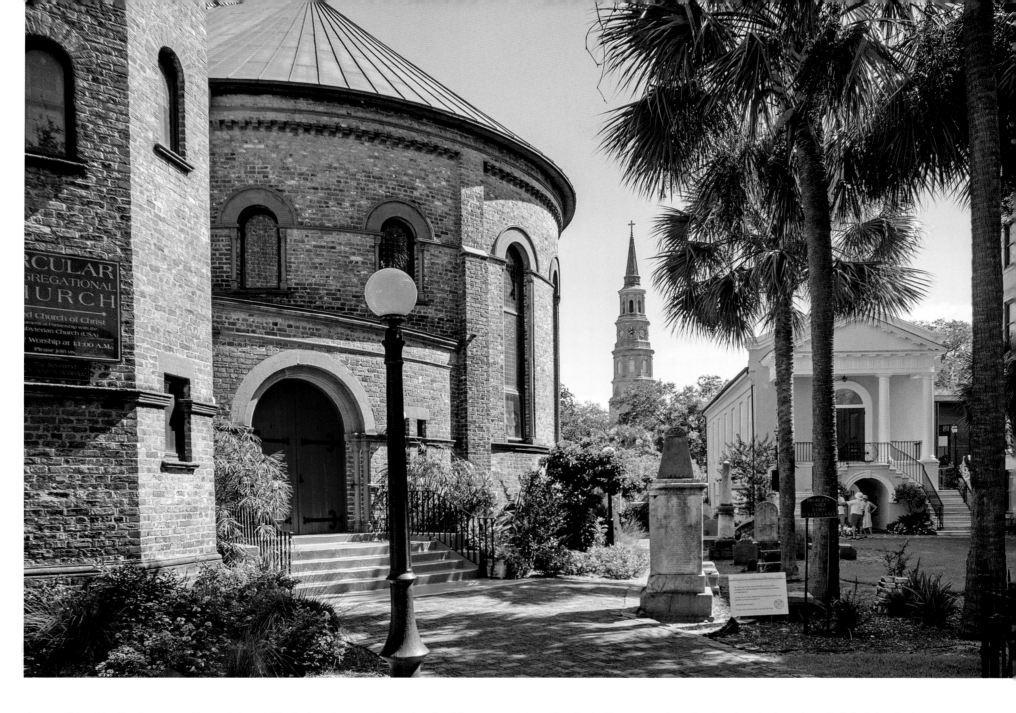

damaged. In 1804 Charleston architect Robert Mills designed a grand new church with a circular Pantheon design, believed to be the first domed church in America. German architect Charles Reichardt added a steeple in 1838, and the architectural team of Edward Jones and Francis Lee added a portico that dominated the streetscape in 1853. The church was destroyed in the Great Fire of 1861. Initial efforts to rebuild were futile, as the progress made came crashing down in the 1886 earthquake. Using recovered bricks, the church was rebuilt in 1892 in the Romanesque Revival style.

ABOVE: Theologically progressive, Circular Church championed Civil Rights in the 1960s and formally embraced the LGBTQ+ community in 1999. It hosts many community events, including annual performances for Spoleto. Its churchyard is among the oldest in the city, with one memorial dating to 1695. About 500 graves are marked today, though thousands of undocumented souls lie buried here as well. A study of its grave markers tells an interesting story of how man's concepts of death, heaven and one's relationship to God have evolved since that first meeting house stood here in 1681.

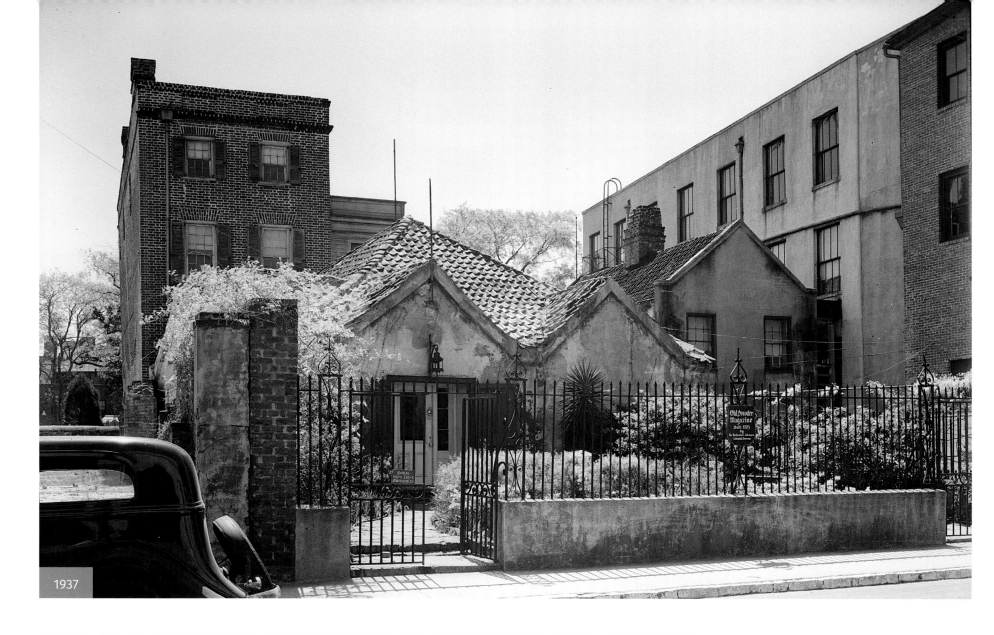

1937

THE OLD POWDER MAGAZINE, 79 CUMBERLAND STREET

The oldest public building in the two Carolinas

ABOVE: As the only British colony in North America surrounded by a defensive wall, Charles Town's bastions held numerous cannon which required a significant amount of gunpowder and a safe place to store it. In 1703, the Commons House of Assembly called for construction of a brick magazine for that purpose.

Completed in 1713, the powder magazine was a one-story masonry building with walls nearly three feet thick at its base. As the walls rose, they became thinner, gradually tapering to only a few inches thick at the vaulted ceiling's apex. If the powder exploded, its force would blow upward through the building's weakest point.

Sand stored in an attic under its tile roof would help smother the resulting fire. Though the Old Powder Magazine never exploded, it did leak. The roof was refitted, and this magazine used until a new one was built in 1737 at the colony's old burial ground, then a less populated area, known today as Magazine Street. The new magazine was poorly constructed, however, and the powder returned to the Old Magazine until another magazine was built, again in the cemetery, in 1748.

The Old Powder Magazine fell into disuse for a time after that, but was repaired shortly before the American Revolution. After a British shell exploded near it,

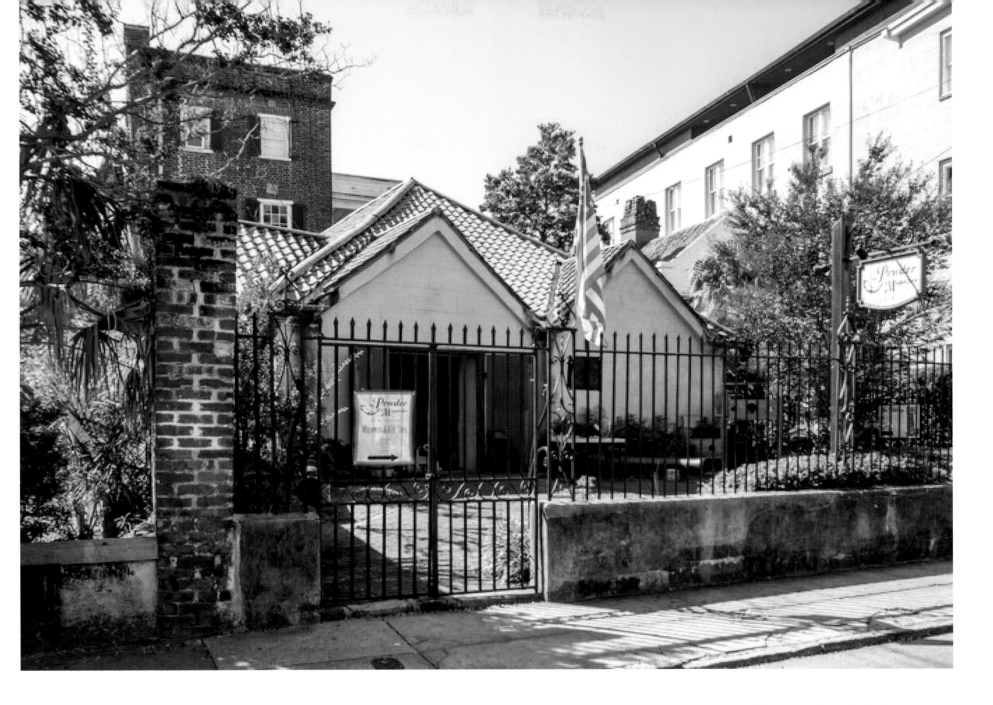

Gen. William Moultrie wrote: "In consequence of that shell falling so near, I had the powder (100,000 pounds) removed to the northeast corner under the Exchange, and had the doors and windows bricked up. Not withstanding the British had possession of Charleston so long, they never discovered the powder..."

Though it still leaked, the Old Powder Magazine was sturdy. By the early 19th century, it was deeded to the Izard/Manigault family and was variously used as a print shop, stable, wine cellar and carriage house before falling into disrepair.

ABOVE: In 1902 the National Society of the Colonial Dames of America in the State of South Carolina saved the Old Powder Magazine from demolition and opened it as a museum. As the oldest public building in the Carolinas, it is a visible reminder of the city's earliest days, under the rule of the Lords Proprietors. In 1993, the Colonial Dames leased it to Historic Charleston Foundation, which undertook an extensive renovation of the museum, including an expensive roof replacement, before returning it to the Dames in 2003. Nevertheless, to this day, the roof still leaks.

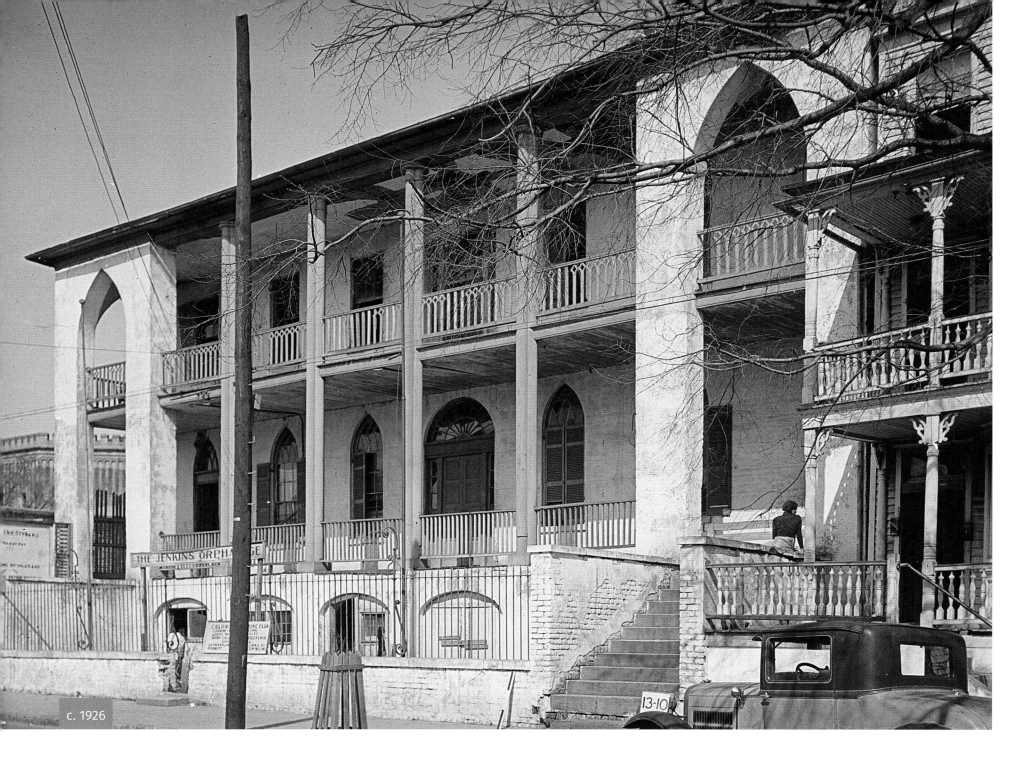

c. 1926

THE OLD MARINE HOSPITAL, 20 FRANKLIN STREET
Where Charleston took center stage during the Jazz Age of the Roaring Twenties

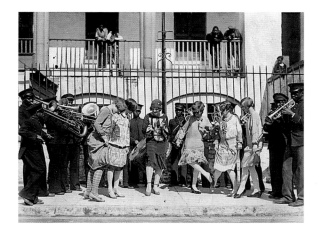

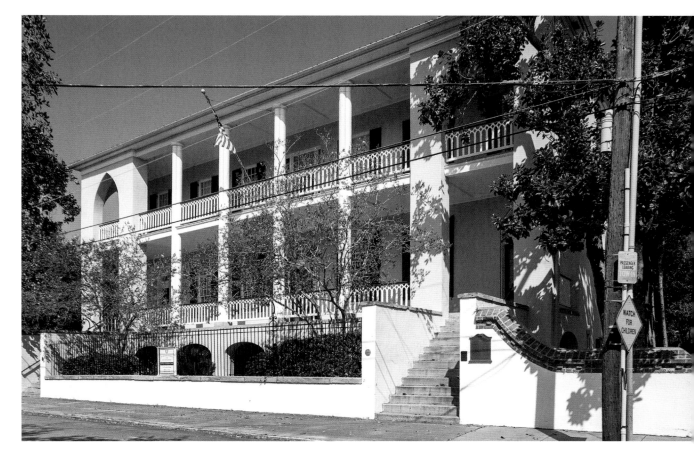

LEFT: In 1798, Congress passed an "Act for the Relief of Sick and Disabled Seamen," calling for 30 Mariners' Hospitals to be built in port cities along the East Coast. These would be supported through taxes on shipping tonnage and the garnishment of sailors' wages, an act some consider America's first income tax.

Charleston's hospital, one of the nation's first federally funded public welfare initiatives, was unpopular with many locals, who considered it an intrusion by the Federal government into local matters. They were especially angry that local artisans were passed over in favor of workers from Washington, D.C. Though the hospital was designed by Charlestonian Robert Mills, by this point in his career he was working for the Federal government and living in Baltimore. Furthermore, he had fallen out of favor with many Charlestonians for his abolitionist leanings.

The first Gothic Revival-style building in Charleston, the two-story hospital was completed in 1834, featuring an arcaded basement, hip roof, and Charleston piazzas across a seven-bay façade. Its original U-shape had a couple of rear wings off either end. Gothic details included two-story lancet arches and clustered columns reminiscent of medieval

ABOVE: The Jenkins Orphanage Bands marched in two Presidential inaugural parades and performed for the King of England. One of its former students developed the iconic dance, "The Charleston," based on the syncopated rhythm that was the bands' hallmark sound.

religious architecture. A model for Mariners' Hospitals around the country, it remained in use through the Civil War even when badly damaged in the Federal bombardment.

From 1866 to 1870, a group of Episcopal women converted it for use as a school for African-American children. Yet the building's true legacy is its time as the home of the Jenkins Orphanage from 1892 to 1939. The famous Jenkins Orphanage bands were at the forefront of the music that characterized the Roaring '20s jazz age. Located behind the Old Jail and Work House where slaves were once disciplined, the specter, Jenkins said, reminded his charges of what could happen to children who misbehaved.

ABOVE: The Rev. Jenkins died in 1937, about the time fire destroyed the hospital's rear wings. The orphanage moved soon after, and the old hospital was purchased by the Housing Authority of Charleston, which was building publicly subsidized housing in the neighborhood. Their offices remain there today. The building, a National Landmark, is one of only eight surviving Mariners' Hospitals remaining in America.

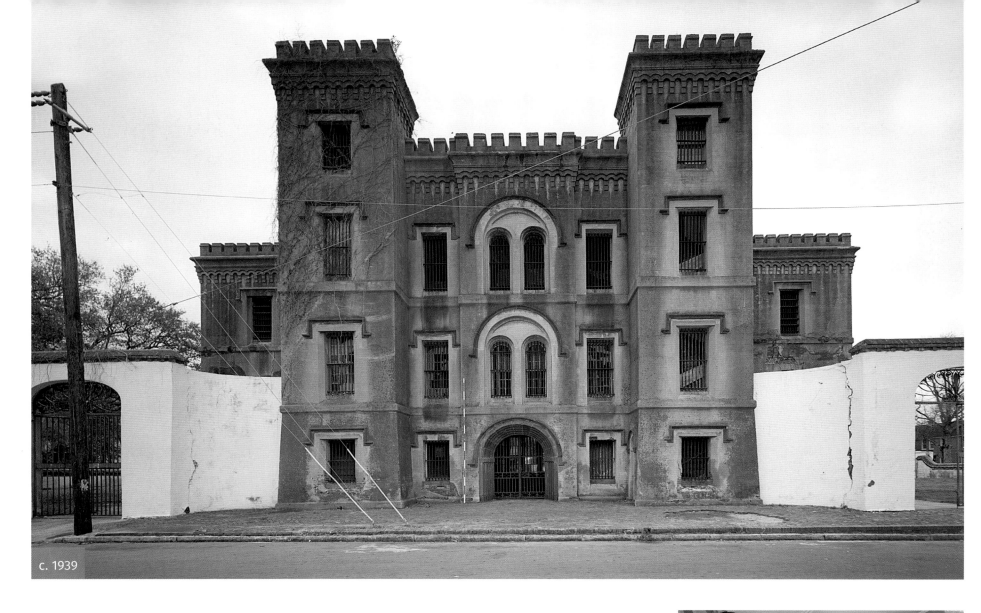

c. 1939

CHARLESTON DISTRICT JAIL, 21 MAGAZINE STREET
Where more than 10,000 souls have died

ABOVE: Built over the colony's first public cemetery, Charleston's Old District Jail housed the city's most notorious criminals, enslaved people and Civil War prisoners from 1803 to 1939. Upwards of 10,000 people have died on this block, their bones unceremoniously interred in unmarked graves.

The jail was a one-story brick rectangle measuring 100 by 50 feet when it was completed in 1802. Designed to hold 130 prisoners, it often housed more than 500.

A four-story wing added in 1822 was mostly replaced in 1856 by an octagonal Romanesque Revival addition and ventilation tower. That, and crenelated towers flanking a gothic entrance, gave the building an

RIGHT: During her time as Chief Advancement Officer for the American College of the Building Arts, the author's office was in what was probably a second-floor bedroom for the warden's family. Though she never worked late alone, she did—on a bet—spend the night there once. Once was enough.

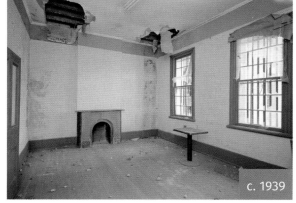

c. 1939

80

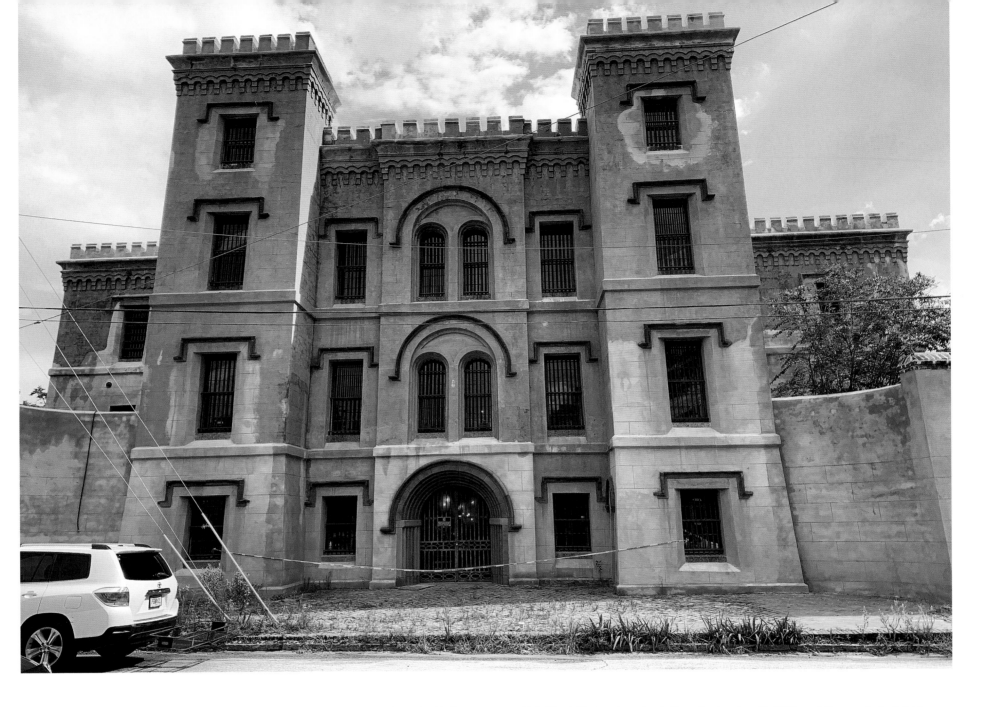

imposing aesthetic that struck fear into the heart of anyone contemplating mischief. For most of its history the jail had no running water. Straw or wood chips served as both bedding and toilet areas. Filth was unavoidable. Inmates were executed in the jail yard, though even more deaths were attributable to the unimaginable conditions.

Though the jail lost its ventilation tower, fourth floor and surrounding wall in the 1886 earthquake, it was not demolished. Daniel Duncan, convicted of murder in 1911, was the last inmate executed before the jail was decommissioned.

The jail's last inmates left on September 13, 1939, and the empty building quietly deteriorated over the next 60 years. Attempts in the 1960s to create an onsite museum were unsuccessful, but the future began looking brighter for the Old Jail in 2000 when it was purchased by the American College of the Building Arts, which used it as a living classroom to teach students artisanal building and restoration skills. ACBA moved out in 2017, and the jail was purchased by Landmark Enterprises, which invested $15 million to rehabilitate it as an office and event space.

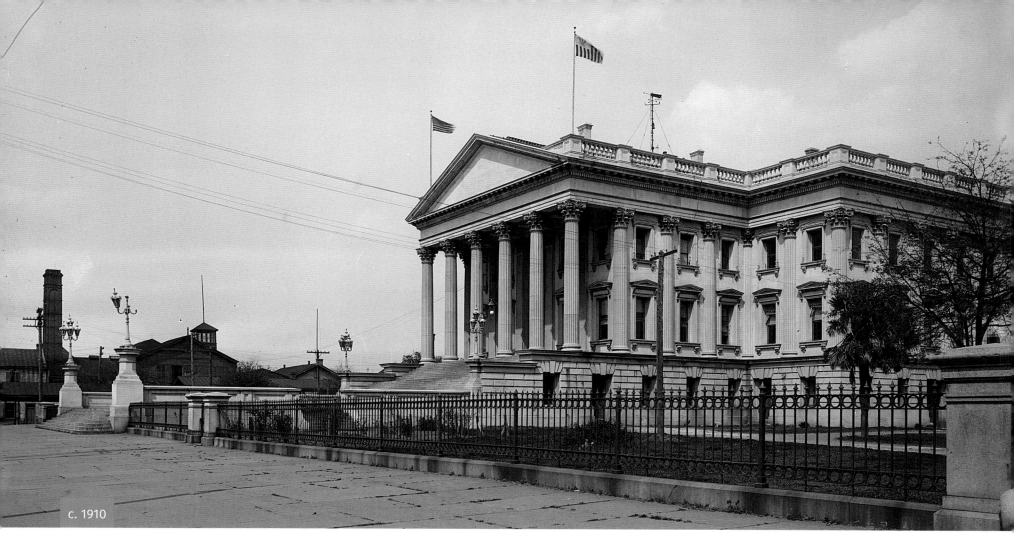

c. 1910

U.S. CUSTOMS HOUSE, 200 EAST BAY STREET
19th-century Federal building design more reflective of Washington than Charleston

ABOVE: Through the mid-19th century, port business, such as the assimilation of immigrants, regulation of commerce, and collection of shipping taxes, was conducted in the Exchange Building at the eastern terminus of Broad Street. Because a larger space was eventually needed, Congress appropriated funds in 1849 for a new customs house at the corner of South Market and East Bay.

Charleston architect Edward Jones won the project's design competition, but Washington authorities intervened and awarded the contract instead to Ammi Burnham Young, a designer of other U.S. customs houses. His final design incorporated elements from four other competition drawings, including Jones'.

It took nearly 30 years to complete the Customs House for various reasons. First, 7,000 40-foot piles had to be driven into the marshy site to support its foundation, then Congress withheld funding as talk of secession grew. Its elevated, rusticated granite basement had been completed and work begun on its columns and marble walls as the first shots of the Civil War rang out. It took 19 acts of Congress before construction resumed in 1870. Though its design was scaled back, it took nine more years to complete.

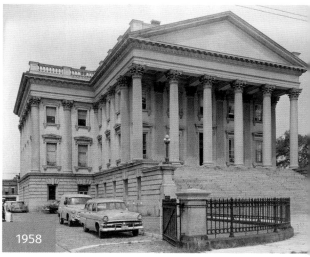

1958

A two-story, cross-shaped building with pedimented windows, its Classical Revival architecture was more reflective of the predominant style of public buildings in Washington, D.C. than those in Charleston. Both east and west temple front entrances had bronze doors, pedimented porticos and triple-tiered steps, leading into a marbled center room with 14 Corinthian columns supporting a second-floor gallery from which offices were accessed. A heating system was added in 1906, followed 10 years later by indoor plumbing and electric lights.

ABOVE: Despite the upgrades, the Customs House was slated for demolition in 1956. Yet thanks to preservationists' outcries, the building was saved and funds for its restoration allocated in 1968. The second floor was restored in the 1990s. Between 2000 and 2011, its doors and windows were also restored, and its security systems and elevators upgraded. The Customs House is one of Charleston's few public buildings that continues to serve the original purpose for which it was built, to house federal offices. Today its three-tiered steps serve as an ideal venue for occasional outdoor concerts.

c. 1923

MARKET HALL, 188 MEETING STREET
An often misinterpreted historic site

ABOVE: One of the lesser understood historic sites in Charleston, Market Hall is often erroneously referred to as the Old Slave Market. This 100-foot-wide strip of land was donated to the city in 1788 by several families who owned land abutting a tidal creek running from the Cooper River to Meeting Street for use as a market. The gift specified the land would revert to the families if it were ever used for any other purpose. Decorative sheep and rams' heads along its frieze identify the west end as a meat market; produce was sold in the middle; and fish by the river. Enslaved people were never sold here.

The hall burned in 1838, and the city hired E.B. White to design a new one. Completed in 1841, its distinctive temple form of brick with brownstone stucco, red sandstone and green ironwork rose above an arcaded ground floor for vendors. Brownstone stairs ascended to a pedimented portico supported by Roman Doric columns. Its 1,700 sq. ft. hall was used for many purposes during its first 60 years. Confederate recruits

RIGHT: In 2002 restorers painted Market Hall's ironwork back to the original vivid green, a contrast to its former conservative black.

c. 1923

mustered here during the Civil War, and after the war, it was used for city offices, lectures and meetings, and as temporary sanctuaries as churches were rebuilt. In the 1870s, Market Hall was one of the most racially diverse gathering places in town, as emancipated and free people of color hosted balls, fundraisers, events and meetings.

In 1899, the building became the headquarters and museum of the Charleston chapter of the United Daughters of the Confederacy. Artifacts included Confederate flags that flew over Fort Sumter, uniforms, and a lock of Gen. Robert E. Lee's hair.

ABOVE: The museum relocated for 12 years after Hurricane Hugo (1989) when structural problems were discovered. When restored, it was repainted in its original vivid colors, replacing a demure gray façade. During this time, the UDC's assumed 99-year lease on the hall may have expired, a debatable matter as no documentation of the 1899 agreement remains, and many today, even in Charleston, eschew matters concerning remembrances of the Confederacy. In the end, the UDC's lease was renewed in 2001. The museum is open when its flag is displayed. Vendors' stalls remain on the ground floor.

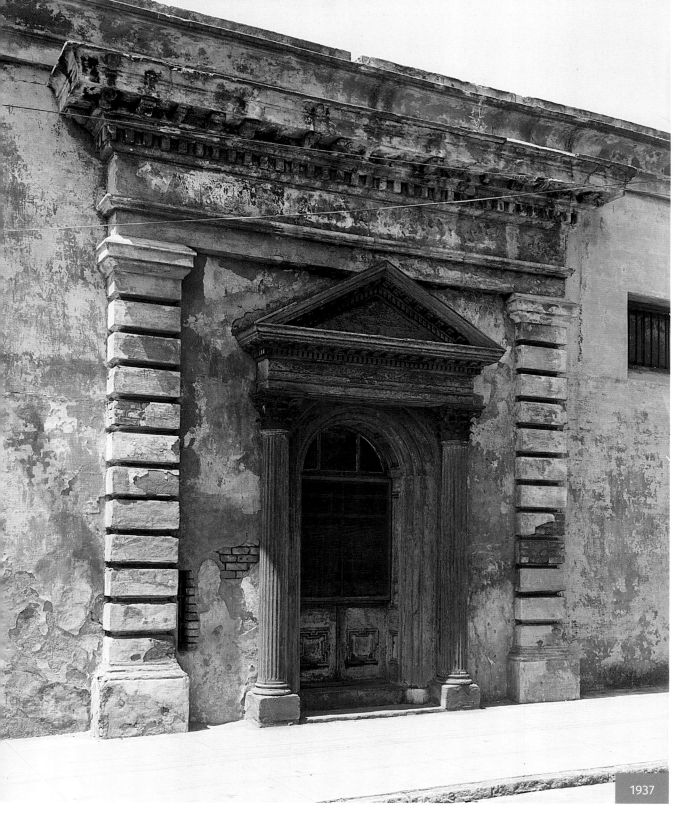

1937

WILLIAMS BUILDING DOOR, 181 CHURCH STREET

An amazing survivor in the midst of destruction

LEFT: In the mid-19th century, Charleston's City Market comprised a mix of businesses, bakeries, cotton warehouses and low-rent dwellings, interspersed with taverns and bawdy houses sometimes said to be of questionable repute. Built closely together, such a mix creates an ideal environment for fires. Thus, any buildings occupying the lot fronting Church Street between Market and Hayne streets before the mid-19th century probably burned in the catastrophic fires that swept through the market in the 1830s: one in 1833, two more in February and June 1835, and then the Great Fire of 1838.

By 1852, however, successful grocer, banker and railroad investor George Walton Williams had built George W. Williams & Co. Wholesale Grocers, a four-story commercial building on the corner of Church and Hayne streets. Here his wholesale grocery business grew to be one of the largest in the South, making Mr. Williams an antebellum millionaire. (Williams would build the Victorian mansion at 16 Meeting Street after the Civil War.) Just south of the grocery building was an attached one-story stuccoed brick building that served as another of Williams' businesses; some suggest a part of his banking enterprise, though again documentation is lacking. What we do know is that this smaller building featured an elegant Greek Revival entrance on Church Street.

Buildings near this corner were all heavily damaged in an 1883 fire. The Greek Revival door, however, survived, as it had the Union Army's bombardment during the Civil War, and later the earthquake of 1886, while buildings surrounding it crumbled. From 1890 to 1918, C.D. Franke Carriage Works occupied a storefront here, incorporating the door. It later served as a warehouse for Goldsmith and Loeb: Wool, Cotton, Hides, and Cotton Tie Manufacturers, who did the

86

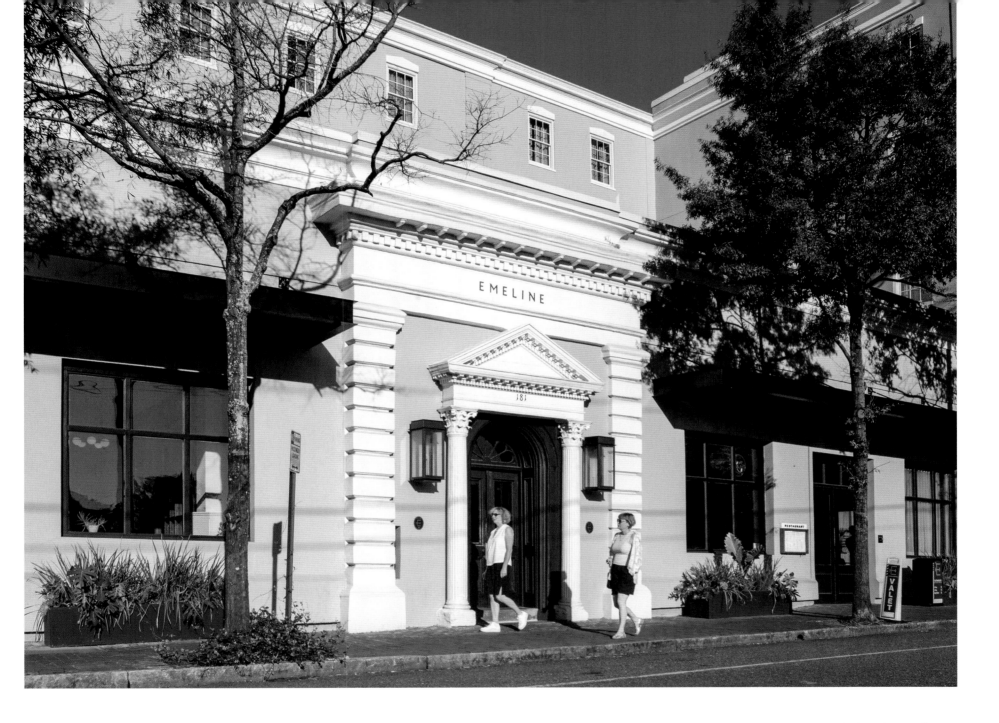

same. In fact, all the buildings constructed on this site throughout the late 19th and 20th centuries incorporated the door into their design.

A more recent fire destroyed the building on this site in 1988. A year later, Hurricane Hugo blew down its ruins, yet the doorway survived despite having to be propped up before repairs could be made. The doorway was then incorporated into the new Hawthorne Suites hotel, later converted to a Doubletree Inn, built on the site in 1990.

ABOVE: The Doubletree was thoroughly remodeled and upgraded when the Emeline hotel opened in the summer of 2020. Among its amenities is a coffee shop named Clerk's Company. The name pays homage to George Williams, who promoted five of his most trusted clerks to become business partners—an act demonstrating his appreciation for the culture of entrepreneurship and the respect that marked his business dealings for decades.

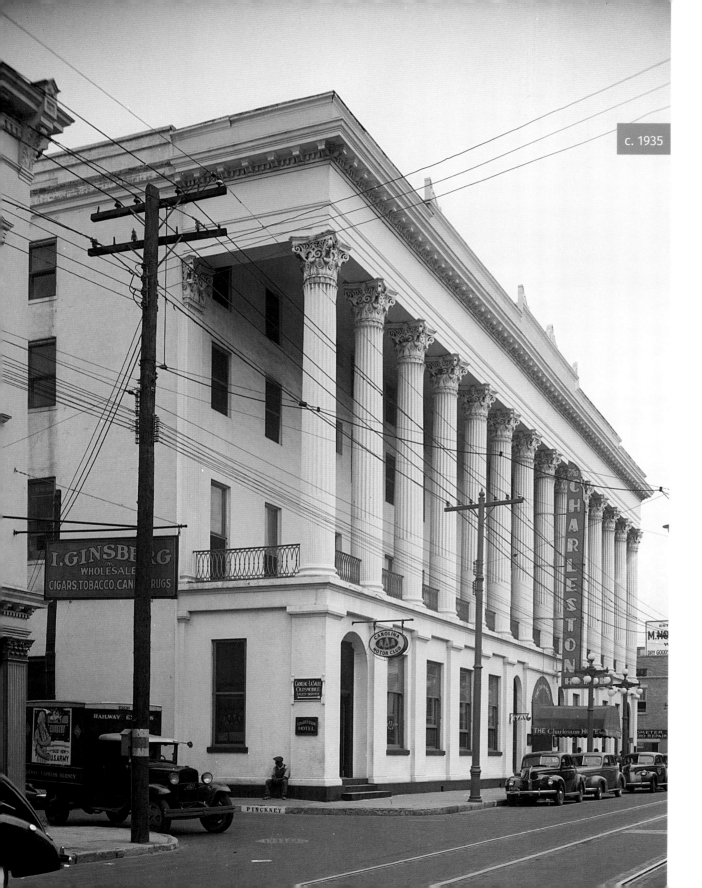

c. 1935

1974

CHARLESTON HOTEL, 200 MEETING STREET

A final link with the romantic days of gas lights and visiting royalty

LEFT: Designed by Charles Reichardt, the Charleston Hotel was an icon of the city's antebellum grandeur, "one of the few remaining links with the romantic days of terrapin soup, gas lights and visiting royalty," wrote *News and Courier* columnist Ashley Cooper in 1986. A block-long colonnade of 14 pillars with Tower of the Winds capitals distinguished its four-story Parthenon-style façade. It had 170 bedrooms with bathrooms, two elaborately decorated dining rooms, parlors, reading and reception rooms, and a gentleman's shaving saloon. Over time, it added its own electric plant, hot and cold running water, elevators, telegraph office, in-house doctor and pharmacist, dairy, poultry farm, cold storage, onsite bakery, and a steam laundry.

Its international guestlist was a virtual Who's Who of the socially elite: Oscar Wilde, Daniel Webster, Jenny Lind, England's Princess Louise, and Presidents Theodore Roosevelt, Calvin Coolidge and William Howard Taft. It hosted an array of balls, banquets and other social affairs.

ABOVE: Completed in 1960 the new Heart of Charleston Motor Hotel offered two new amenities: a swimming pool and off-street parking.

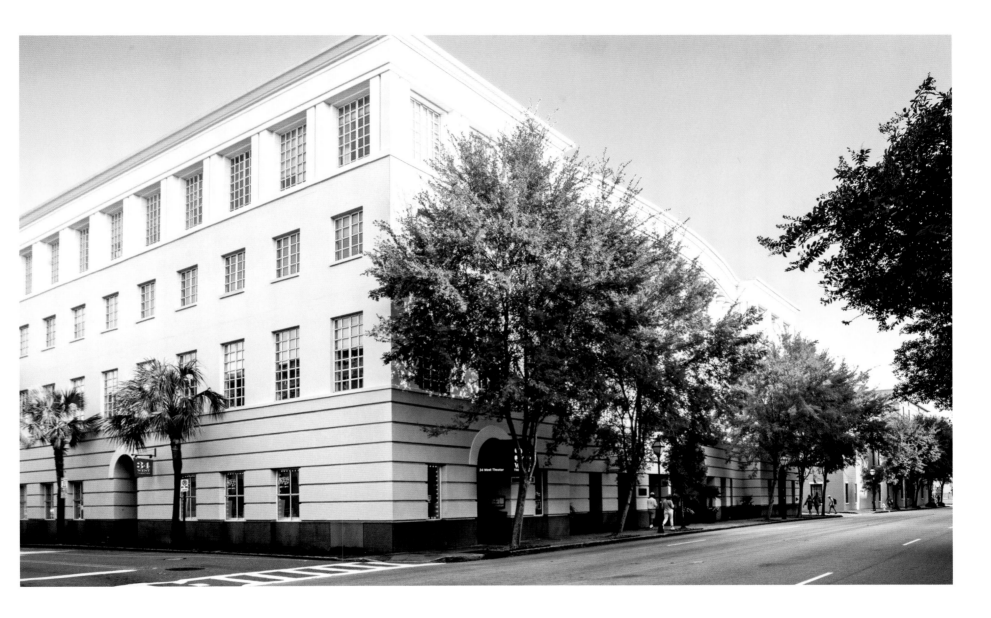

The Civil War took its toll on the hotel, however. As the 20th century approached, it was taking in boarders at cut-rate rents. Many rooms remained vacant at the start of its long decline throughout the century. Unable to keep pace with the amenities of newer hotels, especially automobile parking, Charleston's *grande dame* was slated for demolition in 1959. Yet the old girl didn't go down without a fight. When steel cables failed to pull down the colonnade, demolition teams brought in a one-ton wrecking ball, bringing down the last column in a haze of dust and rubble in April 1960.

ABOVE: The Charleston Hotel's destruction in 1960 prompted the city to expand its protected historic district above Broad Street. About 150,000 of the hotel's locally made bricks were salvaged to build the new one-story Heart of Charleston Motor Hotel, with ample onsite parking. In 1990, that establishment was demolished to make way for the Bank of America Place. Designed in a modern architectural style, the large bank pays homage to the original building with a raised portico topped by three-story inset columns—a reminder of, if indeed no match for, the Charleston Hotel.

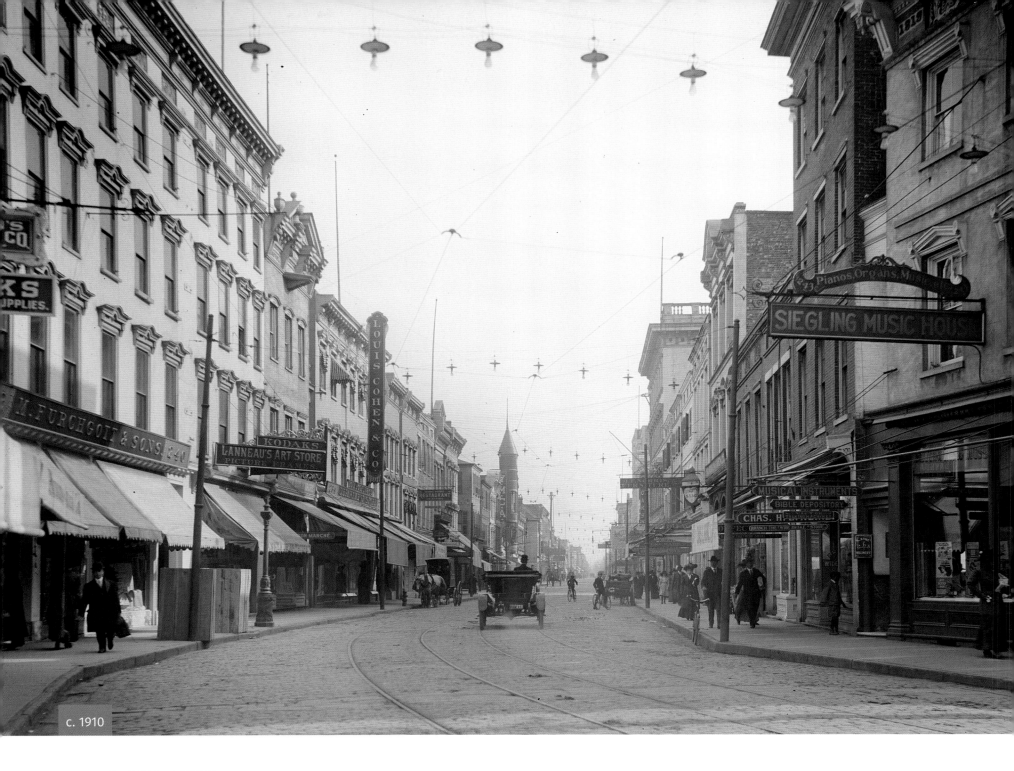

c. 1910

KING STREET

One of America's most chi-chi shopping districts since the mid-1700s

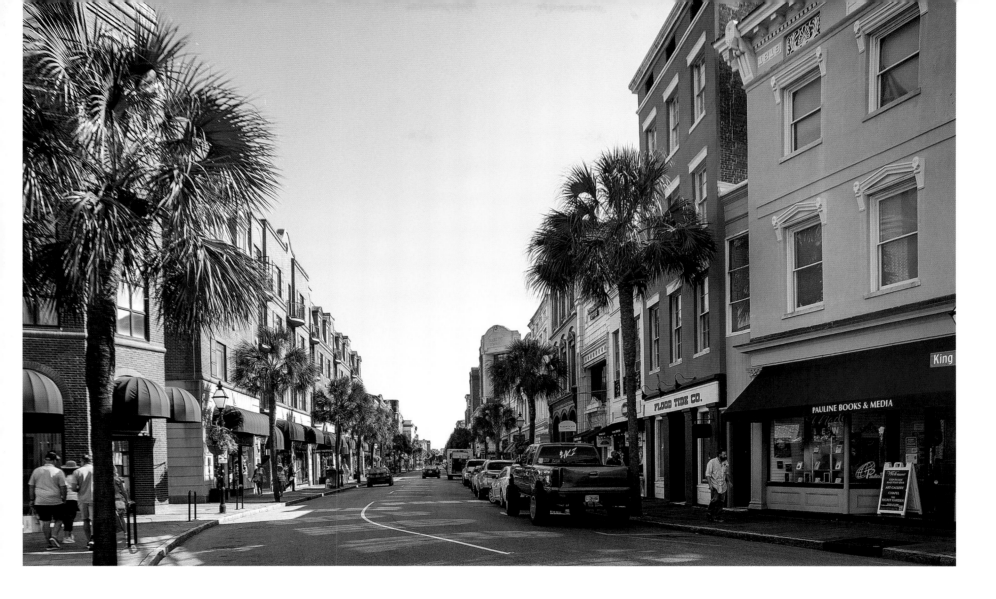

LEFT: Long before the Europeans arrived, Native Americans had worn "a broad path" along a ridge of high ground skirting the peninsula's creeks and marshes, connecting inland settlements to the harbor's fishing grounds. Colonial settlers' pack trains used the path to transport deer skins and enslaved Natives to ships along East Bay Street, Charles Town's first commercial center. By the 18th century, however, drivers had begun trading directly from the path itself, at which point it became known as King Street, in honor of King Charles II. Its prominence as Charleston's principal trading corridor was sealed when, in the 1830s, the railroad established its terminus there.

King Street continued to boom until the 1960s, when schools integrated and many white families fled to the suburbs. The shopping experience was also changing to a new indoor concept, and Northwoods Mall was completed in 1972 with acres of convenient parking. One by one, King Street's shop windows were boarded up, a wasteland of urban blight. Historic Charleston Foundation's Director called King Street "the weak, sick spine of the city."

ABOVE: Mayor Joseph P. Riley Jr. made the street's revitalization his top priority when elected in 1975. What Charleston needed, he proposed, was a major hotel and convention center to bring pedestrians back to King Street. This, however, required the redevelopment of an entire block in the heart of historic downtown, bounded by King, Market, Meeting and Hasell streets. More than three dozen 19th-century buildings would be impacted or demolished. Preservationists gave a collective gasp. Not since the Ordinance of Secession was signed in 1860 had anything been so divisive. After a decade of controversy, lawsuits, countersuits, editorials, name-calling, threats and redesigns, a compromise that pleased no one was reached, and city leaders broke ground on the new convention center in 1985. The redevelopment was a huge success, though it would be years before many old friends patched up their differences.

King Street's antiques district, from Broad Street to the Market, was recently voted "Best Antique Shopping in the U.S." by *Travel + Leisure* magazine, and its fashion, entertainment and dining districts are now considered some of the finest in the country.

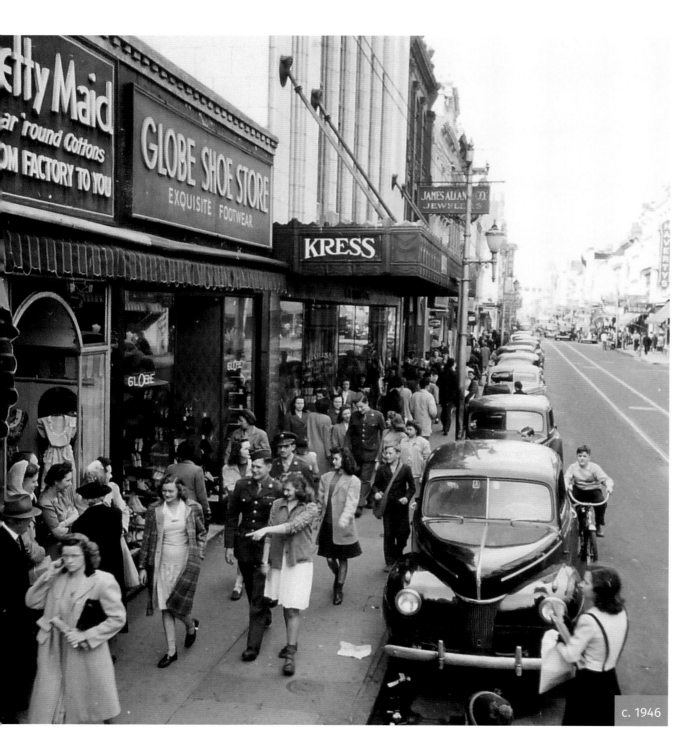

c. 1946

KRESS BUILDING, 281 KING STREET

Sparking the Civil Rights Movement in Charleston

LEFT: A retail icon in cities across America from 1896 until the 1980s, S.H. Kress & Co. stores were known for architectural excellence. Charleston's three-story Art Deco Kress, built in 1931, had Mayan Revival details in butterscotch terra-cotta with geometric motifs. A writer for *Sandlapper* magazine once wrote, "Kress stores served as city anchors, drawing urban, country and small-town people to their lunch counters ... friends you could count on for last-minute toiletries and a grilled cheese." Unless you were black.

Kress's policy of not serving African Americans at their lunch counters sparked the Civil Rights movement in Charleston. Though pastors and NAACP leaders advocated for civil rights, Charleston's greater African-American community generally was not active in the movement—until 24 teenagers from Charleston's all-black Burke High School, wearing suits and dresses, walked to the store on April 1, 1960, and sat down at the

BELOW: The Kress sit-in by the city's teenagers was the first overt action of the Civil Rights Movement in Charleston.

1960

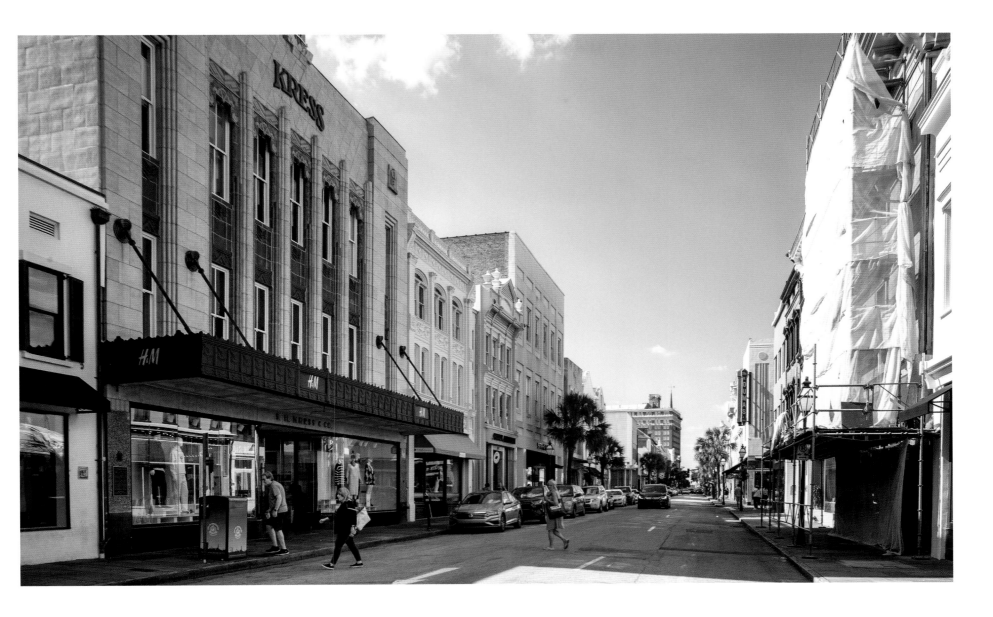

counter. As expected, they were denied service. Store employees asked them to leave, but the students remained seated, and quietly hummed, prayed, or just sat for the next 5½ hours. As the store closed, they were arrested without incident and charged with trespassing. Police Chief William Kelly, who sympathized with the students' cause, calmly managed the city's response to the sit-in. Bail was posted at $10 and all charges were later dropped. The brave demonstration of these teenagers inspired adults to embrace the equal rights movement and no longer sit safely on the sidelines.

ABOVE: Charleston's Kress store closed in 1981. The building was extensively renovated in 1999 and its lunch counter removed. Many businesses have occupied the building since then, including clothing stores, a rug gallery, law offices, a cookware store, and most recently an H&M home goods store. A historic marker erected in 2016 interprets the history of this site to locals and visitors shopping along King Street.

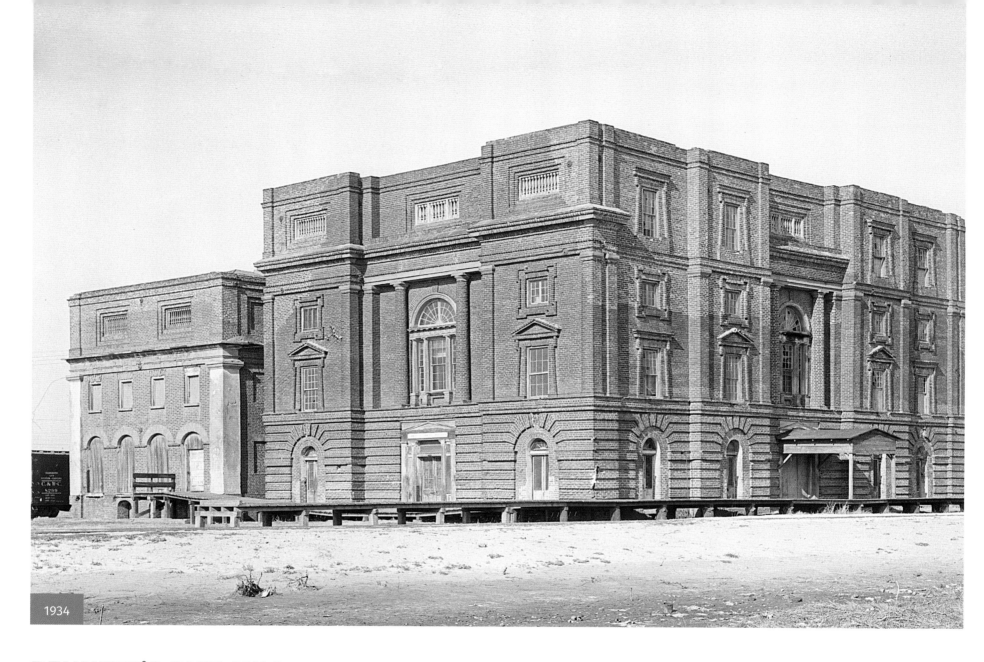

1934

BENNETT'S RICE MILL
Once one of America's finest examples of 19th-century industrial architecture

ABOVE: The wealth and power of Lowcountry planters were epitomized in Bennett's Rice Mill. Built in 1844 by Gov. Thomas Bennett, the imposing industrial structure integrated Classical Revival and Italian Renaissance styles. Its steam-powered technology and location along the Cooper River made it the city's most effective mill.

Without enslaved labor, rice production fell sharply after the Civil War, before a 1911 hurricane pushed seawater into the last rice fields, ending the industry.

Bennett's heirs sold the mill, which then served briefly as a peanut factory and railroad warehouse until the 1938 tornado took off its roof. Eventually, neglect and exposure caused its walls to crumble. It was condemned in 1952 and sections demolished for safety reasons. By that time, however, preservation had become a tenet of Charleston's culture, and many fought to save the mill. Yet funds, as well as a viable use for the property, never materialized.

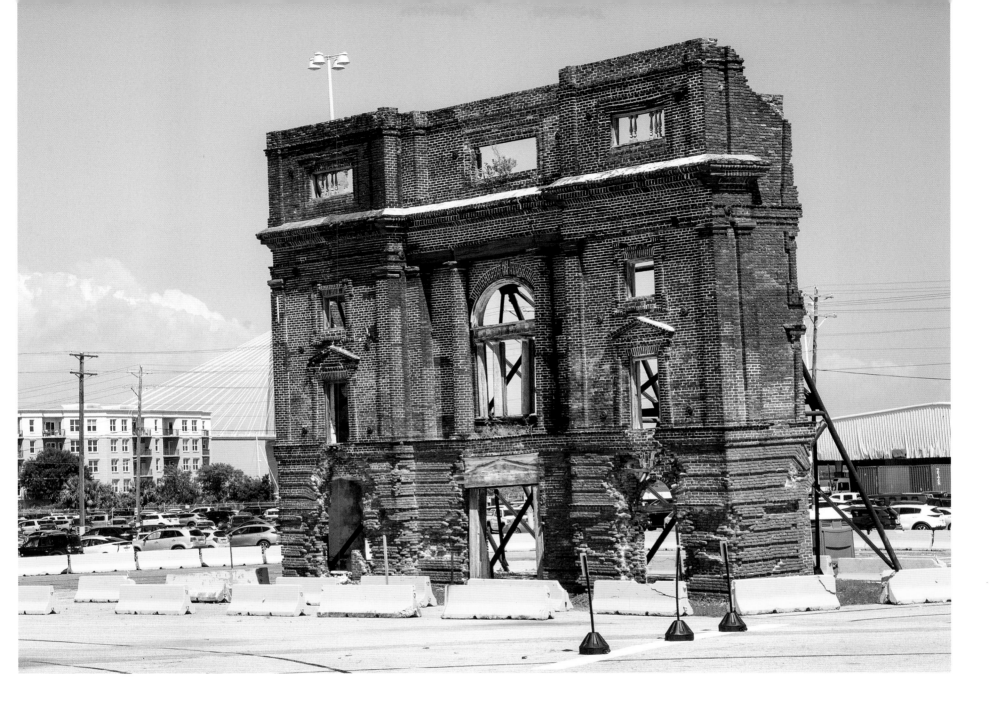

ABOVE: In 1958, the S.C. Ports Authority purchased the mill as part of its new Union Pier facility, working with preservationists to conserve its ruins. Sadly, a 1960 tornado brought down all but the mill's western façade. The Ports Authority assuaged preservationists' alarm by stabilizing the last remaining wall with a steel frame that protected it even through Hurricane Hugo (1989). Today its façade is visible only at a distance because of the port's security protocols, its original beauty recognizable only to those who can discern its classical features.

In May 2022, the Ports Authority announced it was selling the 70-acre waterfront tract for the largest downtown redevelopment project ever proposed. Plans include intensive development of condominiums, apartments, hotels and retail/office space, with four- to eight-story building heights that would dwarf the remains of what was once the South's most prominent industrial building. In a 2022 position statement, Historic Charleston Foundation listed preservation of the Bennett Rice Mill façade as one of its top five redevelopment priorities. Cross your fingers.

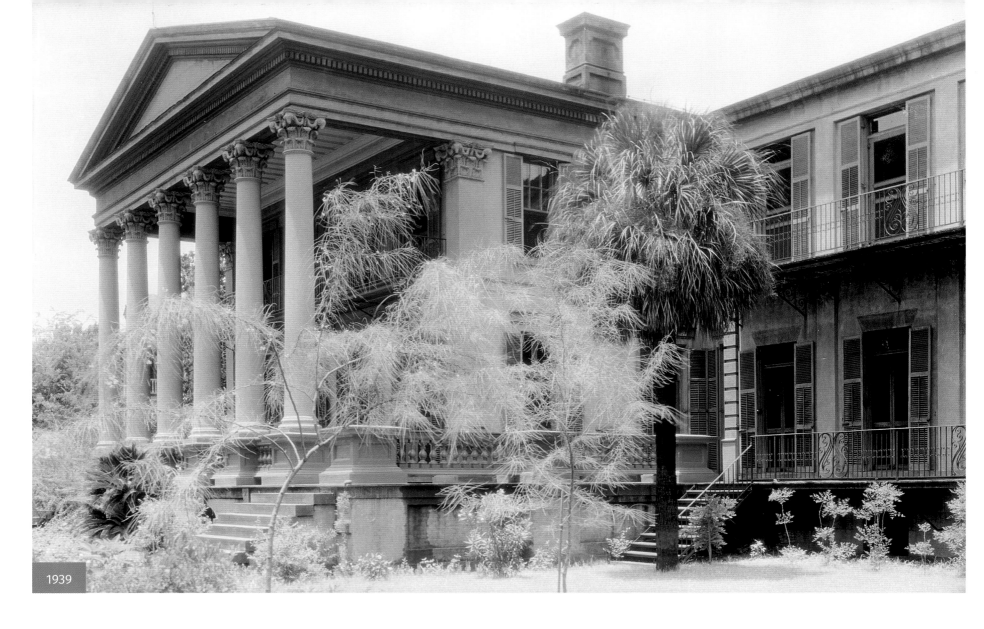

1939

ISAAC JENKINS MIKELL HOUSE, 94 RUTLEDGE AVENUE

Antebellum mansion once a library now a star of reality television

ABOVE: Isaac Jenkins Mikell was one of the most successful sea island cotton planters of the mid-19th century, making millions from his three plantations in the years leading up to the Civil War. Mikell married four times. His third wife, however, was the love of his life, Mary Martha Pope, and it was for Mary Martha that he built this grand Italianate villa, with both Greek and Roman Revival elements, in 1853. Like other planters, Mikell and his family would travel annually by boat from his Edisto Island plantation to their Charleston townhouse for the social season, roughly late January through May, tying up at the docks on what is now Colonial Lake.

Described in 1857 as "one of the most ambitious of the private dwellings of Charleston," Mikell's stuccoed-brick house was distinctive. An imposing two-story portico supported by six Corinthian columns and two pilasters made of hand-carved cypress, with capitals featuring carved rams' heads, dominated its southern façade. Like most Charleston houses, however, its entrance is on the gable end, facing Rutledge Avenue. A sweeping mahogany staircase rises from the foyer to the second floor, and its principal rooms are decorated with antebellum woodwork, black marble mantels, arched doorways, ornate ceiling medallions and elaborate cornices.

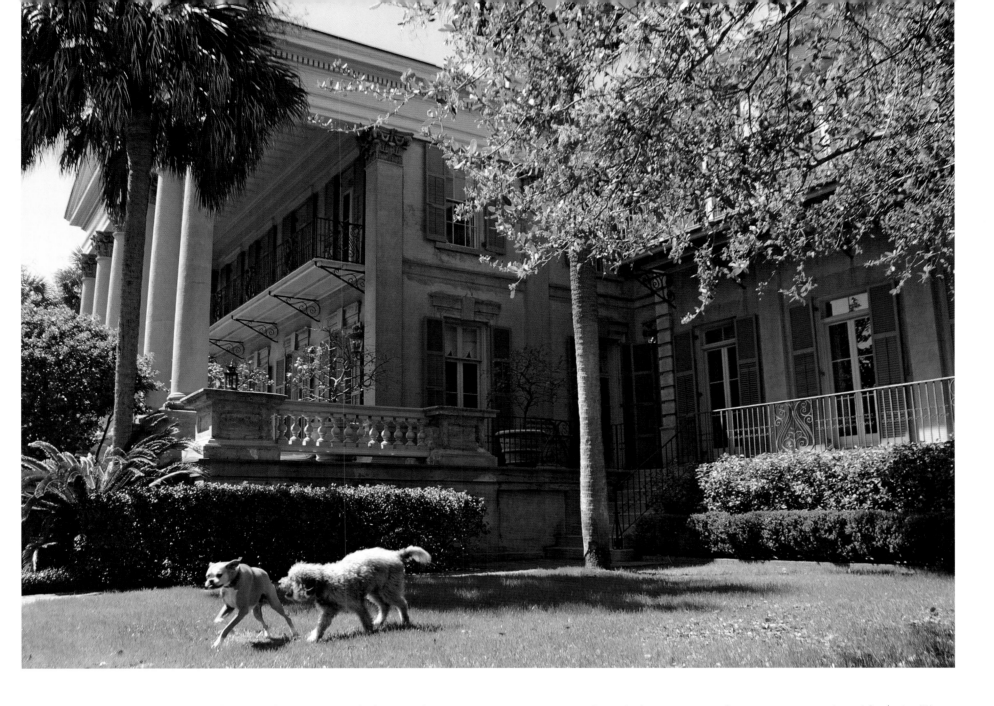

After the war, when Charleston's real estate values were severely depressed, the Mikells sold the house to a local merchant. It passed through several owners, including Mayor John Ficken, until 1935, when it was sold to Charleston County to serve as its library. When the library moved to its new home on Marion Square in 1960, Mr. and Mrs. Charles Woodward, part-time Charleston residents and preservationists, stepped in to restore the grand estate. It was later divided into four apartments. Actors Don Johnson and Melanie Griffith stayed in one while filming *Paradise* in 1991.

ABOVE: In 2008 the 10-bedroom, 9,500 sq. ft. property was purchased for $4.8 million by Patricia Altschul, a Manhattan philanthropist, art collector, and widow of former Goldman Sachs partner Arthur Altschul. Today the house and its garden often appear on the Bravo reality show *Southern Charm*, which Altschul produces and often appears in alongside her son, Whitney Sudler-Smith. Having been carefully restored, the house remains very much as it was when Mikell built it for his true love. It was listed on the National Register of Historic Places in 2014.

c. 1900

GAILLARD-BENNETT HOUSE, 60 MONTAGU STREET

Some of the finest decorative plasterwork found in America

ABOVE: In 1800, rice planter and merchant Theodore Gaillard III built one of Charleston's most distinctive properties, a two-story Adamesque double house over an English basement on a large, high lot with views of the Ashley River and Charleston Harbor. Its T-shaped floor plan had two rooms on either side of a central hallway. Though the same size, they were oriented differently to capture cooling sea breezes and maximize light. The northern rooms were decorated in a comparatively restrained style carved in wood, while the southern rooms and hallway featured some of the most exuberant Adamesque plasterwork in America. A marine-themed mantel in the drawing room included seashells; hallway cornice moldings were decorated with urns, leaves and rosettes; the rectangular ceiling medallion was in a feathered pattern.

U.S. Sen. and Revolutionary War Gen. Jacob Read bought the property in 1815, then sold it to James Shoolbred, Charleston's first British consul, four years later. Shoolbred added the Palladian portico and double stone staircase. In 1851, local mill owner Washington Jefferson Bennett purchased it and probably added the cast iron balconies and wall with iron gates that led to the carriage house. Robert E. Lee gave a speech from Bennett's portico in 1870, one of his last before he died just six months later.

ABOVE: The house changed hands numerous times after that, before a preservation-minded couple purchased it in 2004 and undertook a multimillion-dollar restoration. Missing or damaged plasterwork was recreated using castings of surviving pieces, and doors were regrained in their original *faux bois* finish of mahogany and satinwood inlay. Paint analysis determined original colors, and layers of paint were removed to reveal the original wood and plasterwork. An octagonal plaster panel above the dining room fireplace was rediscovered, as were dramatic black highlights in the ceiling cornices.

A number of exterior changes were also made. The demolition of a neighboring 1960s ranch house restored the original garden's expansive footprint. A two-story kitchen house, *c.* 1852, was renovated as a separate residence with the removal of a poorly constructed 1950s addition and installation of a clay tile roof. The carriage house was converted into a workshop and upstairs apartment. The property now operates on geothermal energy, eliminating exposed wires and utility meters. A pool and pool house were added on the northeast corner. The property sold again in 2018.

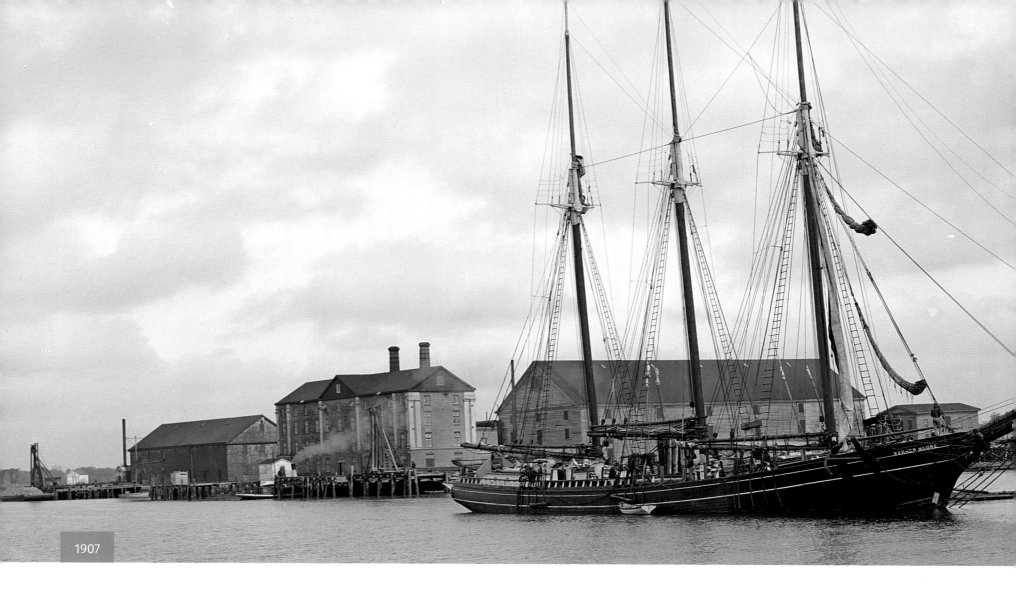

1907

WEST POINT RICE MILL, 17 LOCKWOOD BOULEVARD
Revolutionizing how rice was processed

ABOVE: Carolina Gold Rice, the driving force of Charleston's economy, was laboriously threshed by hand—until 1787 when Jonathan Lucas invented a revolutionary water-powered mill. Fifty years later his grandson, Jonathan Lucas III, built Charleston's largest steam-powered rice mill on a lot owned by his father-in-law, Thomas Bennett Jr. The four-story mill was surrounded by a cooperage, blacksmith's, wharves and other supporting buildings. Soon the Lucas/Bennett family was milling 40 percent of the Lowcountry's rice.

Lucas's son, Thomas Bennett Lucas, bought the mill from his father's estate in 1847. Following his own death in 1858, the family sold it to a group of investors known as the West Point Rice Mill Company. It was a prosperous but short-lived venture, as weeks before South Carolina seceded from the Union, a fire destroyed the mill and its ancillary buildings. Fortunately, the company was insured and, despite the

RIGHT: Work began to rehabilitate the West Point Rice Mill in 1937.

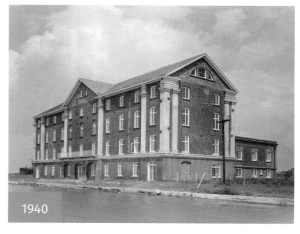

1940

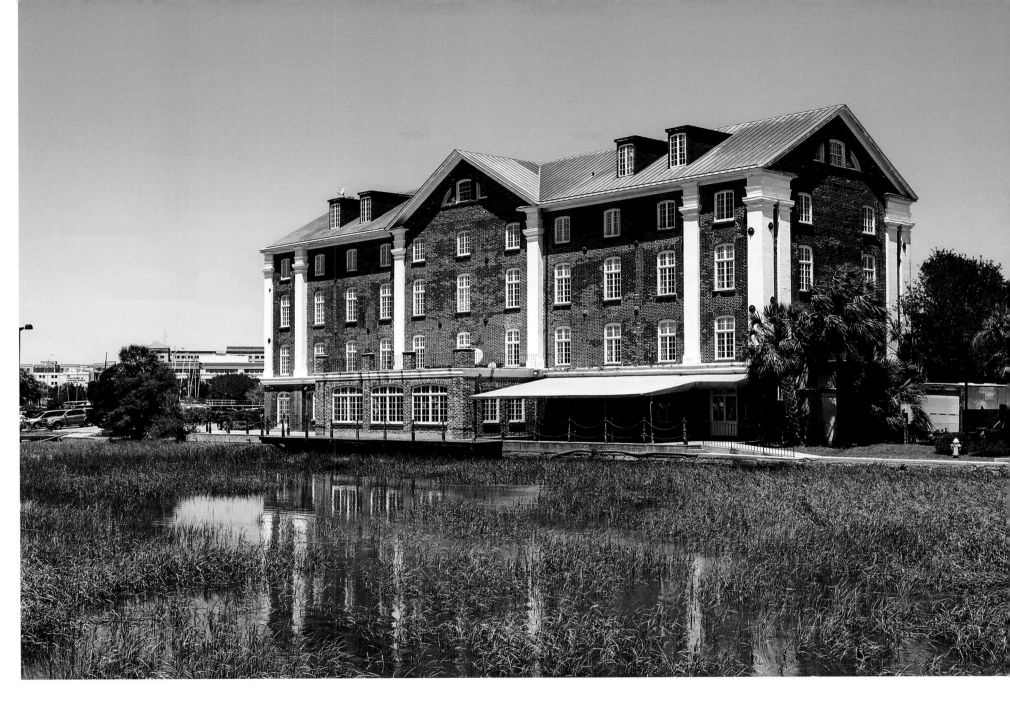

challenges of a Union blockade, they rebuilt a new Greek Revival mill, completed in 1863 with corner Doric pilasters and a Palladian window on its eastern façade.

The 1886 earthquake damaged the mill's brickwork, and a 1911 hurricane effectively ended what little was left of the Lowcountry's rice industry. By 1920 the mill had closed and its machinery sold to the Henry Ford Museum in Michigan. The city purchased the 43-acre property in 1926. It briefly served as a warehouse before being renovated in 1937 to become a seaplane terminal, though that venture failed.

ABOVE: After serving as offices for the Civilian Conservation Corps, U.S. Navy, Army Corps of Engineers, and Trident Chamber of Commerce among others, by 1986 the building sat vacant again. It suffered damage from both a fire and Hurricane Hugo in 1989, after which it was leased to a private development firm who completed a $3 million rehabilitation with a first-floor restaurant and offices above. Though its dependencies are long gone, the mill continues to serve as offices for the development firm that rehabbed it. The city's Parks Department maintains the building.

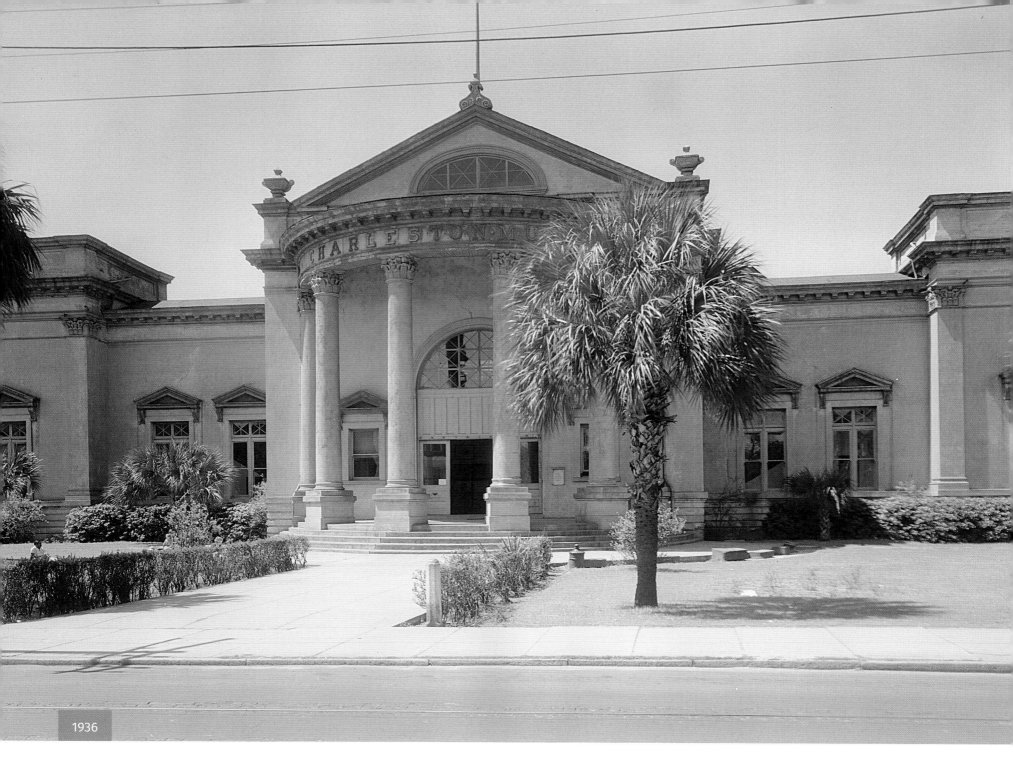

1936

THOMSON AUDITORIUM, 121 RUTLEDGE AVENUE

Where generations of kids learned about the world

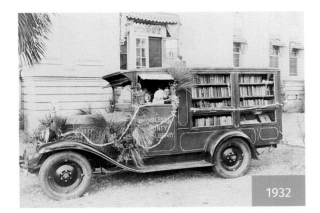

1932

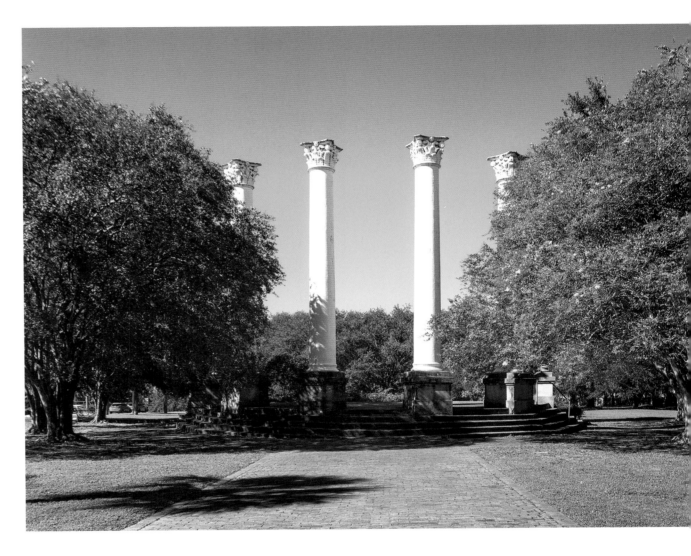

LEFT: Confederate reunions had become big events throughout the South in the final decades of the 19th century, drawing crowds of 40,000 to 50,000 people. Much like today's Olympics, cities competed vigorously for the opportunity to host these reunions, which Charleston did, using $30,000 donated to the city by the estate of John Thomson to build a reunion hall. Working under tight deadlines, architect Frank Pierce Milburn built the nearly 8,000-seat hall in just 90 days as a temporary structure using a cast iron frame, exterior stucco and Beaux Arts details. Despite its structural shortcomings, it looked impressive.

The city hoped the hall might lure future conventions, though few groups needed a venue that large. It served briefly as a theater and temporary location for the City Hospital. In 1907, the city rented it to the Charleston Museum, which would stay for the next 74 years. Generations of children discovered much about the world at the Charleston Museum, entering the hall underneath the awesome 60-foot skeleton of a misguided right whale captured in Charleston Harbor in 1880. There were also shrunken heads from Africa, an Egyptian mummy excavated in the 19th century, dusty taxidermied remains of exotic animals, and ornithologist Arthur T. Wayne's expansive bird collection.

Yet Thomson Auditorium was not built to be a permanent structure, which explains why, by the 1970s,

ABOVE: Charleston's first bookmobile, a 1931 Chevrolet pickup truck modified to hold 300 books and with doors to prevent fallen items.

the un-airconditioned building was showing serious signs of deterioration. Its collections were duly moved to a new museum at 360 Meeting Street.

Though Charleston is known for preserving old buildings, City Council agreed with experts that Thomson Auditorium was a fire hazard—and they were right. On October 18, 1981, the auditorium went up in flames that could be seen for miles, though nothing more was lost than some old paperwork and outdated office furniture. A cause was never determined.

ABOVE: Only the four Corinthian columns of Thomson Auditorium's portico remain on what has once again become a public park, modeled after a design created by Frederick Law Olmsted in 1894. Plans for the park had been put on hold when the auditorium was built. With 2.7 acres, Cannon Park has walking paths and a playground, but is perhaps most often used by dogs catching frisbees.

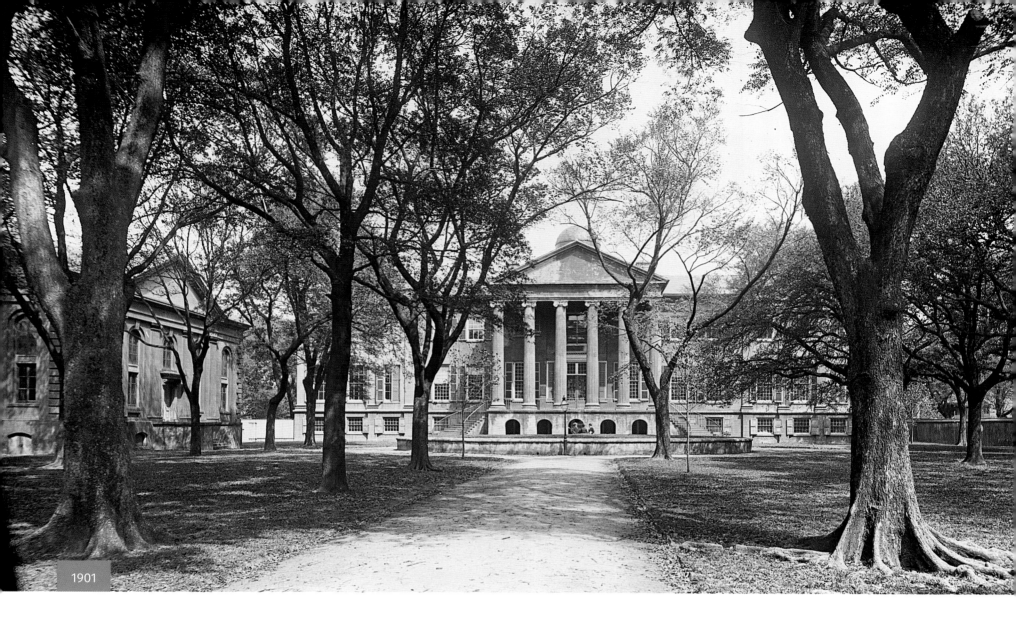

1901

COLLEGE OF CHARLESTON CISTERN YARD, 66 GEORGE STREET

The heart of America's oldest municipal college

ABOVE: British military barracks occupied this site when, in 1770, Lt. Gov. William Bull called for the creation of a provincial college, America's 13th oldest institution of higher education. Among its founders were three signers of the Declaration of Independence, three framers of the U.S. Constitution, five of America's first foreign diplomats, and an inaugural justice of the U.S. Supreme Court.

From 1790 until 1829, classes met in the barracks until Main Building, later renamed Harrison Randolph Hall, was completed. A 30-foot oval cistern was dug south of Main Building in 1857 to catch rainwater runoff from its roof, control flooding in its basement, and provide drinking water. Nine feet deep with a 40,000-gallon capacity, the cistern consisted of four underground brick vaults topped by a stuccoed ellipse.

Before an 1850 renovation of Main Building, reorienting its northern entrance to the south, the yard served as a workspace where the college sexton grazed his livestock. It also held privies and a fire house. The mess and smells were among factors that led to the city's takeover in 1837, making it America's first municipal college.

The College was evacuated during the Civil War as Union shells rained down. Only the sexton stayed to protect the campus when Charleston fell to Federal troops.

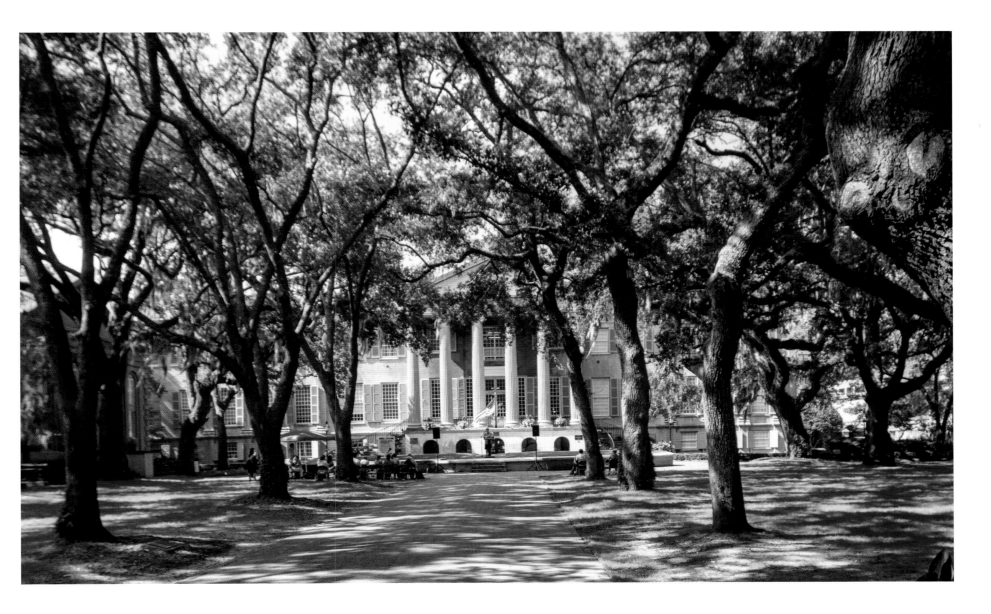

ABOVE: Despite the 1886 earthquake destroying both wings of Main Building and 1989's Hurricane Hugo toppling its centuries-old oak trees like Lincoln logs, after more than 250 years Cistern Yard continues to be the heart of the College of Charleston. A green space for generations of students and a venue for graduations, cultural events, protests, and occasional movie shoots, here lifelong friends have met, freshmen been "initiated," couples fallen in love, dignitaries spoken, artists performed, and futures begun. Since 1933, spring graduation has taken place on the Cistern, one of the College's most treasured traditions. It is one of only a few colleges whose graduates wear formal attire—dinner jackets with boutonnieres and white dresses with bouquets—rather than academic regalia. According to long-time Alumni Director Karen Jones, only a few incidents of inclement weather and the polio outbreak of 1939 have interrupted graduates' walk across the Cistern to receive their diplomas. Since 2017, the College has sponsored a December holiday light show on Cistern Yard, with thousands of cascading lights twinkling from among the oaks.

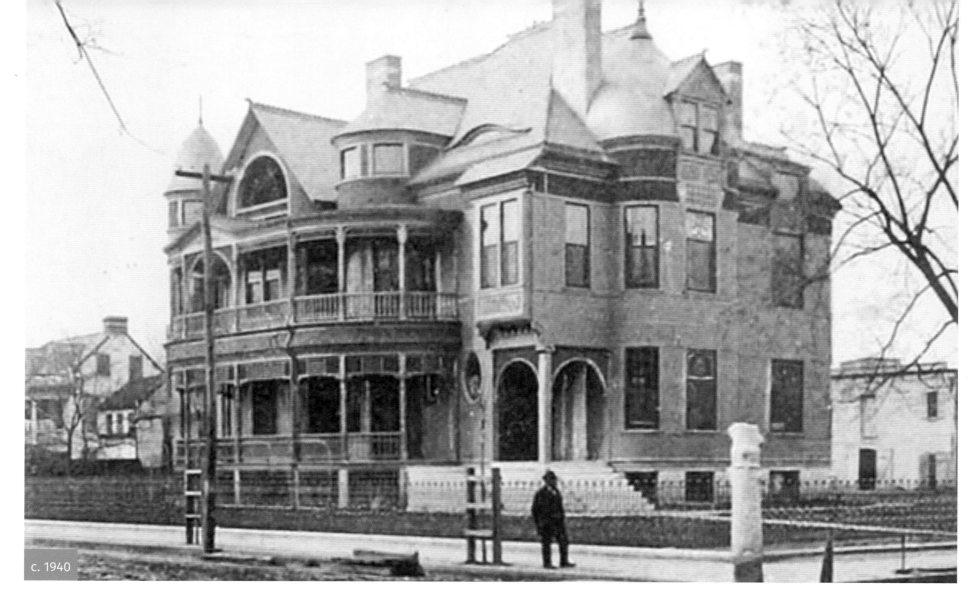

c. 1940

WILSON-SOTTILE HOUSE, 11 COLLEGE STREET

Possibly the most beautiful dormitory in the United States

ABOVE: Samuel Wilson, a prominent banker and tea merchant in the grim years after the Civil War, brought a rare remembrance of gentility and beauty to the ruined city when he built his Queen Anne residence at the corner of Green Way and College Street in 1890.

Among Wilson's commercial successes was the Charleston Teapot, which opened in 1873 on King Street, selling high-grade black and green teas, and later coffee roasted onsite to entice his customers in.

Thus, the savvy entrepreneur generated the wealth needed to build one of Charleston's finest examples of Victorian architecture, with multiple shapes and textures including a delicate yellow clapboard façade with circular turrets, fish-scale shingles, a two-story wrap-around veranda with turned columns and jigsaw-cut trim, and heavy, distinctively carved oak doors.

In 1912, Albert Sottile, founding president of the Pastime Amusement Company, bought the house.

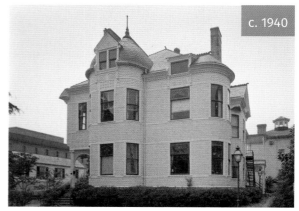

c. 1940

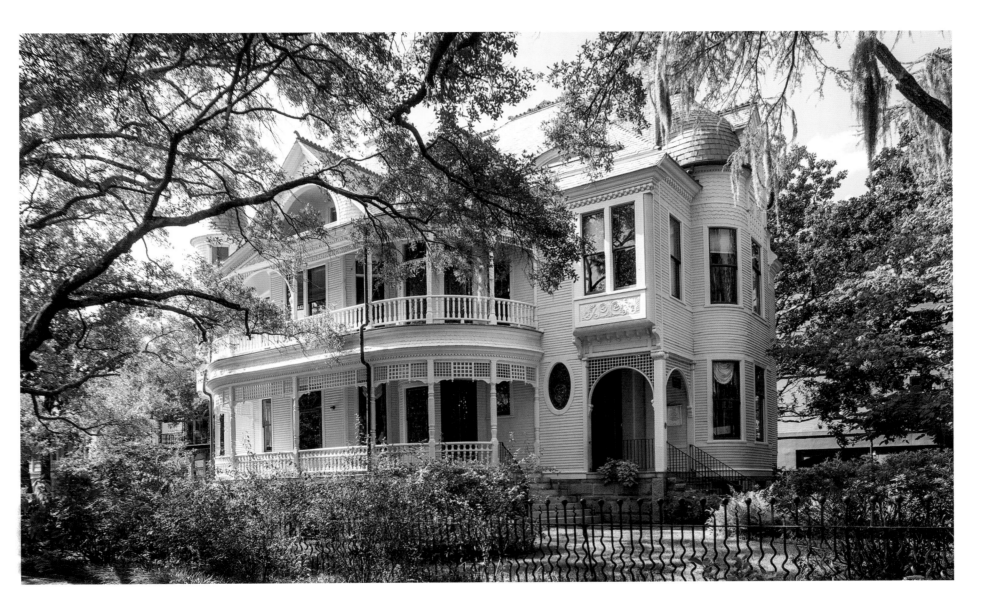

Sottile developed the nearby Garden Theatre, Gloria Theater, and the Riviera on King Street, the Arcade on Liberty Street, and the Victory on Society Street. Sottile's family would live here for the next 52 years. Four years after his death in 1960, they sold the residence to the College of Charleston, and from 1964 through the 1980s, Sottile House served as what may have been the most beautiful college women's residence hall in America, with stained-glass Tiffany windows, marble mantels, gold-leaf moldings, built-in mahogany cabinets, crystal chandeliers, and manicured gardens.

ABOVE: Today, the College houses its institutional advancement offices in Sottile House, where one can appreciate how the dramatic mahogany-paneled stair hall, elaborately fretted woodwork above the doorways, antique lighting fixtures, and tile entryway might put alumni in the mood to consider a donation. Each room, now an office, has a unique shape and size.

OPPOSITE: Albert Sottile, Charleston's great entertainer, understood the value of visual delights.

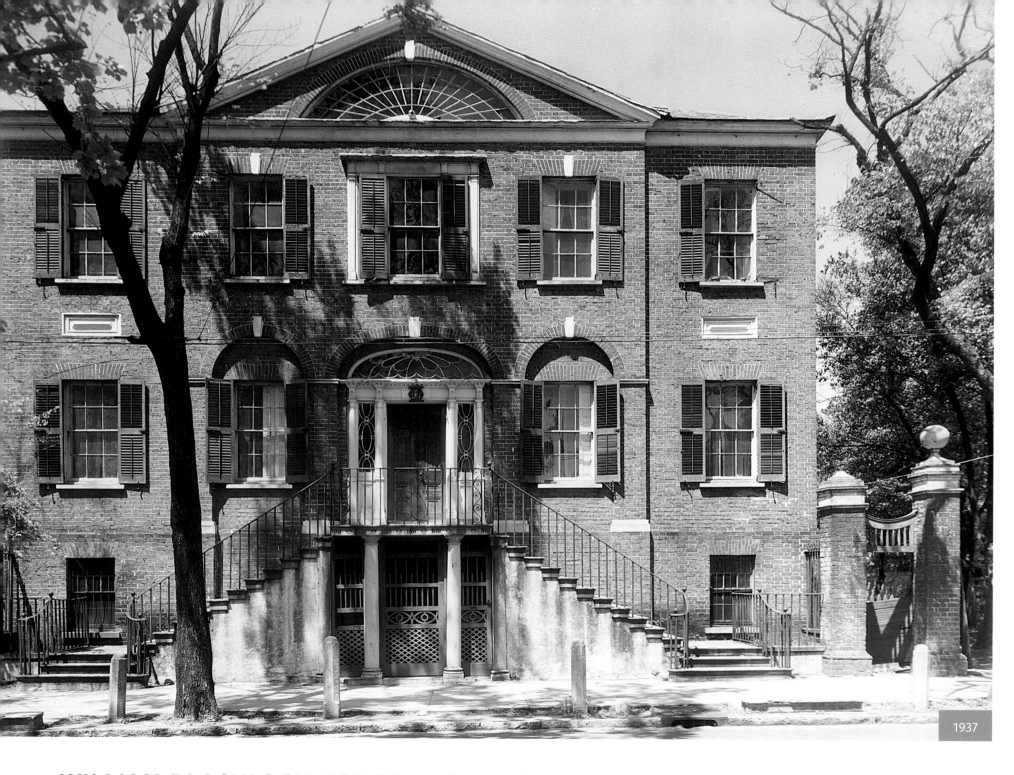

1937

WILLIAM BLACKLOCK HOUSE, 18 BULL STREET

One of America's most important Adamesque houses

One critic called it "violative of every principle of historic Charleston architecture." Nevertheless, both the police station and the Citadel's wing were demolished in 1959 to make room for a new two-story library with pink marble veneering and aluminum trim. Though it served as the county's main library until 1998, few Charlestonians ever considered its design anything more than distasteful.

After the library moved in 1998, the vacated building deteriorated quietly but surely for 15 years. *Post and Courier* reporter Robert Behre wrote: "Widely loathed, the old library's most luxurious feature—pink marble siding—became obscured by a black ooze seeping from the aluminum windows. It looks like the Blob is working away on the inside."

ABOVE: In 1994, the library was sold to a private developer who built a nine-story hotel there in 2013. Though there was debate regarding the hotel's height, few voices were raised in support of preserving the Modernist library. Even fewer appreciated that even as its disdained architectural style was being lost, so too was the story it told of making Charleston's public facilities more accessible to all.

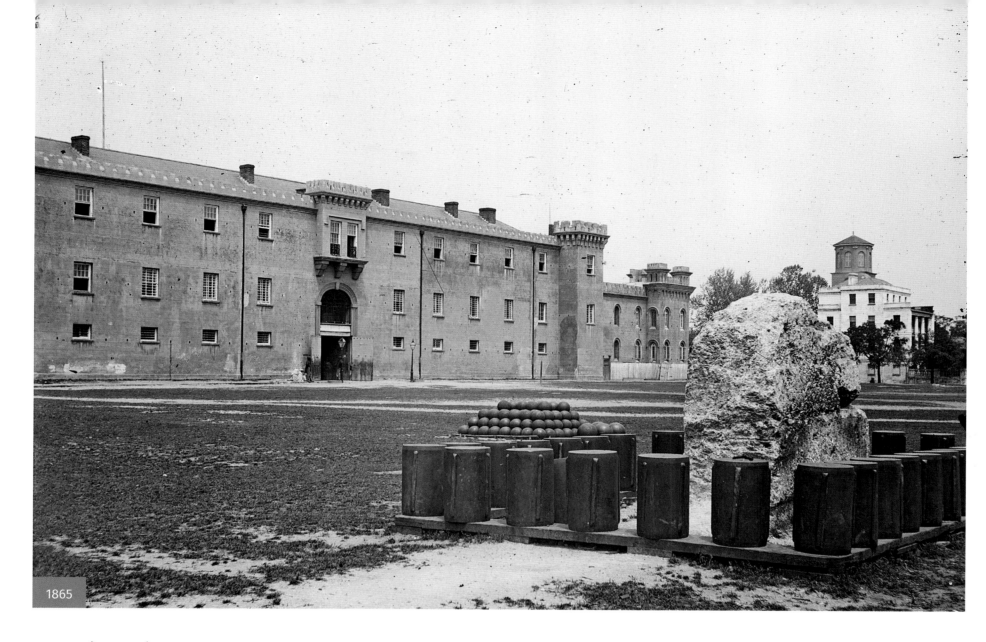

1865

THE (OLD) CITADEL, MARION SQUARE

Institution that played a key role in the Civil War now welcomes visitors

ABOVE: As the city grew in the years following the American Revolution, it established an auxiliary guard to maintain the peace. To house the officers, the city built a guard house northwest of Meeting Street's intersection with Tobacco Street in 1806. In the aftermath of the 1822 Denmark Vesey slave insurrection charges, the state legislature passed "An Act to Establish a Competent Force to Act as a Municipal Guard for the Protection of the City of Charleston and Vicinity." In 1829, architect Frederick Wesner replaced the first arsenal with a two-story brick structure surrounding an interior

courtyard with a wooden parapet. Its interior was distinguished by large archways on both floors. Because of its castle-like appearance, people began calling it The Citadel.

Initially the arsenal was guarded by federal troops; however, state troops replaced them as tensions rose during the Nullification Crisis of 1832. A decade later, Gov. John P. Richardson proposed converting the arsenal into part of a new S.C. Military Academy, with campuses in both Columbia and Charleston. Beginning in 1845, freshmen attended the Columbia arsenal, before transferring to the Citadel for the last three

ABOVE: Located in the heart of Upper King Street's entertainment district, the Charleston Music Hall is among the city's hottest venues. Alive with excitement once again, the hall has hosted such acts as David Byrne, Joan Baez, and comedian Dave Chappelle. Ricky Skaggs recorded his Grammy-winning song "Simple Life" on the band's *Live at the Charleston Music Hall* album in 2002. With 965 seats, the hall also stages local performance companies and can be rented for corporate events.

c. 1920

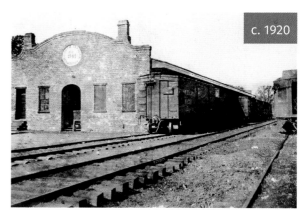

c. 1920

RIGHT: The National Trust for Historic Preservation listed the warehouse as part of the William Aiken House and Associated Railroad Structures in 1963, noting that these buildings constitute the best extant collection of antebellum structures interpreting development of America's earliest railroad facilities. In 1991, before Upper King Street was revitalized as an entertainment district, the warehouse was purchased and rehabilitated by musician Kevin Wadley as a live music venue. Since then it has become a staple of the city's nightlife scene along the Upper King Street corridor. The Charleston School of Law's library occupies its northern end.

S.C. RAILROAD WAREHOUSE, 32 ANN STREET

From railroad warehouse to music venue

ABOVE: Because Charleston's elite eschewed the noise, fumes and "unpleasantness" of steam engines in the city, the railroad initially terminated at Line Street. From there, cotton was loaded onto a cart and driven the last mile and a half to the port. It was a losing proposition and, in the 1840s, a new railroad complex was developed at this location. The S.C. Railroad Warehouse featured a platform along its eastern façade. The building's barrel-vaulted roof is supported by Howe arch trusses, an innovative engineering technique and one of the oldest surviving examples of its kind in America. Its Ann Street façade is five bays wide with simple brick pilasters, surmounted by an arched pediment with a decorative round window.

Unfortunately, six months later *The Best Friend of Charleston*, America's first regular steam locomotive, also became the first to explode when a fireman, annoyed by the whistle of escaping steam, tied down a safety valve. The railroad went bankrupt after the Civil War and the earthquake of 1886, and in 1894, the U.S. Circuit Court declared the railroad company defunct. Its assets were auctioned. Though the warehouse continued to be used for storage, time and neglect took its toll.

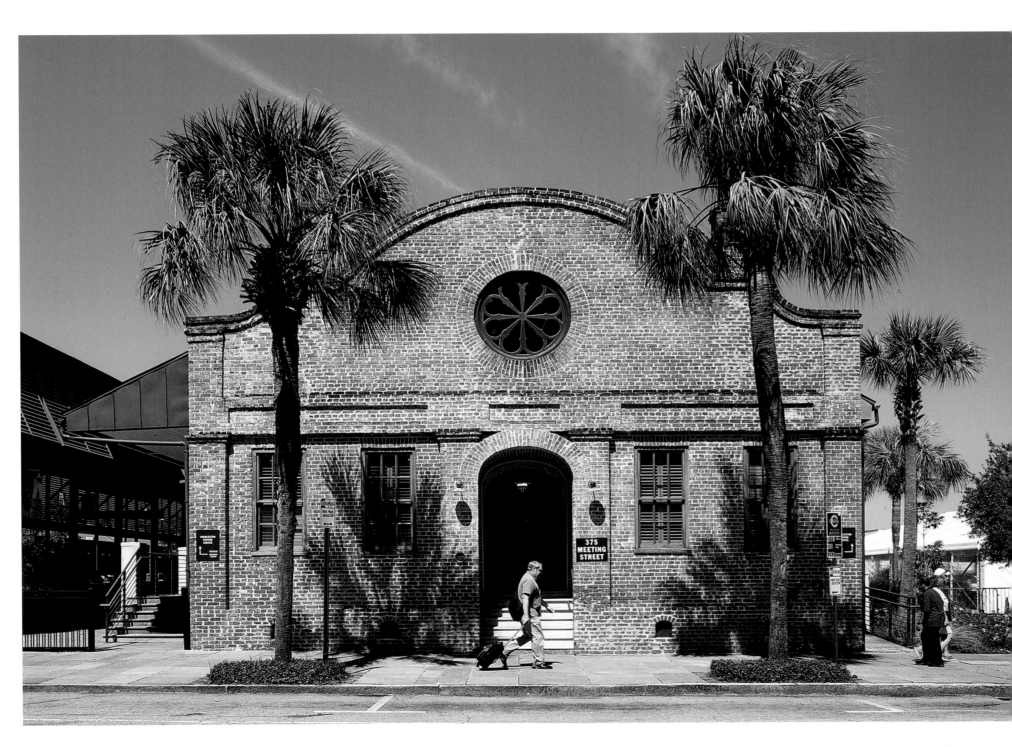

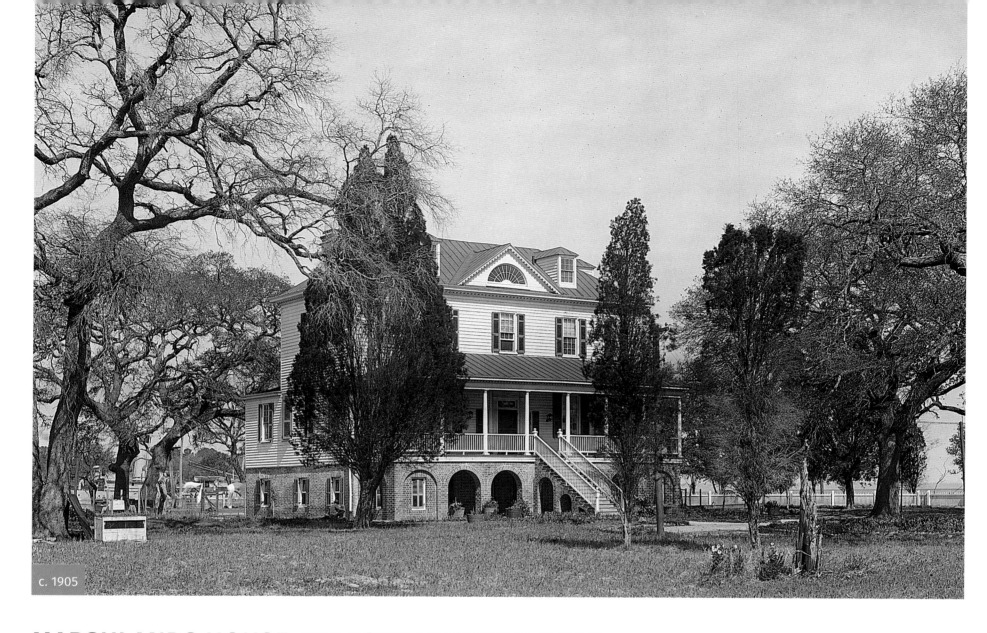

c. 1905

MARSHLANDS HOUSE, 331 FORT JOHNSON ROAD
Redefining the mobile home

ABOVE: Charleston's rice industry was at its peak in 1810 when John Ball built Marshlands House on his Chicora Plantation, 822 acres along the Cooper River about six miles above the city. An excellent example of a Federal-style plantation house, the two-and-a-half story clapboard residence had a single-house floor plan and unusually high brick basement, reflecting the prominence and wealth of its owner. Its interior detailing featured fine wood gouge work and Adamesque ornamentation. In fact, First Lady Grace Coolidge used photographs of its interiors when remodeling the White House in 1925. A "chambermaid's stair," or secret passageway, provided escape in times of danger.

The property changed ownership several times, including by members of the Heyward, Wragg and Manigault families. During the Civil War, it became headquarters for the U.S. Sanitary Commission. Its last private owner was Cecilia Lawton, a successful businesswoman who operated a dairy and bought the Mills House Hotel after the Civil War. After that, the house was better known as Lawton Mansion. Mrs. Lawton sold the property in 1901 to the U.S. Government for development of the Charleston Naval Shipyard. Marshlands House served as officers' quarters and administrative offices for the next six decades, as the military's industrial complex grew up all around it.

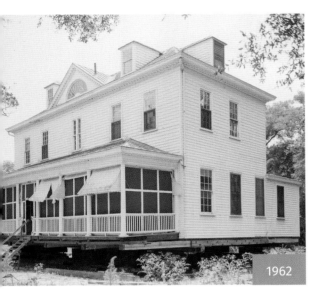

1962

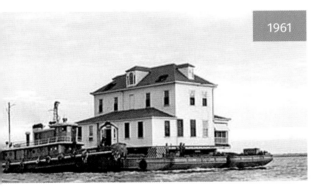

1961

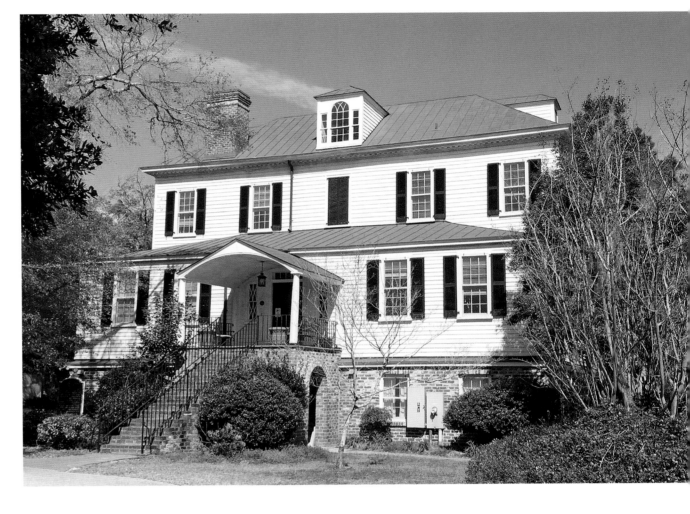

TOP: Marshlands House elegantly dominated Chicora Plantation on the banks of the Cooper River, until it was dwarfed by the Navy's military/industrial complex in the 20th century.

ABOVE: When the Navy's plan to demolish Marshlands House was announced in 1961, Dr. G.D. Grice led efforts to load it onto a barge for relocation at Fort Johnson.

The mansion soon seemed very much out of place and scale, however, and in 1961 the Navy announced plans to demolish it to make way for a new dry dock.

A coalition of preservation groups, including private foundations, the City, College of Charleston, and Medical University of South Carolina, collaborated to save the house. Removing its brick foundation and chimneys, the mansion was lifted onto a barge and floated seven miles downriver to Fort Johnson on James Island. Given its superior post-and-beam construction with pegged mortise and tenon joinery, the house made the trip with no structural problems.

ABOVE: Restorers rebuilt the house's foundation and chimneys, repairing its roof and siding and reversing modifications to the piazza. Other than its relocation, Marshlands House remains basically unaltered from John Ball's day. Added to the National Register of Historic Places in 1973, today it serves as offices for the Hollings Marine Laboratory, a state/federal partnership and part of the S.C. Department of Natural Resources which is headquartered at Fort Johnson.

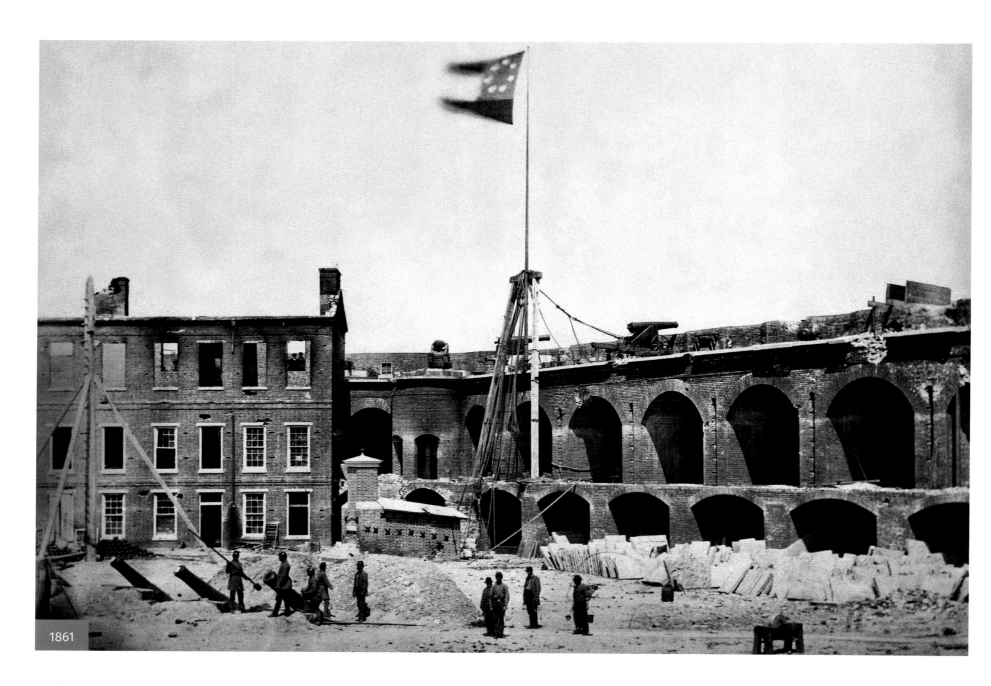

1861

FORT SUMTER, CHARLESTON HARBOR
Where the American Civil War began

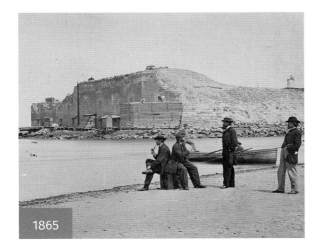

1865

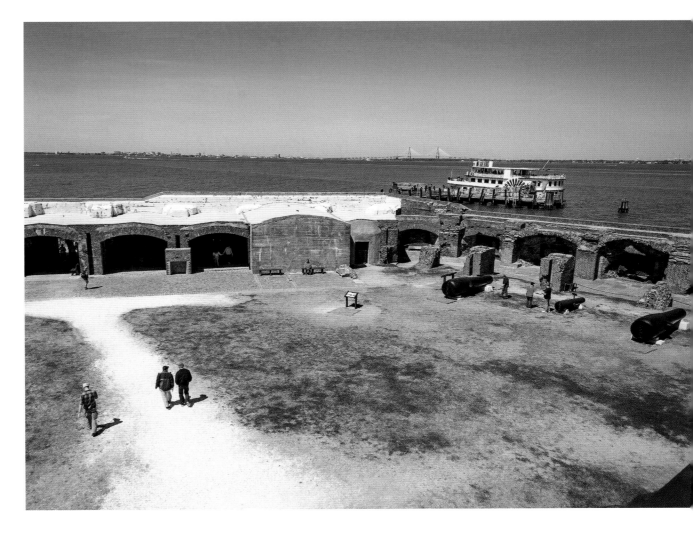

LEFT: After the War of 1812, officials reinforced America's harbor defenses by building heavy masonry forts with high walls. Charleston's new fort was sited a mile west of Fort Moultrie on Sullivan's Island. Though merely a sandbar, a fort here would dominate the harbor.

Beginning in 1829, nearly 70,000 tons of stone were used to create a 2.5-acre man-made island. By late 1860 the fort's exterior was completed. Named for Revolutionary War Gen. Thomas Sumter, the pentagon-shaped fort was 170–190 feet long with five-foot thick walls rising 50 feet above the low water mark. Designed to hold 650 troops and 135 cannon aligned in three tiers, its interior remained unfinished. On December 20, 1860, South Carolina seceded from the Union. Gov. Francis Pickens wrote to Washington, claiming possession of all federal property within the state. Feeling his position at Fort Moultrie was tenuous, Maj. Robert Anderson moved his Federal troops to Fort Sumter during the moonless night of December 26.

Gen. P.G.T. Beauregard demanded that Anderson surrender. Anderson would not. In the early morning of April 12, 1861, the state militia fired upon the fort. For 34 hours volleys were traded. Anderson surrendered on April 14 and Pvt. John S. Bird Jr. of the Palmetto Guards raised his unit's flag over the captured fort.

ABOVE: By the end of the Civil War, Fort Sumter was nearly destroyed, despite protecting Charleston's harbor until the city's fall.

Anderson struck the U.S. colors, taking the flag with him as he returned with his troops to New York, where they were honored with a parade on Broadway. No one was killed on either side during the fighting.

Though shelled for 437 days with 7 million pounds of ordnance during the war, Sumter remained a critical frontline position in Charleston's defense until the city fell, by land, on February 18, 1865. On April 14, four years to the day he took it down, Maj. Anderson raised the flag he had taken home with him. President Lincoln was shot that evening.

ABOVE: Efforts to rebuild the fort amounted to little, though it briefly served as a lighthouse station. Air raid stations were established there during both World Wars. In 1948, the fort was transferred from the War Department to the National Park Service and designated a National Monument. Accessible only by boat, today Fort Sumter is among Charleston's most popular tourist sites. Anderson's flag is displayed in its interpretive center.

c. 1920

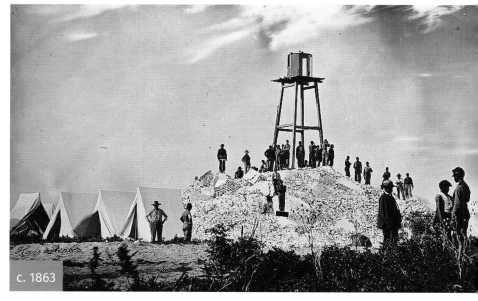

c. 1863

MORRIS ISLAND LIGHTHOUSE
Site of one of the bloodiest battles of the Civil War

LEFT: Three years after their arrival in 1670, colonists built their first navigational signal on a small island south of Charles Town's harbor. By 1767, John Morris had cultivated a thriving farm with crops and livestock there as well. In 1838 a second lighthouse was built and 15 supporting structures later added for the lighthouse keeper and his family, including a large residence called Beacon House.

Morris Island became a key strategic position during the Civil War: Fort Sumter controlled access to Charleston, and Morris Island controlled access to Fort Sumter. In July 1863, 650 members of one of the first African-American regiments to bear arms in the U.S. Army attacked one of the island's Confederate batteries, but were defeated. One of the bloodiest battles of the war, the entangled bodies of black and white soldiers lay three deep. Beacon House, used as military headquarters, was shelled by both sides.

A new lighthouse was built in 1876. Soon after, jetties were added at Charleston Harbor's entrance to deepen its shipping channels, but these altered the natural migration of sand to Sullivan's and Morris islands, and both began to erode. Congress appropriated funds to build wings on the jetties to help protect the islands. The northern wing was completed, and Sullivan's Island saved. The southern wing, however, was not and Morris Island continued to wash away.

ABOVE: Confederates evacuated Batteries Wagner and Gregg on Morris Island in September 1863, after which Federal troops occupied the works to fire on Fort Sumter.

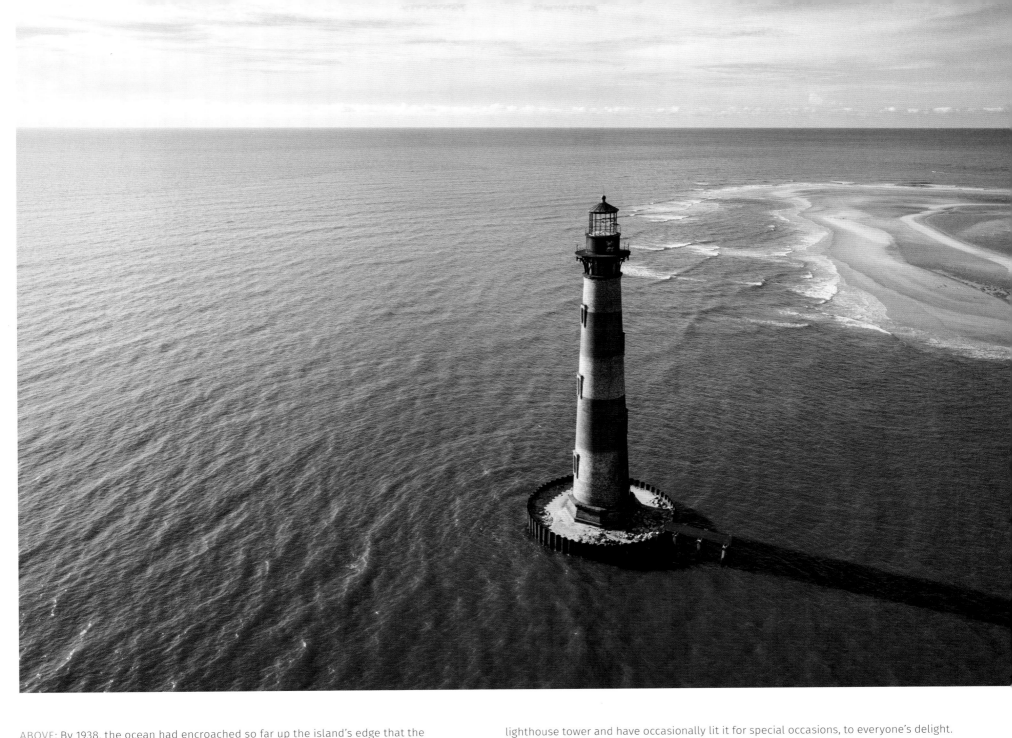

ABOVE: By 1938, the ocean had encroached so far up the island's edge that the lighthouse was automated and other buildings demolished so their debris would not endanger mariners. Beacon House was sold to Dr. Richard Prentiss for $55 for deconstruction. Dr. Prentiss used most of the salvaged material from Beacon House to build two houses on Edisto Beach, which were washed out to sea in later storms. A group called Friends of the Lighthouse have worked diligently to stabilize the defunct lighthouse tower and have occasionally lit it for special occasions, to everyone's delight.

Occasionally a uniform button, belt buckle or dangerously unexploded piece of ordnance washes up along Charleston's beaches. Other than such surprises, only the lighthouse remains of Morris Island, where thousands died during the Civil War. Not even their graves escaped the encroaching ocean. The island all but disappears during high tides, a victim of man's interference with nature's coastal dynamics.

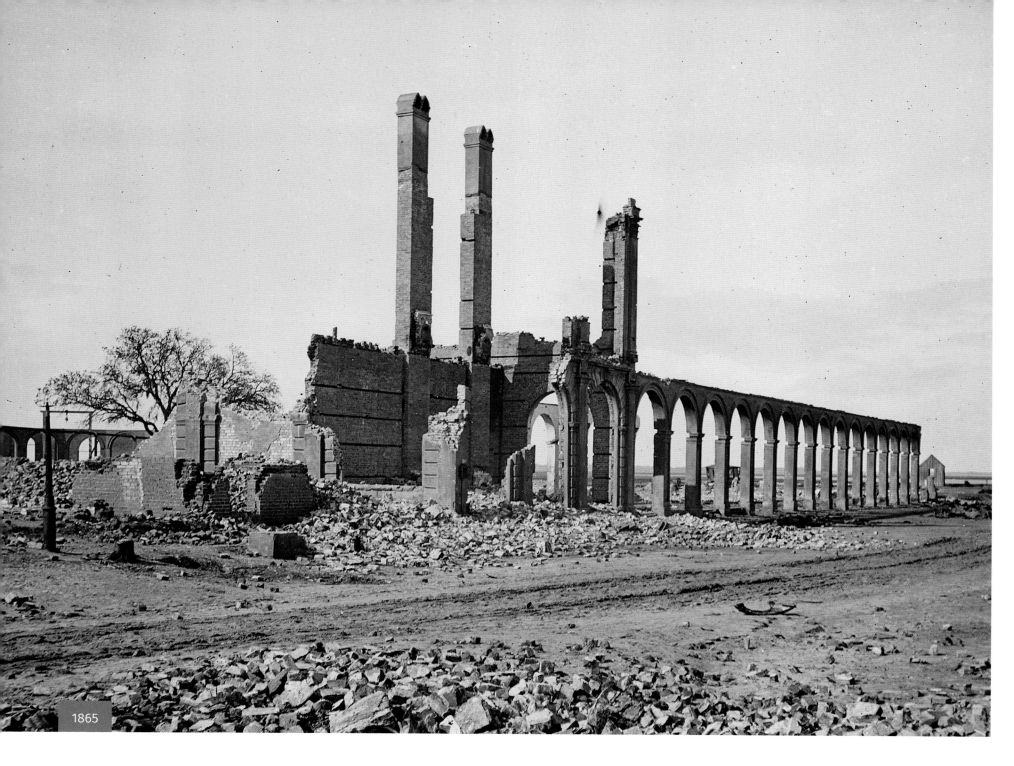

1865

NORTHEASTERN RAILROAD'S WILMINGTON DEPOT
More Charlestonians killed in a moment than in four years of bombardment

LEFT: As he marched from Savannah to Columbia, Union Gen. William Tecumseh Sherman cut two of the state's three railroad lines, leaving the Northeastern line out of Charleston as the only option for a Confederate retreat. Believing that saving troops to fight another day was more critical than saving a city that now seemed undefendable, Gen. P.G.T. Beauregard ordered an immediate evacuation of remaining Confederate troops. The order specified that the Confederates were to leave nothing behind that could aid the enemy when the city fell. Ships were scuttled, ordnance destroyed, and warehouses full of supplies and cotton torched. The Ashley River bridge was set on fire, flames racing out of control on the city's northwestern edge as troops moved remaining supplies to the Wilmington Depot on the city's east side for evacuation. Between 8 and 9 a.m. on February 18, 1865, the last train pulled out, loaded with all the soldiers and ammunition it could hold. As it left the station, starving women and children dodged piles of burning debris to reach the depot, desperately hoping to find food or supplies left behind. They did not know an inner room still held 200 kegs of gunpowder.

Lt. Moses Lipscomb Wood, 15th S.C. Volunteer Infantry Regiment, was on one of the train's last cars looking back at the depot. He explained: "I ... was put in charge of a detail of about 75 men to load what cars we could ahead of us. We had not been out of the depot long before the women and children rushed in to see what they could get. The depot was filled with powder and explosives and caught on fire and was blown up—causing the most pitiful sight I saw during the war. Women and children, about 250, were killed and wounded, and some were carried out ... with their clothing burned off and badly mutilated." The site was obliterated. Only the tracks and rubble remained.

ABOVE: The Northeastern's train tracks were absorbed into the S.C. Ports Authority's purchase of its Union Pier industrial area in 1958. A strip along East Bay Street was developed for commercial use, including a small row of offices, a bank and gas station. Developers designed the buildings using a train station motif, though few who pass by daily are aware that one of the deadliest events in Charleston's history occurred here.

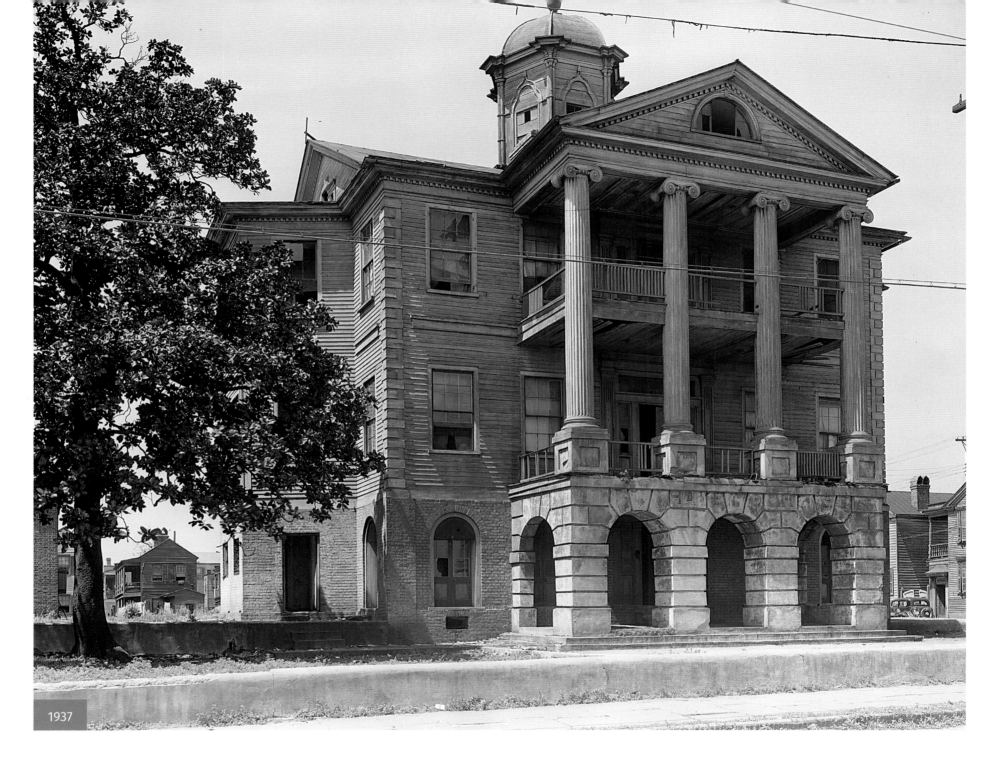

1937

FABER-WARD HOUSE, 635 EAST BAY STREET

Chronicling the history of Charleston's East Side

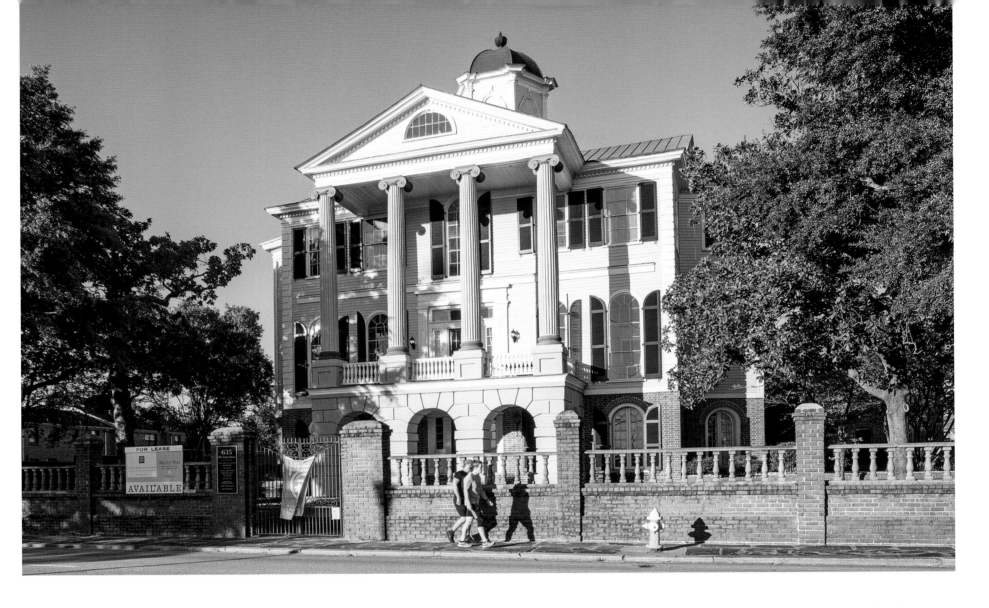

LEFT: Perhaps the best example of Palladian architecture in downtown Charleston, the Faber-Ward House exemplifies the shifting fortunes and social history of Charleston's East Side. Rice planter Henry F. Faber began building his three-story townhouse in 1836, with a grand two-story portico featuring four Ionic columns above a high ground floor with arched openings. Faber succumbed to typhus in 1839, asking his brother Joseph to complete its construction. The house continued as a residence of the planter class throughout the 19th century, including for the widow of Joshua John Ward, the largest slaveholder of his day. Meanwhile, Charleston's East Side became more industrialized. The Railroad continued down the waterfront and the Cigar Factory and other businesses were developed nearby. The Southern Express railroad bought the house in 1907, dividing it into apartments for middle-class workers.

As the 20th century progressed, African Americans began traveling more frequently, though were not welcomed in many whites-only hotels. From 1922 to 1932 the Faber-Ward House became the Hametic Hotel, one of the Green Book properties that welcomed black travelers in the pre-Civil Rights era. When the hotel's owner went bankrupt, its property was forfeited to the city and again converted to apartments. The house had fallen into slum conditions by the 1960s. When threatened with demolition, Historic Charleston Foundation purchased it in 1964 but did little with it. In 1971, U.S. Congressman Arthur Ravenel Jr. bought the house with promises of restoring it to its former grandeur, converting it and its outbuildings into offices and several nice apartments. By the late 1980s, however, the house had again fallen into disrepair.

ABOVE: In the 1990s, Ravenel began renting office spaces in the Faber-Ward House, listed on the National Register of Historic Places in 2019. In 2022 the house underwent a major exterior restoration. Its interior continues to house various business offices.

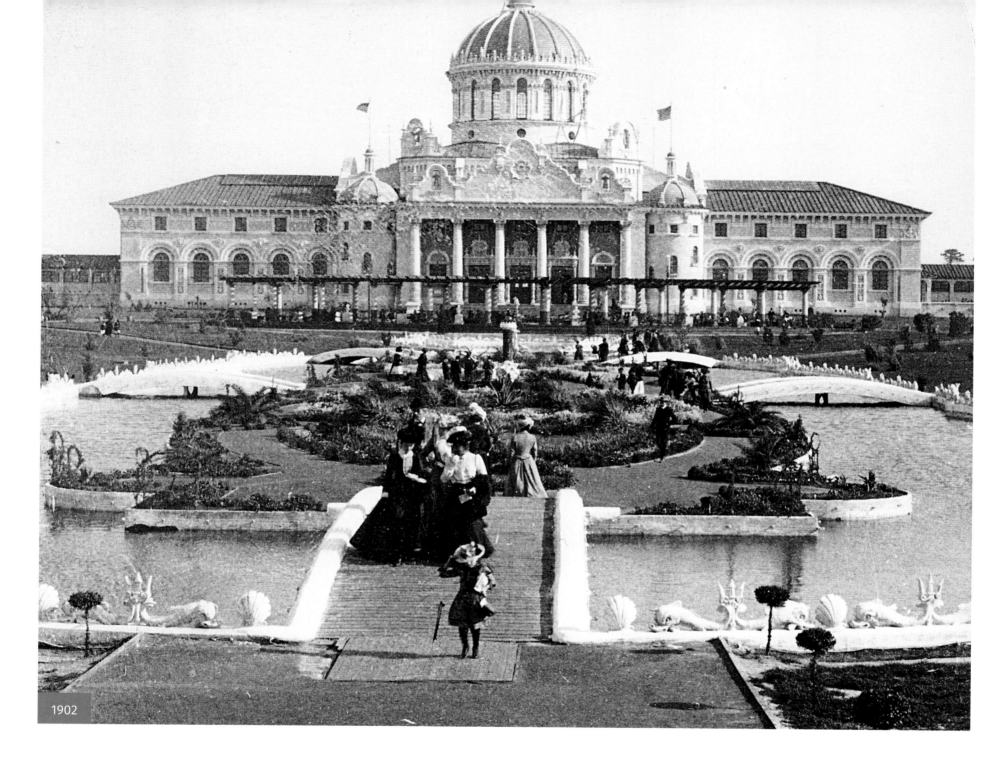

1902

HAMPTON PARK

Pleasure garden, siege camp, dueling site, racetrack, POW camp, and Ivory City

LEFT: Hampton Park is a case study of historical contrasts: the site of not only garden strolls and family picnics, but also of war, death and inhumanity.

In 1770 John Gibbes established Orange Grove Plantation here with a magnificent garden featuring exotic plants such as the pineapple. Unfortunately, the British destroyed all of it in 1780 when it became their base camp during the Siege of Charleston. After Gibbes' death, part of the plantation was sold to the South Carolina Jockey Club, which built its Washington Race Course here. The club's annual Race Week, held each February, was the pinnacle of Charleston's antebellum social season. Located outside the city's boundaries, it was also a good site for dueling. In the absence of such exciting activities as racing and dueling, farmers leased the grounds to graze livestock.

The races took a break during the Civil War, when the track became a POW camp for Union soldiers. After the war, emancipated slaves staged one of America's first Memorial Day celebrations here, reburying Union soldiers who had been unceremoniously interred in ditches. It next became the site of the South Carolina Interstate and West Indian Exposition in 1901. The expo's magnificent "palaces" and buildings, designed in an exotic Spanish Renaissance style, were painted a creamy off-white, thus its nickname the Ivory City. Yet perhaps the expo's grandest feature were its sunken gardens, with fountains, bridges and pools. Nevertheless, the expo was a financial failure and closed halfway into its anticipated one-year run. The Ivory City was quickly dismantled, and its raw materials auctioned as scrap.

The city then bought the property to create a public park, paving the racetrack in 1924 to accommodate automobiles. During the mid-20th century, the park even had a zoo, but when it failed to meet national animal welfare standards in 1971, the city closed it. Its animals were either given away or set loose.

RIGHT: Today Hampton Park is a 60-acre municipal garden. A small portion of the expo's sunken gardens was retained to become a duck pond. Only one small building of the Ivory City remains, storing gardening supplies. On any given day, cyclists, joggers and dog walkers enjoy taking laps around the mile-long racetrack, now Mary Murray Boulevard.

c. 1910

COOPER RIVER BRIDGES
Three bridges spanning history

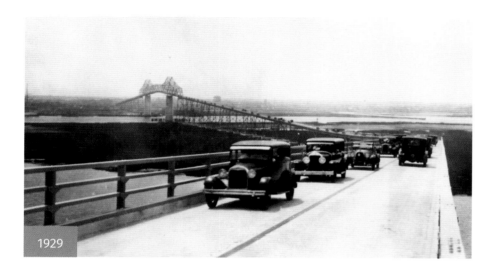

1929

LEFT AND BELOW: A trip across the John P. Grace Memorial Bridge, completed in 1929, was akin to a roller coaster ride. Cars passed precariously close to one another as they traversed the 10-foot-wide lanes with neither curbs nor median, just metal fencing and a 250-foot drop into the Cooper River. At 2.7 miles long and 15 feet higher than the Brooklyn Bridge, the Grace was the largest bridge of its kind in the world at the time of its completion. Those who traveled it vividly recall its steep dips and rises, with curving grades of 5 and 6 percent.

The bridge was built to promote the Isle of Palms as a tourist destination. A 50-cent toll helped recover its nearly $6 million construction cost. It was named for Charleston's first Irish mayor, who championed its construction and was president of the company that built it. After the company's bankruptcy, Charleston County purchased the Grace in 1941, selling it to the state two years later.

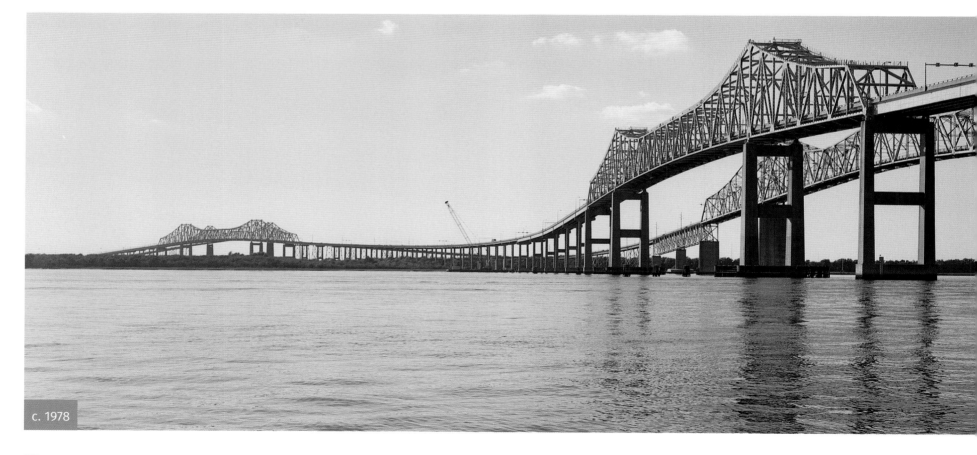

c. 1978

The wear and tear of increasing traffic, deferred maintenance, and hurricanes made it clear by the late 1950s that Grace's narrow lanes, designed for cars such as the Ford Model A, were no longer safe. In April 1966, a three-lane bridge was added as a companion to the Grace. Named in honor of Highway Commissioner Silas N. Pearman, most people simply called it "the New Bridge." Though higher than Grace, the Pearman Bridge had more gradual approaches, wider lanes, shoulder curbs, and smoother curves and dips. The Old Bridge's lanes were then both restricted to southbound traffic.

While the New Bridge, with two northbound lanes and reversible third lane, helped, the Grace continued to deteriorate, making what had been a tight drive, even in one direction, downright frightening. In 1979, an 8-ton—then 5-ton—weight limit was placed on the Old Bridge, and the reversible lane of the Pearman became a southbound lane for those too heavy or too intimidated to cross Grace.

More traffic and the coastal climate continued to compromise the two cantilevered truss bridges. By the 1990s, officials declared the Pearman Bridge was no longer up to the region's heavy traffic demands and the Grace was obsolete to the point of being hazardous. Additionally, the bridges' heights, which had distinguished them each when built, now prevented the port from accommodating today's larger ships.

RIGHT: State senator Arthur Ravenel Jr. spearheaded the initiative to fund a new bridge in the 1990s. Construction of the cable-stayed Arthur Ravenel Jr. Bridge began in 2001 and was completed—early and under budget—in 2005. In addition to eight wide vehicular lanes, the bridge features pedestrian and bike lanes. Shortly after the Ravenel Bridge opened, the Grace and Pearman bridges were imploded.

ABOVE RIGHT: For a brief time in Charleston's history, as the new Ravenel Bridge was being constructed from 2001 to 2005, the three Cooper River bridges stood side by side.

BELOW LEFT: Drivers passed dangerously close to one another on the original Grace Memorial Bridge, with nothing more than a low metal fence to protect them from plunging into the river below.

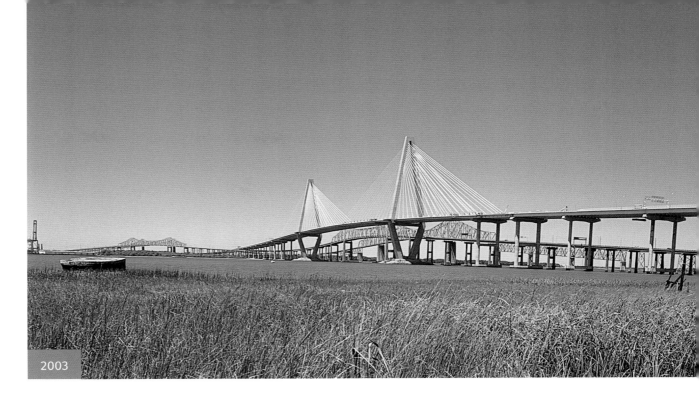

2003

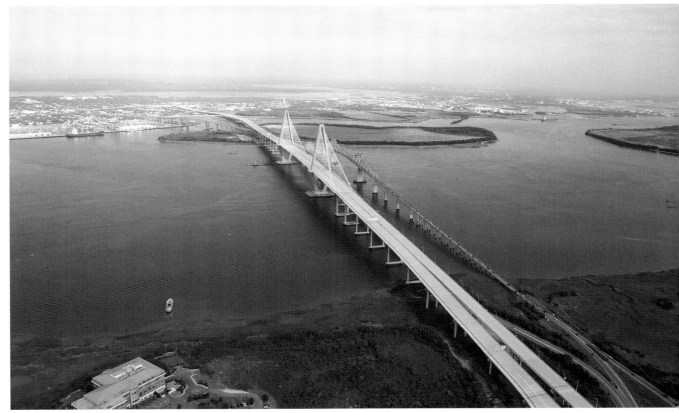

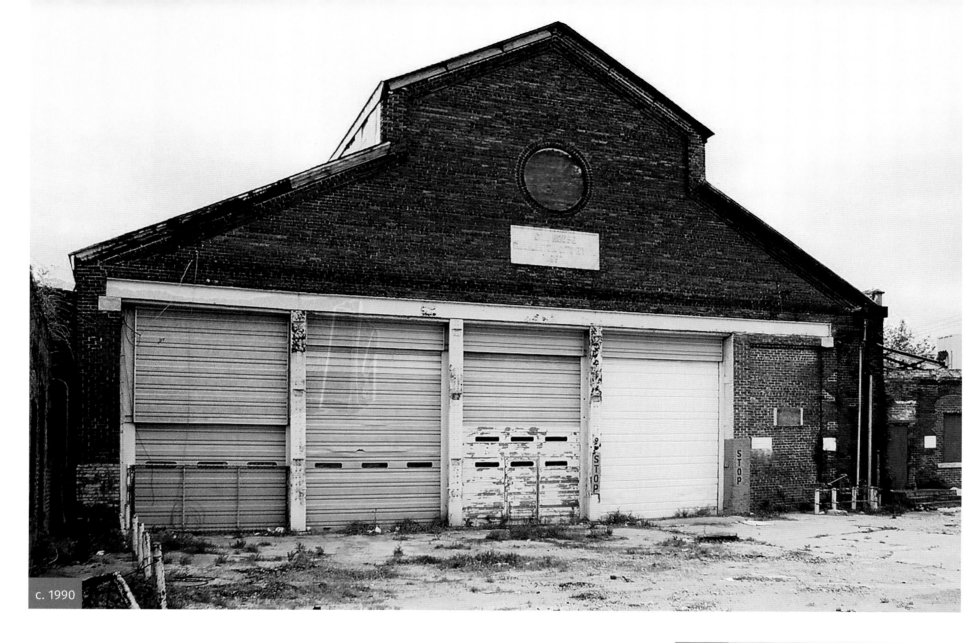

c. 1990

OLD TROLLEY BARN, 649 MEETING STREET
Remnant of a golden age given new life and purpose

ABOVE AND RIGHT: From 1897 to 1938, electric trolleys defined Charleston's golden age of mass transportation. Their tracks provided convenient mobility from the Battery to the Navy Shipyard and Harleston Village to the Isle of Palms. Because trolleys were the largest user of electricity at that time, they were owned and operated by the power company, which built an electric generation station on upper Meeting Street, as well as a "car house" across the street, where they kept and maintained the trolleys.

As automobiles became common, the trolleys' profitability declined. They also had become a bit of a nuisance, as their tracks ran down the middle of what were now two-lane streets. Finally, new diesel

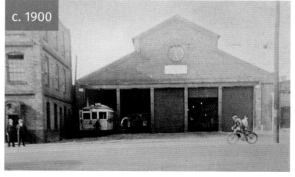

c. 1900

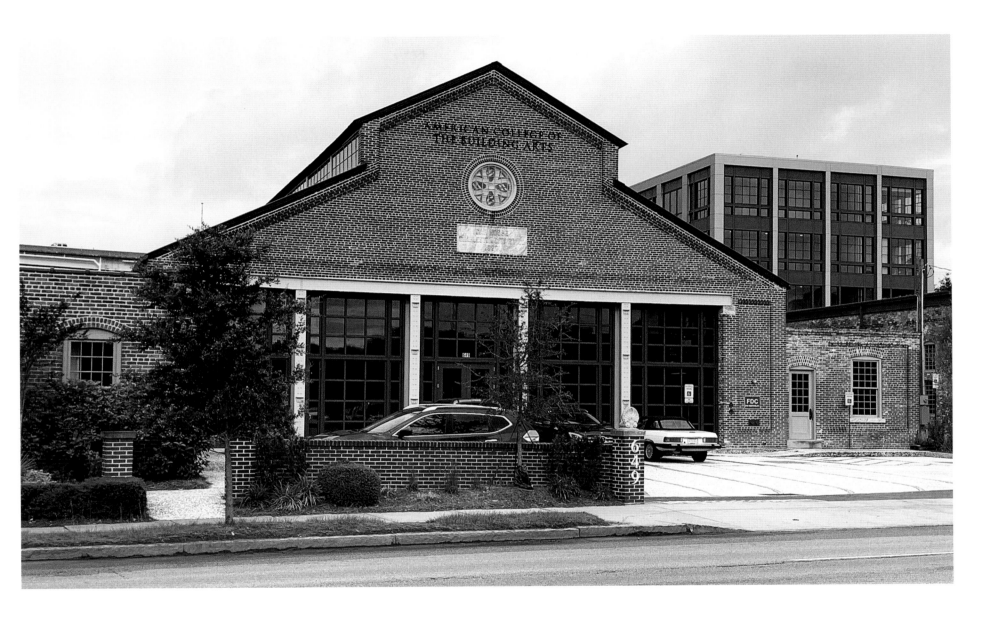

buses offered mobility that was not limited by fixed tracks. On February 10, 1938, the company offered free "last-day trolley rides" with marching bands and a parade up Meeting Street to the car house, now better known as the Trolley Barn, where they pulled in for the last time. The Trolley Barn became a maintenance garage for the buses through the 1960s, and a warehouse for some time after that. By 1980, the building had been abandoned. Hurricane Hugo in 1989 compromised its roof, leaving the Trolley Barn a dilapidated eyesore for decades.

ABOVE: The Trolley Barn received a new lease on life in 2017 when it was rehabilitated as the new campus of the American College of the Building Arts, the nation's only four-year college to integrate a liberal arts curriculum with training in the traditional building trades. After a two-year rehabilitation, it is again a vibrant space.

Remnants of the trolleys' tracks peek through worn spots in the pavement of many Charleston streets today. The power company, now SCANA, still owns narrow strips of valuable real estate throughout Charleston that once defined the trolleys' right-of-ways.

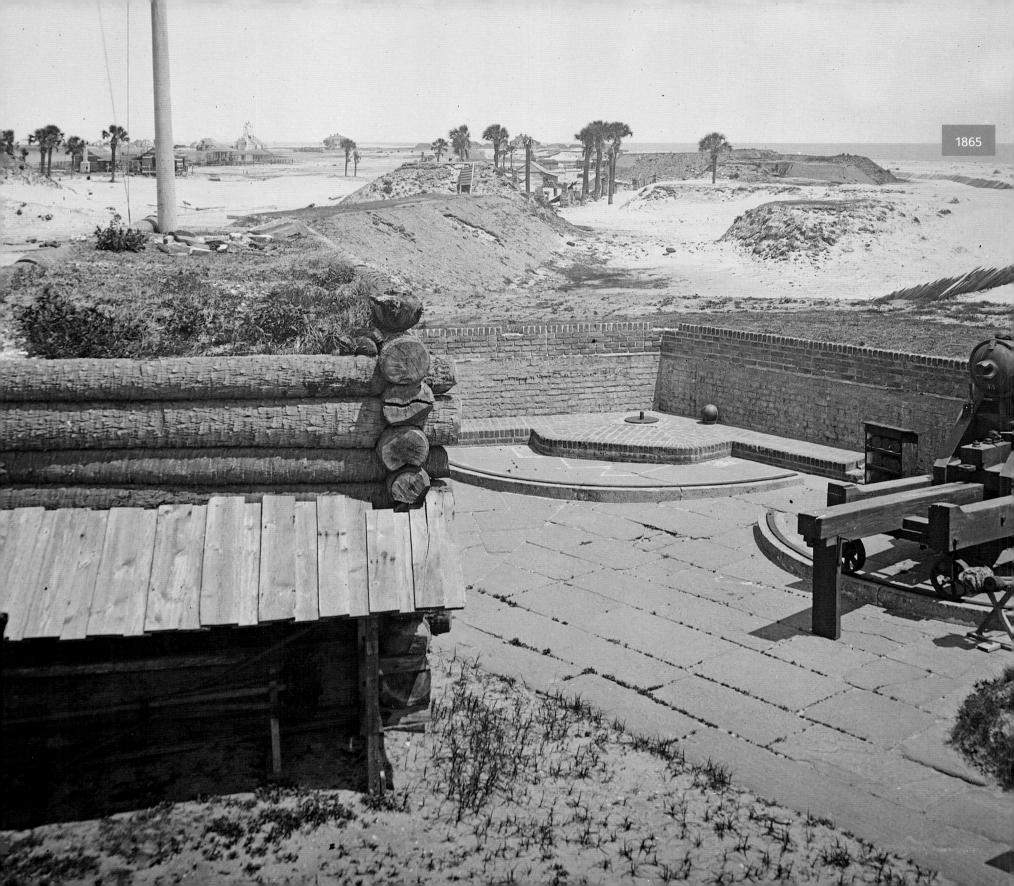

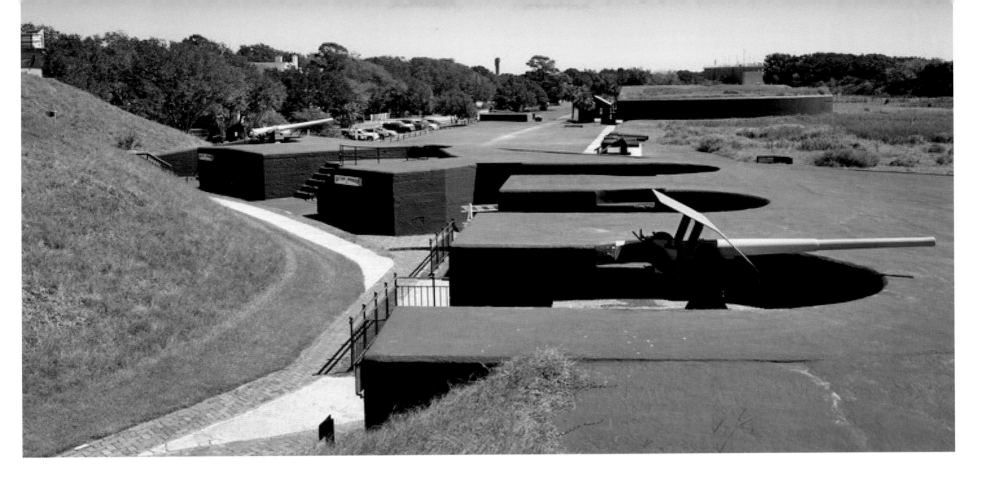

FORT MOULTRIE, SULLIVAN'S ISLAND
Guarding Charleston Harbor from the Revolution to World War II

LEFT: A small, unfinished fort made of palmetto logs and sand in 1776 played a key role in the early days of the American Revolution, when a small group of Patriots successfully turned back nine British warships. The fort, named for its Patriot commander Col. William Moultrie, was no longer garrisoned after the Revolution. Its building materials were scavenged by locals, and its ruins battered by several hurricanes.

A second fort was established in 1798 amid concerns about unrest in Europe, yet it too was destroyed in an 1804 hurricane. A third fort was completed in 1808, though it saw no action until the Civil War. Before then a young Lt. William T. Sherman and macabre writer Edgar Allan Poe were stationed here. Abner Doubleday, credited with inventing baseball, served at the fort before evacuating to Fort Sumter a week after South Carolina adopted the Ordinance of Secession.

ABOVE: Three concrete batteries were built at Fort Moultrie in 1901, and 3,000 soldiers were stationed there during World War I. Afterward it served as a National Guard and ROTC training facility and a Civilian Conservation Corps camp. In 1944, a joint Army/Navy facility made the last renovations and updates to the fort. In 1960, Fort Moultrie was transferred to the National Park Service and today serves as a museum and educational interpretive site.

RIGHT: For several months following his capture in December 1837, Seminole chief Osceola and 237 of his people were incarcerated here. A popular prisoner welcomed into Charleston's cultural and social life, Chief Osceola died while incarcerated at Fort Moultrie in 1838, a victim of malaria and tonsillitis. Though his dying wish was to be returned for burial in Florida, his physician decapitated Osceola and displayed his head among his collection. Osceola's remains were buried, and remain, at Fort Moultrie.

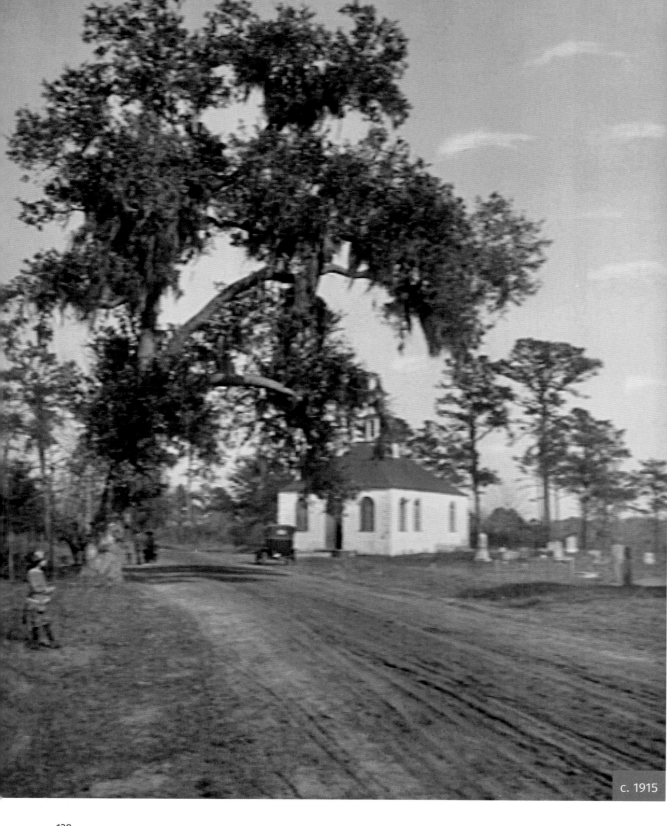

c. 1915

CHRIST CHURCH, HIGHWAY 17 NORTH

Nearly three centuries of revolutions and restorations

LEFT: While the Charles Town colony was known for its religious toleration, the Church of England was its predominant denomination. In 1706, the Commons House of Assembly passed the Church Act, dividing the colony into 10 parishes that served as civil administrative districts as much as religious ones. One of those was Christ Church, encompassing the area that lay "Southeast of the Wandoe river." A parish primarily made up of plantations, its population was 86 percent enslaved by 1720, according to historian Matthew A. Lockhart.

Within a year of the Act, a small wooden church was built at this site. That church burned in a 1725 fire and was replaced by a brick sanctuary. Yet more hard times were ahead for Christ Church. It burned again in 1782, this time by British troops as they evacuated Charleston at the end of the American Revolution. Though its interior and roof were lost, its walls were restored and a cupola added in 1787.

After South Carolina seceded from the United States in 1860, a long earthen defensive line was built using enslaved labor from neighboring plantations that ran from Boone Hall, along the parish churchyard, and east to Hamlin Sound. Trees were cleared for more than a mile around the battery to better spy any approaching enemy. Nevertheless, the site fell to Federal forces in February 1865, and Union cavalry from the 21st U.S. Colored Infantry Regiment camped here. Because their horses were such valuable assets, they were stabled inside the church, while soldiers slept around the churchyard. Christ Church's interior was again destroyed, leaving only the walls and roof.

The congregation again undertook restoration of the parish church, and by 1874 had reconsecrated the sanctuary. In 1961, new wings were added to each side of the chancel to house a sacristy and rector's office. The historic church was listed on the National Register of Historic Places on November 27, 1972.

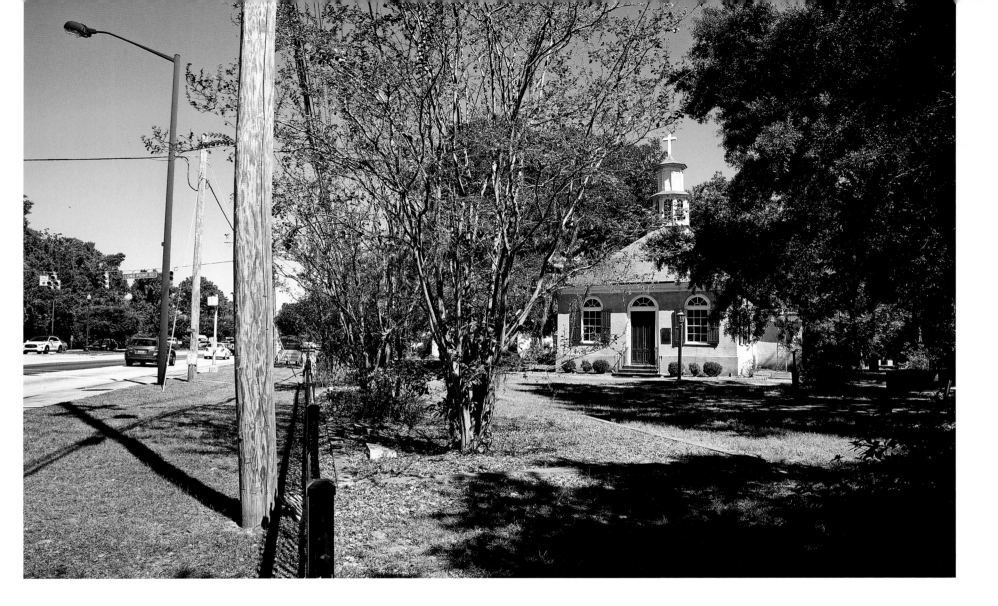

ABOVE: Though wars and fires have necessitated reconstruction and updates over the centuries, Christ Church has maintained its colonial architectural integrity. Graves found in the churchyard today date as far back as the mid-1700s. The 1862 Confederate earthwork can still be seen along its northern property line, though today it might be mistaken for a drainage ditch.

A larger sanctuary and supporting buildings were built behind the historic church in 2003. But perhaps the church's biggest change is not visible as one passes along busy Highway 17. Following the Revolution, Anglican parishes became members of the Protestant Episcopal Church in the United States of America. Revolution was once again in the air as, in 2012, Christ Church's congregation voted to join most churches within the state's diocese in breaking ties with the national Episcopal Church over theological differences concerning same-sex marriages and the ordination of gay bishops.

In 2017, Christ Church's congregation voted to join the more conservative Anglican Diocese of South Carolina.

The split resulted in lawsuits involving who owned historic church properties deeded to the Episcopal Church after the Revolution—the Diocese or the congregations? In 2022, the S.C. Supreme Court determined that Christ Church belonged to the national Episcopal Church, regardless of the majority vote of its congregants. Nearly three-quarters of the church's members began seeking a new place to worship. The rest continue to worship at Christ Church.

ABOVE: While the Christ Church sanctuary has changed little since its 1726 reconstruction, everything around it has changed drastically, including the major Highway 17 thoroughfare that was once the dusty King's Highway. What was a quiet rural site now bustles as one of the Lowcountry's major transportation arteries, rattling the bones of pre-Revolutionary settlers.

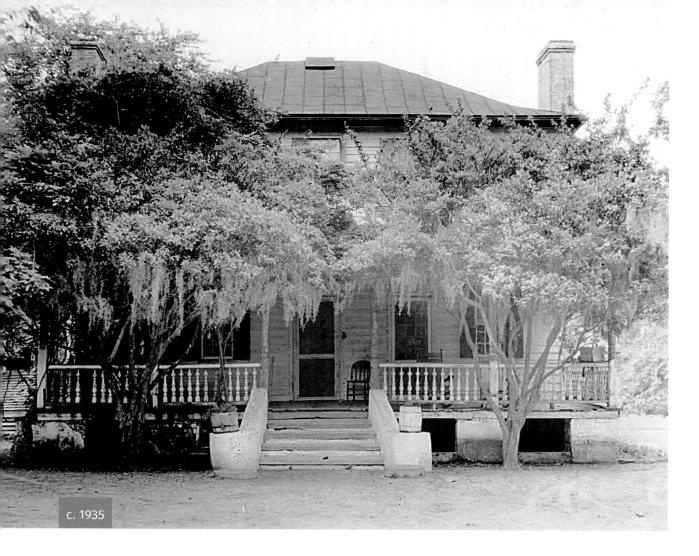

c. 1935

1938

1938

BOONE HALL PLANTATION
One of America's oldest plantations in continuous use

ABOVE: Few places conjure up the romantic image of a Southern plantation more so than Boone Hall—a bit ironic when you consider the "big house" was built in 1936. Still, having produced various staples for more than 330 years, the property is one of the oldest—perhaps *the* oldest—plantations in the nation to have remained continuously productive, through good times and bad.

Theophilus Patey (or Paite) immigrated from Yorkshire, England, by way of Barbados before 1681 when he was granted land along the Wampocheeone Creek. Upon his daughter's marriage to Maj. John Boone, Patey deeded the new couple 400 acres. They built the first documented wooden house here around 1790, a symmetrical two-story farmhouse with a one-story front porch. The Boones grew rice and indigo, until Sarah Gibbes Boone sold the plantation to Thomas Vardell in 1811. Members of the Boone family are believed to have been interred in a brick vault on the property.

Vardell grew indigo and cotton for about six years before losing the property in a debt arrangement to three men, who then sold it to brothers Henry and John Horlbeck, local architects and builders, who established a prosperous brick-making business here. By 1850, with a labor force of 85 enslaved workers, the Horlbecks were producing nearly 4 million bricks a year for some of Charleston's grandest residences. They also planted pecan trees, becoming the largest supplier of pecans in America by the turn of the 20th century. Yet perhaps the Horlbecks' most lasting visual legacy may be the beautiful oak allée they planted in the early 1840s. (Some sources credit the Boones with beginning the tree line a hundred years earlier, though the trees there today date to the Horlbecks' ownership.) With 90 live oaks and one magnolia tree lining both sides of the three-quarter-mile dirt driveway, this magnificent vista was the inspiration for the setting of Twelve Oaks plantation in the 1939 classic *Gone with the Wind*.

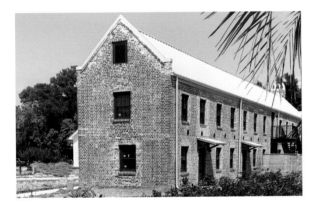

TOP: Nine cabins built between 1790 and 1810 for enslaved families run alongside the allée. They are unusual as they are made of brick, probably replacing earlier wood ones. Each cabin features a central fireplace with a room on either side. More than one generation of a family lived in each, often housing nine to ten people. Sharecropping families continued to live in the cabins until the 1940s. They now provide visitors with a vivid interpretation of the lives of the enslaved.

ABOVE: The gin house, believed to have been built in the 1850s, has recently undergone extensive renovation. While the brick exterior remains intact to preserve the structure's historical integrity, the interior has been extensively remodeled to include a welcome center and gift shop on the first floor and a rentable venue for events on the second floor.

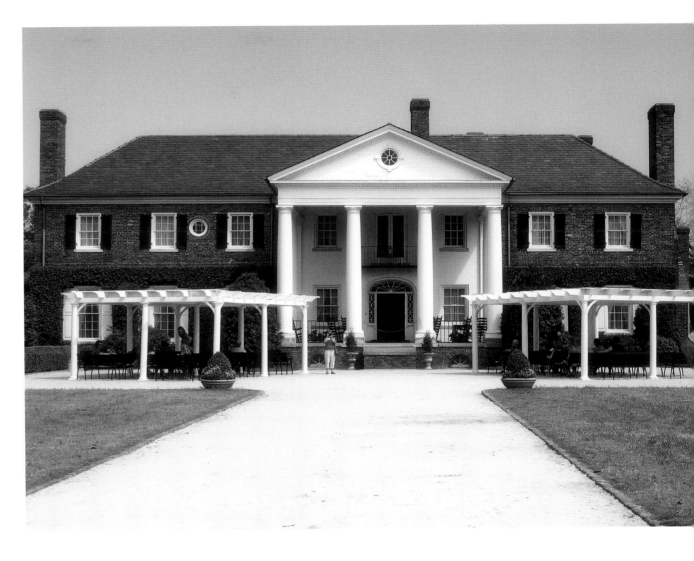

ABOVE: In 1935, the Horlbecks sold the property to wealthy Canadians Thomas and Alexandra Stone who, feeling the farmhouse did not fit their image of what a southern plantation should look like, demolished the old residence to replace it with the Colonial Revival-style mansion (à la *Gone with the Wind*) that greets tourists today. Four years later, the Stones sold the property to Georgia's Prince Dimitri Joriadze, who raced thoroughbreds under the brand Boone Hall Stables. His Princequillo was the fastest horse in America in 1943. The Joriadzes sold the plantation to Dr. Henry Deas in 1945, who sold it to Mr. and Mrs. Harris M. McRae in 1955. The McRaes opened it as a tourist attraction shortly thereafter, and it remains so today. Boone Hall was listed on the National Register of Historic Places in 1983.

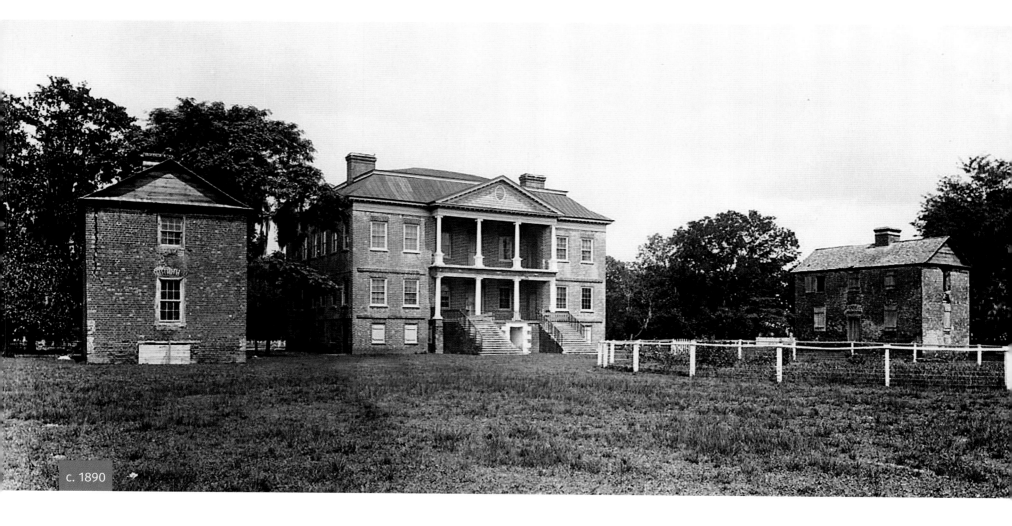

c. 1890

DRAYTON HALL, 3880 ASHLEY RIVER ROAD

A time capsule of colonial plantation life for both planters and the enslaved

ABOVE: One of the finest examples of Georgian Palladian architecture in America, Drayton Hall is the only plantation house along the Ashley River to have survived both the American Revolution and Civil War. Painted only a handful of times over the past 270 years and never upgraded with plumbing or electricity, the house stands as an authentic example of colonial architecture and the lifestyle of Lowcountry planters.

John Drayton was the third son of Thomas and Ann Drayton. He already owned numerous plantations when he purchased this site in 1738. His purpose was not to create another working plantation, but to establish his family seat with a house that reflected his wealth and accomplishments. Drayton probably consulted pattern books popular at the time, incorporating a floor plan from James Gibbs' *A Book of Architecture* (1728), interior detailing similar to that of Inigo Jones (1573–1652), and features used by Andrea Palladio in the Villa Cornaro in Venice, c. 1551. With the symmetry and classic style of Greek and Roman temples, colonnaded paths connected the main house to two flanking buildings. Drayton surrounded his hall with an English-style garden using indigenous plants and trees. His son, Dr. Charles Drayton, later expanded the garden incorporating exotic plants shared by French botanist Andre Michaux in 1799.

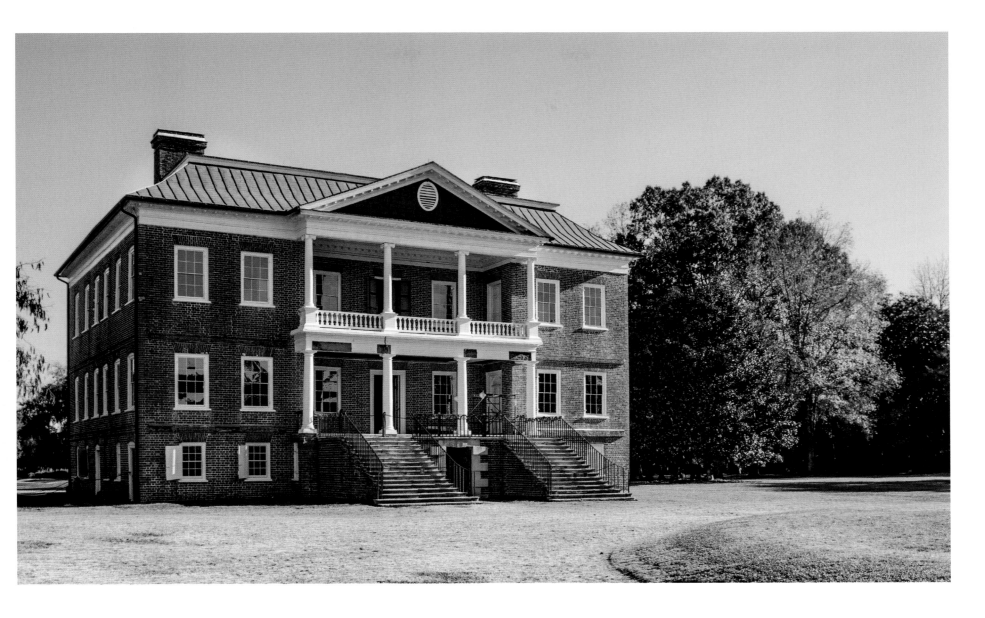

Seven generations of Draytons lived here through the 1960s, though one of the flankers was destroyed in the 1886 earthquake and the other by an 1893 hurricane. Freedmen and their descendants continued to live on the site for generations as well, farming the land and raising their families. Thus Drayton Hall never sat idle; their presence kept Drayton Hall alive, preserving the property. Upon her death in 1969, Charlotta Drayton left the property to her nephews, Frank and Charles Drayton, requesting in her will that neither they nor their heirs ever modernize the house.

ABOVE: Without the financial resources to maintain the property, the brothers honored their aunt's will by transferring Drayton Hall to the National Trust for Historic Preservation in 1974, which opened it as a museum two years later. The main house and dependent buildings interpret the history of both the black and white families who lived here for nearly three centuries. An expansive visitors' center was completed in 2015. An active archeological site, its grounds represent one of the most significant historic landscapes in America, including the largest known African-American cemetery.

INDEX